A PAINTER OF DARKNESS

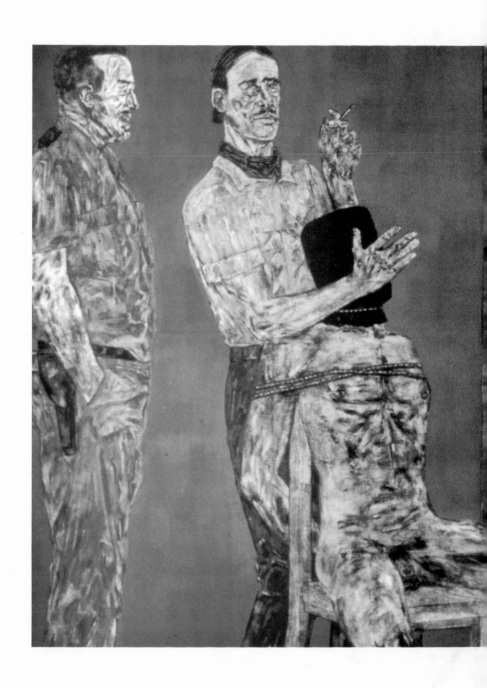

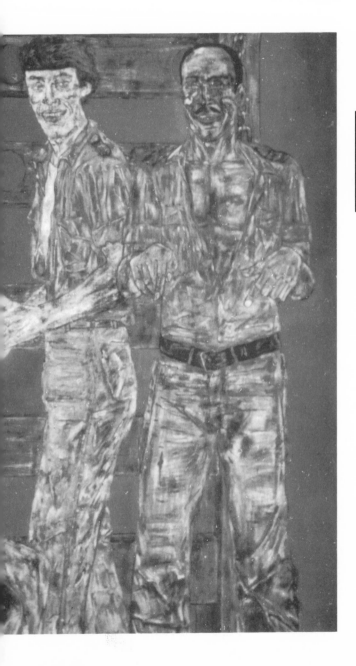

INTERROGATION II,
1981

A PAINTER OF
DARKNESS

LEON GOLUB
AND OUR TIMES

GERALD MARZORATI

VIKING

VIKING
Published by the Penguin Group
Viking Penguin, a division of Penguin Books USA Inc.,
40 West 23rd Street, New York, New York 10010, U.S.A.
Penguin Books Ltd, 27 Wrights Lane, London W8 5TZ, England
Penguin Books Australia Ltd, Ringwood, Victoria, Australia
Penguin Books Canada Ltd, 2801 John Street,
Markham, Ontario, Canada L3R 1B4
Penguin Books (N.Z.) Ltd, 182–190 Wairau Road,
Auckland 10, New Zealand

Penguin Books Ltd, Registered Offices:
Harmondsworth, Middlesex, England

First published in 1990 by Viking Penguin,
a division of Penguin Books USA Inc.

10 9 8 7 6 5 4 3 2 1

The Leon Golub paintings reproduced in this book
are courtesy of Barbara Gladstone Gallery, New York.

LIBRARY OF CONGRESS CATALOGING IN PUBLICATION DATA
Marzorati, Gerald.
 A painter of darkness : Leon Golub and his times/Gerald
Marzorati.
 p. cm.
 ISBN 0-670-81979-4
 1. Golub, Leon, 1922– —Criticism and interpretation.
I. Title.
ND237.G6113M37 1990
759.13–dc20 89-40321

Printed in the United States of America
Set in Sabon
Designed by Liney Li

For Barbara M.

[W]e have developed a sort of compunction
which our grandparents did not have,
an awareness of the enormous injustice and
misery of the world, and a guilt-stricken
feeling that one ought to do something about it,
which makes a purely aesthetic attitude
toward life impossible.

—George Orwell

Acknowledgments

I would like to thank Nan Graham, who understands that editing is not simply (but is finally) work done on the page; Andrew Wylie, who believed in the book when all I had was an idea; Nancy Spero, for her patience, generosity, and insights; Peter Schjeldahl, who has taught me so much about looking; and my colleagues at *Harper's Magazine*, especially Michael Pollan, who remind me each working day that both art and politics are best approached with an open mind, without cynicism, liberally.

Contents

I

THE · SUSAN CALDWELL GALLERY

JANUARY · 1982

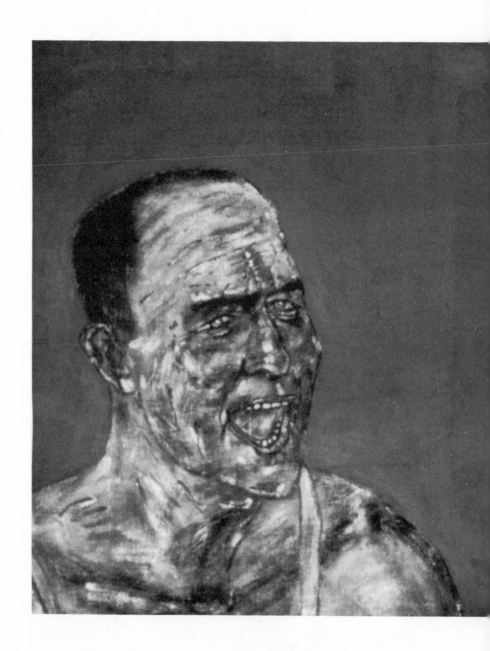

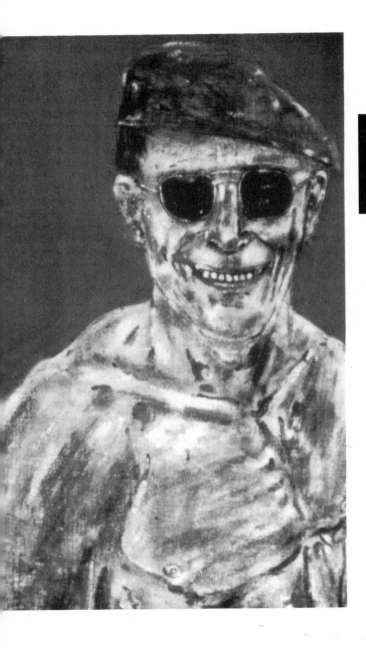

It BEGINS WITH the work. I did not know Leon Golub; I did not know of him, although I should have. I wrote about art, but I was new to it—his name meant nothing to me. And then I saw paintings he had done: That's where the story begins. There were only the paintings, then, only a few of them; and paintings—I knew this much—tell us less about painters than we have convinced ourselves they do.

I more or less stumbled upon Golub's paintings on a cold and fading afternoon in January 1982. They were at the Susan Caldwell Gallery in SoHo. It was a one-man show, but there had not been a lot of publicity for it, or talk building up to it. And anyway, it was January, and the shows that mattered were seldom held in January, so near the holidays. The important shows were in the fall and in the spring. In January, the art dealers liked to exhibit the work of new artists they had taken on, or to mount group shows, mixing the work of artists they represented with that of others under some rubrical title that lent the gallery, if only for a few weeks, an air of curatorial detachment.

I knew the rhythms of the galleries. I wasn't writing art criticism; I was an editor, and I had ideas about being a writer—writing, perhaps, was something toward which I was heading. I was working at an "alternative" weekly paper, *The SoHo News*. Downtown in New York City in the late 1970s and early 1980s *The SoHo News* was an unconventional, erratic fixture, but enough of a fixture to give me that sense of belonging, somewhere or to something, that you need in New York, at least in the beginning. I started working at the paper when I was twenty-three—eventually editing the work of critics, reporters, too. And

along with this, after some time, I had the job of writing each week for the paper—for its centerfold pullout, listing events of the week—a brief art guide.

I was interested in art, and in artists. Living in New York, downtown, I met many painters and sculptors and photographers, young ones mostly; and I found it easy to talk with them— or, more accurately, to listen to them. Especially the painters. Why painters struck me (and still do) as more given to talk than other artists I don't know (not that painters are loquacious, the way a novelist, a storyteller, tends to be). I know, simply, that I was taken with the talk of painters, the sense it conveyed of effort and purposefulness. I liked to visit their studios, to sit and talk there; there is something about the quiet, and the shaggy workshop order, and the smells of oil and turps, and the look of a picture just begun.

In the quiet satisfaction this gave me, I recognized a certain elegiac feeling: I was not naïve about this. The stillness of the studio, soft voices, a piece of canvas stretched on a wall: Wasn't this a setting from the past? A thing lost? What did this have to do anymore with the way we lived? It could make me melancholy, and that was its own pleasure, as anyone young and new to New York soon learns. Talking with a painter in a loft downtown into the early morning, then walking north, pensive and smoking, collar up against the chill (whether there was a chill or not)—I was full of feeling, and liked it. Painting, in this way, was something I used to cultivate a sad thoughtfulness: a saturnine drug.

But there was something else: Painting had persisted. It had persisted despite everything, including the elegiac. It had not been overwhelmed and crippled by the elegiac in the way, say, that poetry had, at least in the West. (You can hardly read an essay about poetry without reading of its diminished place in the culture.) The elegiac has surrounded painting for many years, it is true. Here is the poet Paul Valéry, writing in 1935 (in his wonderfully discursive little book on Edgar Degas, *Degas, Dance, Drawing*)—writing at a time when Picasso and Matisse were alive and working; writing at a moment when notions such as modernism and the avant-garde continued to be crucial to art and thought (as they no longer are); writing as someone who had

spent his life among advanced painters; but writing, already, elegiacally:

> *It sometimes seems to me that the labor of the artist is of a very old-fashioned kind; the artist himself a survival, a craftsman or artisan of a disappearing species, working in his own room, following his homemade empirical methods, living in untidy intimacy with his tools, his eyes intent on what is in his mind. Perhaps conditions are changing, and instead of this spectacle of an eccentric individual using whatever comes his way, there will instead be a picture-making laboratory. . . .*

Already, for Valéry in the 1930s, the painter was something out of the past, a holdover. I imagine the painter was, in a sense, already old-fashioned in the Paris of 1860, at the very beginning of modernism—Paris was by midcentury a centralized, bureaucratized, industrializing, "modern" city. Manet, Pissarro, Monet: Whatever their pictures, their original, "radical" ways with form and color and subject matter, their approach to work must have seemed to many oddly outmoded.

Of course, the "picture-making laboratories" Valéry imagined have come to pass; mechanically and electronically produced pictures—the products of the film and television industries' picture-making labs—have a central place in our life. Daily experience is crowded with encounters of this imagery: advertisements in the morning newspaper, billboards and posters on the street, films of all kinds, and of course TV. In no way do I wish this weren't so; I appreciate the information these images convey, and also the sensations, which can be strong, deep, aesthetic. At any rate it is simply the way the world is now—layered with images.

This proliferation of images would seem to have had its effect on painting, however. If painters had come long ago to seem old-fashioned—if they had appeared to society, even in 1930, or in 1860, to have served a more vital role sometime in the far-off past—they had not lost their place in the world of art. They had continued to be modern, avant-garde, long after Valéry wrote of

Degas. But this had changed by the time I got to New York, in 1975. Painting was now being ignored, when not scorned, even by many who looked at and wrote about art—even by some who made art. Why work on canvas with paint in an age of Nikons, shoulder-mounted video cameras, computer imaging? It was a question asked dismissively: There was thought to be no good answer. Painters painted (it was said) because they clung to a nostalgic idea of the artist, the artist as individual, original spirit; or they painted because it was the one art form that—unlike video art or performance art, say—still might make them big money.

Once I began to know a few painters, I, too, found myself quietly asking: Why paint? But I was not asking the question of any painter directly—and I wasn't asking it dismissively. I was mulling it over, in one way or another, almost all the time. I asked it to myself when I visited the galleries. It was what I wanted an answer to when I sat and listened to painters; I sifted what they said for insights. I thought it a big, crucial question: Really, ultimately, why paint? Walking late at night, thinking, it was always the question I came back to—a vast question, a social and political as well as aesthetic question. How and why do we picture things as we do? Not an elegiac, melancholy question. It was more than that.

2. THE SOHO NEWS art guide: Each week, with a pen and a note pad in my jacket pocket, I walked down Madison Avenue on the Upper East Side, across Fifty-seventh Street, along the industrial-looking streets of SoHo. Each week, I saw artworks by dozens of artists. And each week I wrote three brief paragraphs for the paper on three shows that meant the most to me. "Art" meant a lot to me; I knew that. That some works of art mattered to me and some didn't I was learning about—and learning why this was.

It was on one of those walks that I came upon Golub's show at the Susan Caldwell Gallery. By this time I had been writing

my three paragraphs, making the rounds, for about two years; and I had come to know that certain galleries—much as certain works of art, certain artists—were more important to me than others. The Susan Caldwell Gallery was not one that meant much to me (it is no longer in business). The paintings I had seen there were mostly cool, geometric abstractions by artists whose names I could not keep straight—painters who continued to work in a style that had had its moment in the 1960s, and then had become stale, academic, a style kept alive by painters who got by teaching graduate students in fine-arts programs, painters who had no real public for their work, not even within the small public for art. I mention this only to reinforce the idea that I did not expect to see artworks at Susan Caldwell that would matter to me—that for me, the paintings of Leon Golub came out of the blue. I had visited the O. K. Harris Gallery, in the same building as Susan Caldwell—this big loft building on West Broadway was a last stop, always a quick run-through—I had left O. K. Harris and dutifully walked upstairs. When I reached the landing for Susan Caldwell, I saw a sign on the door:

PLEASE BE ADVISED THAT THE CURRENT EXHIBITION AT SUSAN CALDWELL, INC., MAY BE INAPPROPRIATE FOR VIEWING BY CHILDREN.

And I thought: *Pathetic.* After all that had come before, after all that had been tried and done in art in modern times, despite all the pseudo-scandals in the art of recent times—perhaps because of them—there were artists who continued to believe that they could shock, that they had to. The sign was not for children, was not a warning: What child today could be shocked by a work of art in a SoHo gallery? The sign was a prop, theatrics, something to build expectations. It was a sign of false pride, false hope. I was sure of this, and as it turned out I was wrong.

3. THE SENSATION OF entering a room hung with pictures you have never before seen, a room of new paintings, of paintings that nevertheless you know, *know instantly,* will engage you: What is it you are sensing just then? And further: How to sort out the muddle of feelings (in this case: attraction, recognition, disquiet, repulsion) so that they might be expressed in words— and then, how to overcome the embarrassment that the expression (in words) of any such subjective, existential encounter must entail?

What is that sensation we feel standing before new paintings that instantly "reach" us, "touch" us? (The words we are apt to use convey the physicality of the encounter.) It is this, I think: It is the knowledge, at once calming and fraught with expectation, that these paintings will hold your gaze—that the time and concentration the painting demanded of its maker is being demanded of you somehow, and you are beginning to "get it," to get in sync not only with the finished picture but with its becoming. It is a sensation of being possessed by that which you, in turn, desire to take possession of. It is a feeling: When your gaze is held by a painting, it is not only a matter of seeing; it is something you sense with your body (your legs moving you closer and back, your fingertips agitating), and, I would say, too, but not easily, *with your heart.*

I had this feeling the minute I glimpsed Golub's paintings. In the middle of the gallery, slowly spinning, alone (it was nearing closing time), I knew I would be spending some time with them. They struck me as morbidly beautiful. And there was the feeling, as they held my gaze, of a deeper recognition—a sense that they were not simply stunning but true.

4. I MADE A quick, provisional sweep of the gallery. Two large rooms, six big paintings. Reading the gallery checklist, a photocopy handout, I saw that three of the paintings belonged

to a series called *Mercenaries,* that the three others were of an *Interrogation* series, and that Golub had worked on and off on each series for at least three years—the earliest painting was dated 1979. Three years, just six paintings: Were there more? Or had they taken so long to do? (The canvases looked scumbled to me at first; and then it sank in that they'd been heavily worked— the paint applied and scraped, applied and scraped.) Had he been showing at another gallery? Had I missed them? This big they would be hard to miss—how big, exactly? (Ten feet high, each of them. Maybe fifteen feet long, the biggest.) And the imagery, the figures, enormous full-length portraits of mercenaries, torturers, and their victims: Was Golub an American artist? A Latin American?

It was unlikely, I reasoned, that Golub was a Latin American. Golub's style, an expressionist-realist style, was "northern," not the surrealist-inspired magical realism of so much Latin-American painting—and not socialist realism, the drab, idealized naturalism shipped to many Latin-American countries by the Soviet bloc along with the pamphlets and guns and dreams of revolution. Anyway, Latin-American painters were rarely given one-man shows by New York galleries (if there were good ones, they were going undiscovered). Golub was an American; and if I had hesitated even a moment in reaching that conclusion, it had to do with what it implied. These men, Golub was saying, are us.

Us? Torturers and mercenaries were something far away; they worked on other continents, in the jungles and mountains and prisons of countries vastly different from ours. Who could really know what went on in such places, or why? The Western nations had different traditions; our military and police were answerable to civilian officials, our rights were guaranteed. Torturers and mercenaries had nothing to do with us, were "their" problem, not ours. This was how torturers and mercenaries had long been understood, especially by Americans, who lived their everyday lives at such a distance, politically and geographically, from the world "out there."

The old truth about torture, mercenaries, this sort of political criminality, helped us—as all long-held, widely accepted truths help us—to organize reality, make sense of the world. Old truths are reassuring, because they harbor connotations of complete-

ness. You hear the old truths, you read about them, and they seem whole, immutable. But old truths, in order to remain immutable, must also be truths that are in no way crucial to day to day life—truths such as those about torturers and mercenaries: Who talked, who examined, who really cared about what went on "out there"? For crucial truths tend to get reexamined; events, the large and sudden pressures history can bring to bear, almost always demand this. And few truths reexamined under such pressure are not in some way altered—often painfully, reluctantly altered. The old truths about torturers and mercenaries had remained for the most part unexamined; they were truths that didn't really matter to us. The old truths began to matter—to seem uneasily incomplete, vulnerable—only when unexpected events brought them to the center of national debate.

The old truth about torture: It is something beyond us, "out there." It is something authorized by tyrannical madmen, men like Hitler and Stalin. It is something done in the "bush," where lawless actions are seldom brought to light. Or, closer to home, in the countries to our south: It is something done by Latins, it has to do with the Iberian heritage, it goes back to the Inquisition, "they" have always tortured their own, always believed that it worked. And there is truth, awful truth, in all this.

Mercenaries, too—in modern times, anyway—had nothing to do with us. They, too, were fighting in the "bush," Frenchmen and Englishmen, the last ragtag vestige of Europe's colonial presence in Asia and Africa. The old truth about mercenaries: Soldiers of fortune have long fought in "their" wars—that is, the wars in the colonies, the underdeveloped world, the world of poverty and color; "they" don't have the resources or skills to train their own armies, so they hire a handful of mercenaries to do the job; "they" continue to believe in the superiority of the mercenary, the white soldier. And as with the old truth about torture, there is truth in this as well.

But there were new truths now about torturers and mercenaries, brought to light by major (by our standards, cataclysmic) events—brought to light in the early and mid-1970s, the period just before Golub began the earliest of the paintings of torturers and mercenaries Caldwell was showing. The Vietnam War, Watergate, Congressional hearings on United States-sponsored co-

vert operations—together, in the course of a few years, these events had badly shaken our belief in a number of important old truths. The Vietnam War played the crucial role in this national reexamination. In a sense, our rethinking about torturers and mercenaries has its roots in the debate over the war. It is difficult to imagine there would have ever been such a rethinking without that debate. And it is difficult to imagine—this struck me in the gallery—that Golub would have made his paintings of mercenaries and torturers had there not been the war in Vietnam, the agonizing debate that ensued, the new truths that emerged from it.

The American people had come to believe by 1970, if not earlier, that direct military involvement in the war in Vietnam was morally untenable. The specter of "losing" Vietnam—whether understood as the loss of South Vietnam to communist guerrillas and North Vietnamese regulars, or a loss of "credibility" that would cost us the respect of allies and enemies alike—was no longer reason enough to send young Americans into combat, or, eventually, to continue the massive, routine aerial bombing of cities, ports, the countryside: that is to say, the bombing of much of what was, and remains, a fairly small Asian nation. We had come to believe that the war was not our business; it might well have more to do with matters strictly Vietnamese than with a Soviet-backed international communist movement; and supporting a corrupt, oppressive, and unpopular regime in South Vietnam was not the best way—neither an ethical nor effective way—to promote freedom and democracy in that country. We had also recognized, slowly and painfully, that we ourselves were capable of political crimes. Thousands of Vietnamese peasants—on no more "evidence" than the accusation of a neighbor, or for no other reason than the necessity to fulfill monthly "quotas" for arrests—had been imprisoned as Vietcong agents, tortured, and sometimes killed, as a result of the C.I.A.-conceived and C.I.A.-administered Phoenix program. And north of Vietnam, in the jungles of Laos, the United States government—secretly, without the consent of the Congress—had paid and used mercenaries with links to the international drug trade to wage a war against communist guerrillas. Suddenly, as a result of the war in Vietnam, the old truths about torture and mercenaries were no longer so

complete and reassuring. There was a new and troubling truth—one with which most Americans did not want to live.

In our willingness to "lose" Vietnam, we expressed the belief that we were no longer willing to fight communism anywhere, at any price, and also that we would no longer automatically come to the rescue of unpopular, authoritarian regimes, however "friendly" they might be toward our interests—that is, our fervid interest in "containing" the spread of communism. This reluctance to intervene directly, with ground troops and air power, in wars being waged in small, faraway countries, was a profoundly new attitude—one brought about, in no small part, by the horrible new truth that we had had a hand in political crimes. Our belief in containing communism, through direct intervention, if necessary, wherever we glimpsed it (or thought we did), had been at the very heart of United States foreign policy throughout the postwar era. But in the 1970s, in the years immediately following the end of our involvement in the Vietnam War, direct intervention was no longer American policy. The country no longer believed in it. The country now believed that the price to be paid—not only in lives and property, but also in the less easily calculable realm of morality—was just too high.

Other long-held beliefs met similar fates at the hands of events, were similarly questioned, shaken, and, when not abandoned outright, modified. In the 1970s, the Watergate affair and the Congressional hearings on worldwide abuses by U.S. intelligence agencies—themselves, respectively, a malignant by-product of and an attempted purging of the thinking that had brought us into the Vietnam War—called into question numerous truths long at the very center of American life. We could no longer simply take for granted the accountability of our elected officials and those who served them; the reliability of the system of checks and balances built into the Constitution; the notion that the United States acted in the world if not always well, then always with pure intentions. We realized that the exercise of our might was in the end perhaps more likely to endanger liberty and democracy than to preserve it. We began to speak, as a nation, of "limits."

Watergate revealed that the war, during the Nixon years, had indeed been "brought home," as the dialectically minded radicals

used to chant. Not brought home in the sense the radicals meant: There were never more than a few hundred Americans who believed they were in open revolt against the U.S. government, and fewer still who acted upon such beliefs. What was brought home were the abuses of power we associated with repressive governments like the one we had long supported in South Vietnam. We learned that men in the White House had criminally compromised the electoral system; that members of the executive branch had ordered wiretaps placed on the telephones of reporters and government employees; and that scores of newsmen, educators, political figures, labor leaders, and even actors and actresses had been placed on a White House "enemies list," and were to be tormented, whenever possible, by every federal agency. The House and Senate probes into the covert and frequently paramilitary activities of the C.I.A. and other intelligence agencies revealed a world riddled not simply with U.S. information-gathering spies, but with mercenaries and hit men doing their dirty, lawless work at our behest. United States government officers had ordered the assassination of foreign leaders, and encouraged numerous coup plots. Secret armies supported and sometimes organized by the U.S. military or the C.I.A. had waged wars never declared by Congress, and never made known to the American people. What I found most chilling about all this, as it was described in the newspapers seemingly daily in 1975 and 1976, was the utter lack of doubt or scruples on the part of those ordering and carrying out the assassinations and coups and secret wars—a cool confidence I sensed as well in the faces of Golub's mercs and torturers. Here, for example, set out in cables from C.I.A. headquarters in Langley, Virginia, to the station chief in Santiago, Chile—I am quoting from the Senate Select Committee on Intelligence report issued in April 1976—is the Nixon administration's strategy for undermining the results of the Chilean presidential election in September 1970 an election in which Salvador Allende won a plurality of the vote:

a) Collect intelligence on coup-minded officers; b) Create a coup climate by propaganda, disinformation, and terrorist activities intended to provoke the left to give a pretext for a coup (Cable 611, Headquarters to Station,

10/7/70); c) Inform those coup-minded officers that the U.S. government would give them full support short of direct U.S. military intervention.

We saw ourselves in a strange and cold new light in the wake of Vietnam, Watergate, and the hearings on intelligence abuses. We understood from this, or the majority of us did, that the old truths about political criminality were not the whole truth—that the whole truth, or something approaching the whole truth, was messier and uglier. Morally, politically, we saw darkness. This, I understood, was the darkness to which Golub was seeking to give shape and form.

We had new knowledge of our role, as a nation, in the work of torturers and mercenaries around the world, especially in the authoritarian regimes of the Third World. And our government, under pressure, acknowledged this knowledge; it sought, beginning in the mid-1970s, to change the nature of our presence in the world "out there," particularly in those parts of the Third World where our presence (economic and political) was great. We could influence the governing and policing of these countries—as we could not, substantially, those of China, the Soviet Union, and smaller communist countries dominated by either of them—because we were such an important source of foreign aid. And we sought to use our influence to curtail somehow the horrors and abuses committed in these countries by political criminals. To continue to receive our aid, countries where these abuses were taking place would have to show signs that they were working to eliminate them—that they were working to ensure their citizens their basic "human rights."

It was not a new notion, exactly; human rights had been discussed in courses in political philosophy for years, and references to them could be found in numerous national and international charters. There is no simple definition of human rights—this explains in part why they get discussed at universities—but in the Western liberal democracies they are essentially understood as civil and political rights. In the liberal tradition, within which these rights have largely developed, they reflect a moral demand for the common, universal treatment of all persons, and are most often expressed as entitlements that enable

persons to make fundamental claims against public authority. Put another way, my "human rights" are rights that permit me to maintain my safety and dignity, the "integrity of my person," even if the state, with its police powers, or some other political group with similar coercive powers—such as a rebel organization—should have what it concludes to be an overwhelming reason to threaten or destroy my "person." Human rights protect me from prolonged incarceration without due process; from mistreatment (intimidation, molestation, rape), kidnapping, and torture by the state, rebel organizations, and paramilitary groups; as well as from summary execution and other forms of political murder.

Put yet another way—the simplest liberal way—my human rights protect me from political cruelty, both physical and mental (intimidation, humiliation). Judith N. Shklar, who teaches government at Harvard and is among the country's most thoughtful liberal theorists, has defined a liberal as someone who thinks that cruelty is the worst thing we do. It is the worst thing we do because the victims of cruelty—that is, political cruelty, which in our age can be loosely understood as the cruel acts committed by the state or those seeking to seize its power through revolution—are made to feel powerless and without real purpose. They are painfully stripped of the strength and fragile hope they need to "pursue happiness"—that is, to create and continue to recreate their private, independent, and essentially non-political (because not publically debatable) lives. They are reduced, in the end—whether they are eventually killed or not—from subjects of their own lives to mere objects. Moreover, those made to live in proximity to cruelty, even if they never actually experience intimidation, torture, or other forms of political terror, are nevertheless profoundly affected. They reign in their thoughts and circumscribe their activities. Not only the public space for the exercise of political freedom, but the private, mental space where one might enlarge human possibility shrinks, shrivels. "Fear destroys freedom" is how Shklar succinctly put it in her 1979 essay on political cruelty.* Thus Shklar, and other contemporary liberal thinkers like the philosopher Richard Rorty, urge us to "put

* Judith N. Shklar, "Putting Cruelty First," *Daedalus*, Summer 1979.

cruelty first"; and those concerned with human rights—as Golub clearly was, making the paintings he had made—do precisely that.

In the mid-1970s our government, in the formulation and conduct of its foreign policy, began (in a fitful way) to put cruelty first. In Latin America, in particular—where it was thought our aid programs might best prove a "carrot" or "stick"—it was no longer going to be enough simply for an authoritarian government to be "friendly" toward us. As we were no longer going to commit ourselves simply to fighting (militarily if necessary) international communism, it was also no longer enough that "friendly regimes" were doing so, or claiming to. We were no longer sure international communism was actually the problem in the Third World; communist activity might be a symptom of other, more long-standing problems, such as unrelenting poverty or the absence of political space for reform. Our government remained concerned that communists not come to power, particularly in the Western Hemisphere: History had shown the political cruelties awaiting any people who took (or were dragged down) that path. However, we saw that the cruelties of friendly authoritarian regimes might well be fostering support for communist revolution—look what had happened in Vietnam. It was now believed by liberal American policy-experts that the best way to maintain stability and prevent communist revolution in Latin America was for authoritarian governments, dominated by their militaries, to shore up freedoms and develop democratic institutions—these having been too often abandoned in the uncompromising, if seldom valiant, struggle against international communists. (How many non-communist, peaceable civilians had been rounded up, tortured, or murdered as "revolutionaries" by men of the sort Golub had painted?) Congress, and then, beginning in 1977, President Jimmy Carter, brought pressure upon the authoritarian governments of such countries as Argentina, Brazil, Chile, Guatemala, and General Anastasio Somoza's Nicaragua to move toward democratic elections and assure all citizens their basic human rights. Improvements in human rights became a condition of continued U.S. assistance. U.S. training of foreign intelligence agencies and police forces was in some cases banned. State Department monitoring of human-rights abuses in Latin America became routine and influential. Human rights became

an essential (and so, of course, complex and difficult) aspect of our diplomacy.

This approach to foreign policy proved to be short-lived. Ronald Reagan campaigned against the Carter administration's human-rights-influenced foreign policy. Human rights, Reagan insisted, were a problem in totalitarian communist societies, not in authoritarian societies; Carter's was a wrongheaded approach, and it was costing us "friends." Carter had hardly ignored the appalling human-rights record of the communist world—he had launched his human-rights campaign early in 1977 with a sympathetic letter to the most important Soviet dissident, the physicist Andrei Sakharov. However, Carter's human-rights officials (and those in Congress concerned with human rights) had *not* believed—and here was the critical problem, from the point of view of the Reagan team—that the human-rights record of now Sandinista Nicaragua was especially dismal, particularly when compared to that of its neighbors, Guatemala and El Salvador, or that of Somoza's Nicaragua.

The Reagan administration, beginning in 1981, called attention to human-rights abuses almost exclusively in Sandinista Nicaragua. (Abuses in Cuba and the Soviet Union, Nicaragua's principal supporters, were also mentioned from time to time, though not abuses in "strategically" important repressive communist countries like China.) The authoritarian regimes in Central and South America, we were told by Reagan officials, were being pressured quietly to ease up on human-rights violations and repressive practices: In time, once the threat of communism was eliminated, they would come around to freedom and democracy. Torturers and mercenaries in Latin America were not mentioned by the Reagan administration at all. Reagan himself spoke of "freedom fighters." For Reagan, it was as if the old truths—the pre-Vietnam, pre-Watergate truths—had never been shaken.

American concern for human rights in the 1970s had not been increasing in a global vacuum, of course. Concern for human rights was perhaps the key development in world politics in the 1970s. Conferences were held; new charters were signed; and non-governmental commissions and Watch Groups were organized in scores of countries and regions. In 1977 Amnesty Inter-

national was awarded the Nobel Peace Prize—an indication of the new and growing role the notion of human rights had in international affairs. American journalists, too, began filing reports on human-rights abuses. In Latin American countries in particular, covering cases of human-rights abuse, and of the intimidation and murder of those speaking out on human rights, became a regular part of the correspondent's beat.

At times during the Reagan years, it could seem as if the administration and those concerned with human rights in Latin America had such contrasting understandings of that region of the world that they might have been talking about wholly different places, wholly different realities. There were two different truths colliding, one based on old and now revived abstractions ("the international communist threat," "national security"), the other on the gritty particulars documented by journalists and human-rights monitors. Golub's paintings were clearly trafficking in the grittier truths. So brutally, expressively real, and so big, bold in their public scale, they glared at me, demanding an acknowledgement. Whatever was being put out by the White House, whatever might be comfortable to believe, this is how it really was.

5. IN EARLY 1982, at the time of Leon Golub's show, you could know, if you wanted to, that there were hundreds of American mercenaries fighting around the world at any given moment, most of them in Latin America. The number might seem small, insignificant, if what comes to mind is an individual here or there: motley, ragtag. But this was no informal thing; it was not a handful of men who could not fit in, men who had gone off at some point (Vietnam, prison) and could not make it back. Many of the men were combat veterans of the Vietnam War, but they were not loners, "losers," everything this implies. They were organized, and they were believers: They fought together against the "communists"—though what deeper, anxious meaning "communist" held for each of these mercs (as he approached a

village for, say, a dawn mortar assault) who can know? And they tended to take on leadership roles, to organize and train and "advise" local fighting men, like the Nicaraguan contras.

The mercenaries belonged to Civilian Military Assistance, founded by Tom Posey, an Alabama grocer and former marine sergeant. He called his men "missionary-mercenaries"; there were one thousand of them; and they were sent as "training teams," actually mercenary commando units, into Honduras. (Later, in September 1984, two of Posey's men were killed and were suddenly and uncomfortably in the news—shot down in a helicopter along the Nicaraguan border.) Civilian Military Assistance received "surplus" military equipment from the Twentieth Special Forces Unit of the U.S. Army in Alabama, and somehow got to use surplus U.S. aircraft to transport equipment and even to stage raids inside Nicaragua, a country the United States was not at war with, as far as its citizens knew.

Or the mercenaries belonged to the Bay of Pigs (2506 Brigade) Veterans Association, the Miami-based anti-Castro group that sponsored mercenaries to fight alongside the contras in northern Nicaragua.

Or the mercenaries belonged to one of the training teams sent to El Salvador by *Soldier of Fortune* magazine, the "Journal of Professional Adventurers," as it calls itself. *Soldier of Fortune* was read by all the mercs, along with those who dreamed of being mercs. They read the stories of men from small prairie towns or rust-belt cities fighting in Ghana or Angola or, increasingly, in Central America. They bought their camouflage fatigues, their guns, too, from the mail-order houses that advertised in the magazine. They advertised themselves, the skills they had to offer, in the classifieds of the magazine: "Mercenary, armed courier, executive bodyguards, commando raids, any high-risk mission possible." Or: "Ex-marine pilot will do anything, anything at right price." They attended the conventions sponsored by *Soldier of Fortune,* and at these they met fellow adventurers.

Some found ways to become what are known as "vacation warriors," taking the short flight to Tegucigalpa from Miami, where (according to the *Miami Herald*) the Howard Johnson's motel near the airport offered "guerrilla discounts" as part of its "freedom-fighter program." They might stay in Honduras a

month or two, getting acquainted, making a connection that could get them to the front for some action. These men knew some of the more esoteric aspects of low-intensity warfare—maybe they'd been sappers in Vietnam, or picked up some knowledge of demolition. They'd been there, learned a few things, could pass them along. It was something they were good at. They had the fine mail-order weapons, these mercs; they were healthy, well fed, strong; the officers in Guatemala, say, or the contra commanders along the Nicaraguan border—they appreciated these men, as perhaps few others did.

So this was the new truth about mercenaries, American ones. And later there would be other truths—obscure, twisted, awful truths. There would be Oliver North and Richard Secord, the "southern front," the "airlift," the "private air network," the "secret team," the "Enterprise," the "Restricted Agency Group," and an operation called "Yellow Fruit." The mercenaries, so far upriver, would come to have a direct if frayed line to the White House.

And as with the mercenaries, so with interrogation, torture: There were new truths emerging, truths that might make us uncomfortable. There was the old truth, yes—the medieval Church had tortured in the belief that a man, a heretic, could be broken, forced to speak the truth. And in Latin America, this belief in torture's efficacy had taken root, flowered. But there were new elements. Torture in Latin America in our time had become technical and systematic; it had been modernized. It was no longer a matter of zealots only, of passions and barbarities; there were specified techniques now, professionals trained to do the job. There were hundreds of ways to torture a man—who would have thought? The new ways had evocative names: the "parrot's perch," the "tiger's cage," and the *submarino;* the "Brazilian phone," the "old-fashioned dance," and the "San Juanica Bridge."

I had learned a good deal about torture from the Argentine journalist Jacobo Timerman. I had read his book *Prisoner Without a Name, Cell Without a Number,* when it was published in 1981, and now, months later, looking at Golub's paintings, I remembered a few of the details. The prisoner in Golub's painting *Interrogation I* is suspended upside down from the ceiling, naked,

and is being beaten with a stick. From reading Timerman, I knew the beatings with sticks were not angry and wild, but rhythmic and precise—back, thighs, calves, and soles, again and again.

In Golub's *Interrogation II,* the prisoner is hooded—"walled up," as the torturers say. (In Argentina today, there are hundreds of men and women with damaged eyes, the result of conjunctivitis never properly treated; the conjunctivitis, the result of dirty canvas having rubbed their eyes for weeks, maybe months). And the torturers here, in this painting, are clowning and razzing, mugging (for their boss outside the picture? for us?) and smoking cigarettes; they're guys on the job, taking a little break. This was the hardest thing to bear about Timerman's book, to realize that the prisoner—walled up, terrified, in great pain, humiliated, disoriented, stripped of all the aspects of esteem and awareness that make him human—to realize that the prisoner cannot help but recognize, and even search out, the humanness of his torturers. In the interrogation room, the prisoner listens carefully to discern the traits and construct the personalities of those who torture him, those who reduce him to something less than human, an animal or thing. In the torturer's jokes and asides and anecdotes—the hints of warmth, and of life going on "out there," beyond the prison's walls—the prisoner senses hope, perhaps his only hope. Golub, in his *Interrogations,* conveys this horrible truth.

And to the old truth—that torture had been an aspect of the culture in Latin America as it had not to the north—there was added not only the new truth of modern, systematic torture, but this: We had a hand in the new-style torture. John F. Kennedy's Alliance for Progress had as one of its components a program that brought Latin-American police officers up to the Agency for International Development's International Police Academy, in Washington, D.C., and sent American advisers down to Latin America to train young recruits in the methods of counterinsurgency. These U.S. advisers included the notorious Daniel Mitrione, who was stationed in Montevideo, Uruguay, and whom Uruguayans credit (if that's the correct word) with carefully imparting to the Uruguayan police the techniques of torture: techniques used widely, routinely, on the thousands of Uruguayans imprisoned during the twelve miserable years that followed a 1973 military coup in that small, long-democratic country. We

in the north sought to exploit the tradition of torture, to put it to use, in Uruguay and in other Latin-American countries. Here is General Ramón Camps, the former commander of the Buenos Aires provincial police and an infamous torturer, speaking proudly in 1981 (the quote would later appear in the heroic report of Argentine President Raul Alfonsin's National Commission on the Disappeared, *Nunca Mas*):

> *In Argentina we were influenced first by the French and then by the United States. We used their methods separately at first and then together, until the United States' ideas finally predominated. France and the United States were our main sources of counterinsurgency training. They organized centres for teaching counterinsurgency techniques (especially in the U.S.) and sent out instructors, observers, and an enormous amount of literature.*

The government of the United States taught the Argentines the "techniques" of counterinsurgency for what reason? What was the point? The precise techniques of torture had their roots in a general theory, the Doctrine of National Security. According to this doctrine, which took root in the militaries of a number of Latin American nations beginning in the 1950s, the real threat was no longer along the borders, with traditional enemies, but within, from communist subversives. Communism was not like an invading force; it was an infection, silently working its way into newspapers, unions, universities, legislatures, into everything. It had to be rooted out, like sin. And like sin, the infection of communism was something few people were likely to own up to. It had to be forced out of them. They had to be tortured.

The role the United States played in the promulgation throughout Latin America of the Doctrine of National Security is a subject of some debate. In Uruguay and in Argentina, French advisers—veterans of France's wars in Indochina and Algeria—are believed to have had considerable influence. Brazilians, however, detect the influence of the United States in their nation's turn away from democracy and toward a "national security" state, a development that began shortly after the end of World War II and culminated in the military takeover of 1964. (The

military's brutal rule lasted twenty-one years.) "Particularly important in determining [Brazil's] course was the influence of the American military on the Brazilian armed forces," is the conclusion one reads in *Brasil: Nunca Mais*, the detailed chronicle of torture and repression in Brazil compiled by the Archdiocese of São Paulo. At least this much is clear: Leopoldo Galtieri of Argentina, Augusto Pinochet of Chile, and hundreds of less-powerful Latin-American military officers were graduated in the 1950s and 1960s from the School of the Americas, run by the U.S. Army in Panama. Whatever military training they received there—in classes with titles like Operation of Internal Security and Urban Counter-insurgency—was not designed to dissuade them from the Doctrine of National Security. And this seems rather clear as well: Wherever in Latin America the doctrine was a cornerstone of military strategy, whether or not the embracing of the strategy was its doing, the United States worked to advise and assist those eager to implement it methodically, with precise, modern techniques.

In El Salvador in the 1960s, the C.I.A. worked to establish among the Salvadorans an extensive paramilitary network. There was fear of communism, a blood hatred of it; and Salvadoran men were trained to root out communists, or those giving aid and comfort to communists, or those who sympathized with communists or might be communists. The paramilitary network, known as Orden, for "order," was directed by General José Alberto (Chele) Medrano, a "specialist" in "counter-insurgency"; that's the way he'd be referred to by members of the Kennedy administration. General Medrano practiced his specialty this way: He ran Orden in the 1960s as a death squad, specializing in murdering peasants who talked too much or too fervently of land reform.

Salvadoran officials today say that the general in those years relied mostly on three young men he called "my three assassins." The three continued their variety of counterinsurgency work after their stints with Orden; it was what they had been trained to do. There was Eduardo Avila, who was charged in connection with the 1981 murder of two American agrarian advisers and the head of the Salvadoran Land Reform Institute. The Salvadoran Supreme Court, on which Avila's uncle sat, let him go on a tech-

nicality. There was Guillermo Roederer, who was caught kidnapping wealthy businessmen for profit, and who went into exile. And there was Roberto d'Aubuisson, whom the U.S. State Department (and most everyone else with any knowledge of the situation) has linked to the 1980 murder of the Roman Catholic Archbishop Oscar Arnulfo Romero.

It wasn't that d'Aubuisson was doing the C.I.A.'s work when he involved himself, as he is alleged to have done, in the assassination of the archbishop, or that the others were simply C.I.A. proxies; it's not that simple. But neither is it as simple as: We had nothing to do with them. A certain doctrine is promulgated, certain skills are taught and appreciated; and then things get turned up a notch, get out of hand. The skills: Our government encouraged them once, had a role in how they were applied.

And still does today? I wondered, looking at Golub's paintings. Who could know for sure? We know, now, that in the late 1970s and early 1980s, while Golub was painting these torturers, military governments with strong ties to the United States were torturing their citizens. Jimmy Carter's stand on human rights in Latin America had begun to have some effect, but by the end of his administration he was speaking out less and less. Ronald Reagan, of course, spoke out not at all. The overwhelming concern of the Reagan administration was contesting Soviet power, and to this end, human-rights violations in friendly authoritarian countries were abided. In Argentina, Brazil, Chile, Uruguay; in El Salvador, Guatemala, Honduras, U.S.-supported militaries and police tortured countless men and women. A story: Florencio Caballero, young, tough, ambitious, Honduran, is recruited to serve his country in a new army intelligence unit, organized with C.I.A. support; the unit would be known as Battalion 316. In 1979, Caballero, along with twenty-four other members of the battalion, was flown to Texas (where, exactly, he is not sure). He was to be trained in methods of interrogation; Honduras, our government believed, had not a centuries-old economic problem but a sudden national security problem, and it believed that men like Florencio Caballero could take care of this problem, get the job done. Caballero and the other members of Battalion 316 were not taught in Texas how to torture men and women, not exactly. As Caballero told James LeMoyne of *The New York Times*:

They taught us psychological methods—to study the fears and weaknesses of a prisoner. Make him stand up, don't let him sleep, keep him naked and isolated, put rats and cockroaches in his cell, give him bad food, serve him dead animals, throw cold water on him. . . .

When I returned to Honduras, I was trained in assaults, bombs, and explosives by Americans, Chileans, and Argentines. Then we seized and investigated subversives.

Caballero worked in a hidden jail, and occasionally, an American C.I.A. agent would visit and be given edited reports on interrogation sessions. Edited out for the agent were the methods the members of Battalion 316 used when the rats and cold water and dead animals weren't enough. Among them: starvation, beating, rape, electric shock.

"Horrible things," Florencio Caballero called them.

And did the C.I.A. agent, reading his edited interrogation reports, understand that the confessions obtained might have been extracted by doing "horrible things"? The C.I.A. agent is alleged to have seen a number of the prisoners: Did he wonder how the new psychological methods taught so carefully in Texas had caused welts and bruises and that look in a prisoner's eyes that is not caused by a splash of cold water?

6. FEW OF THE specifics of U.S. mercenaries or torturers in Latin America came to mind as I began to look closely at Golub's paintings that winter afternoon. But I don't know if or how I would have felt so strongly about his pictures if I didn't have an understanding of these things. It is possible that someone without this understanding—or someone who simply refused to believe such things went on—might simply have turned away and left the gallery, dismissed Golub's paintings, dismissed Golub as a polemicist or a propagandist. For a long time now, the way to dismiss an artist who is revealing to us an aspect of modern life we do not want to see has been to label him "political."

And yet as important as I think this understanding was to my "getting" Golub, it alone would never have kept me in front of the paintings. I was not quick to dismiss art because its imagery was social, political, in-the-world in that way. In fact, I made a point of searching out works of art that took on the question of the collective social and political fabric; I admired this kind of ambition, in paintings and sculpture, in poems and novels, too. But in truth I had a hard time with most self-described political art. It so rarely worked, worked *as art*. There was, in the early 1980s, a good deal of art around—paintings, sculpture, works incorporating photographs—made by artists with whom I shared political convictions and sentiments. This I could tell quickly from the work they made and showed. I thought Ronald Reagan was a reckless, even dangerous president. I did not understand the need for thousands of costly nuclear weapons, nor the desire of superpower leaders to create more and more. I was not romantic about the Sandinista regime in Nicaragua, but it angered me that my government appeared bent—in an old-fashioned, pre-Vietnam, "romantic" way, at an awful cost of life and property— on toppling the regime by force. And there were artists around who felt as I did, who made works of art to express their politics, and to persuade others. Protest art. Activist art. Art for social change. Art meant to make things happen, shake things up. And most of it was bad art, insignificant art. It loudly promised what it could not deliver: attention, reaction, change.

There is so much that art cannot do now; we hear this all the time. But there is so much that art could never do. A work of art—a painting, a sculpture—cannot stop a war, cannot bring about justice, cannot begin to affect things in that way, cannot work that broadly or quickly. A painting or sculpture cannot even explain a war or an injustice, how it came about or why it continues. A work of art today cannot even guarantee that any-body, anybody *just then,* will be watching, looking at it. Those who make protest art—and the visual artists of our time who take on the question of the social and political fabric tend to do so to protest—simply ignore this. Or maybe not. Maybe artists who make protest art think it's enough that we understand their good intentions.

What we get from this art is not strong and deep sensations,

recognitions—these being the things we expect from art—but only the sense that we should share in the artist's indignation. These artworks shout at us, despite the fact that very few works of art (fragile, singular, largely ignored by society at large) can shout loudly, or for long. But maybe society's reaction is not the point. Maybe the point is the release of that shout. A work of protest art, even more than a badly composed, thickly painted expressionist picture, tends to be little more than a sloppy sign of the artist's feelings.

Art cannot bring about political change; it cannot do what the media and the electoral process and direct political action—street demonstrations, insurrections—do. Visual images created by artists can play a part in such change: Posters can be held aloft by demonstrators, graphics can be published in pamphlets by revolutionaries. But the power of these images is largely contingent. In a museum, away from the demonstration, ripped from the page of the newspaper, political posters and graphic art lose their power. Their power depends on a moment that has passed. They are perceived now not as art but as artifacts. Not even a political cartoonist of genius—and there have been many—can overcome this dependency. And why would he want to? Being of the moment is precisely the point.

Art cannot be a form of political action. This is as true now as it ever was. It was true even when artists themselves thought otherwise, as they did most notably in Moscow in the years just after the Russian Revolution. There has been, since the 1970s, a romance among many artists and critics with the constructivist art of this period, a romance because it is not so much the work itself that is looked to—bold, beautiful work, much of it—but to what is seen as the role the artists and their productions played in the newly forming Marxist-Leninist society. Artists at that moment set aside their individuality, their criticality—that is, their "bourgeois-liberal" understanding of what an artist is. For the proletariat masses, they painted and sculpted and eventually designed (they mostly abandoned by 1922 or so the "anachronistic" forms of painting and sculpture) not works reflecting life as it was lived at that historical moment, but abstractions that expressed the shape and form of the future.

That future never arrived, of course. History shows how

quickly and violently the dreamy promised future began to be pre-empted: It was doomed, we know now, by the early 1920s, well before Stalin declared socialist realism the official and only acceptable style of art, and made the teaching of constructivist principles a crime against the state. Perhaps if the constructivist artists of the Russian avant-garde had not been so quick to act on their desires to be engineers at the service of the revolution, if they had clung to an individual, critical "bourgeois-liberal" understanding of their role, they might have been able to sense the gathering darkness, illuminate it in some way. I doubt it would have forestalled the terror and repression even for a moment, but it might have left a small body of work to which men and women—perhaps young Russians today—could look for meaning and recognitions. If nothing else, the artists might have had a means to deal somehow with being stripped of their hope, their beautiful illusions. As it was, many of them were destroyed. When an artist or critic I know begins talking with fervor of Russia and the constructivists, of a "paradigm" or "model for action," I tend to recall the miserably inept figure paintings Vladimir Tatlin made in the 1930s, as he groped, I suspect, for a pictorial language of which "they" might approve. In their own pathetic way, these are among the saddest pictures I know.

Art cannot say: *This is how it must be.* It cannot speak in that tense. Artists who have attempted to do this—and there have been others besides the constructivists, though none more imaginative—wind up showing us only how a particular era imagined a utopian and unattained future. Like the protest artists, they leave us artifacts. Some of these artifacts are wonderful things, but they speak not of any future. They are what has been salvaged of a ruinous past.

Art cannot shape the future; it can, at best, bequeath to it a picture of its own time. A painting—and I am concerned especially with painting—cannot eliminate the harshness and pain of poverty, but it can painstakingly portray it, so that the society, when it is ready to look (later, in its galleries and museums, in a receptive spirit), may see it and sense it and perhaps have a recognition. (The old, worn pair of carter's boots van Gogh bought at a Paris flea market and then painted—after walking in

them and muddying them—is such a picture.) A painting cannot topple a terrible ruler; but how many paintings (by Francisco Goya, for instance) have shown us the face of such a man, helped us to recognize the look, the inner weakness, that must be cloaked in power? Such works are very much of their time, not ours. But they were not made to change their time. Rather, they were made to illuminate their time, to lend it shape and color. It is only because painters have worked so hard at illuminating their own time—looking with detachment upon life; using the gaze their own time equipped them with; drawing on painting's rich tradition for inspiration; searching for new forms and details with eye and hand, then working to get it all down right on the canvas—it is only this age-old method, with its slowness and intensity, that makes for products that might stand up to time, might continue to hold meaning centuries later.

Most art (protest art aside) is not concerned with questions of the social and political fabric, its cruel threads. "This is a political age," Orwell pronounced in 1948, and so it remains; but an American would not know it from viewing the best paintings of our time—or from reading the bulk of our poets and novelists. It has perhaps been the luxury of American artists— and this has been said often enough—to plumb continuously and guiltlessly the private and the purely aesthetic; cruelty, political cruelty, is something few Americans experience directly, particularly if they are, like most artists, white and male. However, there may be another reason, one bearing more on matters of art than on politics: To create a memorable work of art that does deal in some way with political power, its victims and victimizers, is perhaps the most difficult to pull off. It demands a particularly fierce detachment. It demands that the painter be at once inside the history of his own time—looking hard for the concrete specifics—and at enough distance from it to render it in all its troubling complexity. It demands that the painter be an honest, accurate witness to the worst that we can do, with no promise that the resulting work will change anything.

A painting can bear witness—that is how he can confront the abuses of political power. A work of art can say: *This is how it was*. Say this to whom? To someone, at some time, prepared to

look hard at it. It could be a matter of months, of years, or of lifetimes. If there is greatness to the work, if it can hold out to men and women across years, decades, even centuries an image of cruel truth or beauty or mystery, it can matter. It can say: *This is how it is.* And in this way, a work of art may help inform consciousness, may in some immeasurable but not necessarily small way, help us to recognize cruelty.

The liberal philosopher Richard Rorty maintains that "the victims of cruelty, people who are suffering, do not have much in the way of a language. [T]hey are suffering too much to put new words together." Rorty thinks it is the novelists and poets and journalists who must put the words together, describe for us in detail not only the pain of the victims but the cruelties of the victimizers. In a liberal society, this is the writer's chief social function, "to sensitize one to pain." Rorty is aware that this sensitivity may take some time to develop—he is not a revolutionary but a reformer. But for him the contribution made by Orwell (who is his model for action) and others is not small. Such writers, he believes, have helped to "reduce future suffering."*

I imagined Golub along these lines: a painter sensitizing us to political cruelty.

7. TO BEAR WITNESS: Isn't this the role of the media? Doesn't the photograph, the film clip, the TV segment address us in this way? In America, in our time, the camera often is such an eye on things: It goes to war, roams the ghettos, has photo opportunities each day at the White House. But there is another truth, expressed sketchily but well, I think, by the Polish poet Czeslaw Milosz. After spending a spring afternoon several years ago at the Musée d'Orsay in Paris, he wrote in his diary:

* Richard Rorty, *Contingency, Irony, and Solidarity*. (New York: Cambridge University Press, 1989).

[P]ainting condenses and fixes this human time of rushing decades that is otherwise evasive, untouchable. Though people may say, And photography? Perhaps. Let others answer the question as to why it is not the same.

I cannot say why photography and painting are "not the same." There is so little that words can do in the face of pictures; at the vertiginous level Milosz abruptly pushes the discussion to—what is a painted picture? What is a photographic picture? Is the difference in how the viewer experiences them?—words fuzz and blur. Those who might be expected to address such questions, those who theorize about art, have tended in our time to evade them. Our critical theorists (neo-Marxist, Frankfurt school-inspired, post-structuralist) have to a great extent emphasized the production of art, not the experience of art. What interests these theorists is not what a painting might say to us, but what Painting—its continued "practice" despite the advent of photography, film, and television—says about us. Why such a romance still with the handmade? Would it exist if paintings didn't command the prices they do? In whose interest is it that the painter remain a hero? In none of these questions is it acknowledged that the painter works with his materials, within the economic system of his time and place, to make something immaterial: a picture. To acknowledge this, you have to position yourself in front of the painting.

Critical theorists have by and large been uneasy in front of the work of art. (For example, Marx, who might be thought of as the first critical theorist, could not understand how Greek art remained, thousands of years after its making, beautiful to him— that is, how it transcended its materials and the context of its production to "touch" him, to elicit recognitions in him.) In front of an artwork, you have to look, open yourself up, work to sense and feel. (And why are we able to do this at some moments and not others? Why can we walk through the familiar galleries of a museum some days and sense nothing, even before works that have moved us time and again? We all sense this, but no psychologist or neurologist has got the answer.) You grope—before a picture, gazing—to grasp the material made immaterial. Little

in this experiencing of a painting is nameable, much less reducible. Theorists, who generalize and reduce to get at bigger truths and meanings, are simply at a loss in front of a painting; so they simply dismiss the importance of being in front of the work. Meaning must lie elsewhere.

Milosz is a poet; he is writing of standing before a painting. And he is on to something, I think, when, in approaching the question of the difference between a photo and a painting, he alludes not to materials but to time. A photographer—setting, framing, then shooting—captures time. He preserves the moment. A painter does not capture. Working and reworking his painting, he accrues time. The only moment that concerns him—the only moment he can hope to capture—is that at which the painting is resolved, complete. (And when is that? Each painting holds its answer, and only in the best paintings is it revealed.) It is this moment that the painter fixes.

How do we experience time in pictures? I cannot say with any certainty. I can say only that the painter with his brush and the photographer with his camera are working with time, within time, very differently. It would be astonishing—it would defy time—if the photographer's picture and the painter's picture were experienced by us as the same. (There are photographs—or, better, works utilizing the photographic process—that are produced in the way, in the "time," of painting: I am thinking particularly of the photoworks produced over the past ten years or so by Cindy Sherman. Her pictures—conceived, sketched, and mostly inhabited by herself—have the pictorial density, the sense of being looked at time after time by the artist in her studio, that ambitious paintings do. Her pictures were among the most inspired of the 1980s, largely, if not wholly, for this reason.)

But there is something more with regard to photography and painting and bearing witness: There are places the camera does not go. And it is this that struck me the day I first saw Golub's paintings. Think of these places the camera does not go as dark places; in a sense we always have. These are the places— places "out there," but also, metaphorically, "within"—where we confront our capacity for evil, our proximity to the irrational, our intimacy with all we label Other and attempt to keep at bay. We want to keep these places dark, hidden from ourselves. In

the dark, out there (and in there), we cannot see ourselves.

To limn the darkness: This, to view the paintings, was what Golub had sought to do—and succeeded. He was showing us what happened "out there," in the world yet to flicker. It is true that there were photographers "out there." In Central America in the early 1980s there were photographers like Susan Meiselas and Harry Mattison and Jean-Marie Simon, who worked hard and admirably, but there were limits to what they could do. They could take pictures of the aftermath, the razed villages and body dumps, and they could show battle, winners and losers. They could work in the present tense, and they did effectively. What they could not take pictures of was power, how it worked, worked in the dark. This would have to be revealed in a different way, imagined, conjured, conceptualized. It would have to be painted.

And it was clear to me that Golub had pulled this off. In some way he, like Joseph Conrad in writing *Heart of Darkness*, had transported himself upriver, where our presence, at the frayed ends of our extension of power, remains "not a pretty thing when you look into it too much." Upriver, men still committed "abominable terrors"—not in pursuit of "ivory," but of something more abstract, if no less pure: "security." Upriver, the victims most often continue to be, as Conrad's Marlow comments as he watches a French man-of-war aimlessly shelling the coastline, "a camp of natives—he called them enemies!—hidden out of sight somewhere."

Golub had limned this cruelty, this darkness. He had made images—men set in the "blank spaces" on the map Marlow spoke of—that were, each one, an acknowledgment of something horribly real. And an acknowledgment, in turn, is what Golub's paintings demanded of me—one precisely of the sort Marlow demanded of the men listening to the tale he told of his journey upriver, of his encounter, profound and symbolic, with the monstrous darkness:

> *It was unearthly, and the men were—No, they were not inhuman. Well, you know, that was the worst of it—the suspicion of their not being inhuman. It would come slowly to one. . . . Ugly. Yes, it was ugly enough; but if you were man enough you would admit to yourself that*

there was in you just the faintest trace . . . a dim suspicion
of there being a meaning in it which you—you so remote
from the night of first ages—could comprehend.

8. MAKING PAINTINGS IN the early 1980s, Golub was not
alone. Artists were painting again. Painting, suddenly, was again
at the center of things. Questions about paintings and painters
were being asked again with a certain urgency.

Earlier, in the mid-1970s, when my interest in art had begun
to deepen—when I got to New York, began to look at art with
determination, and also to read about what I was seeing—paint-
ing was not an issue. New paintings were around (traditional
realist pictures, super-realism, late-modernist abstractions, "pat-
tern and decoration"), and they had their defenders. But these
paintings were not at the center of things. Conceptual art, public
sculpture, environmental art, video art, performance art—down-
town, where most of the work got made, this was what mattered.
No one was arguing about painting. It is true that at this time,
in the mid-1970s, there was not much arguing about art of any
kind: This was the time of "pluralism," of live and let live. But
painting didn't really even have a place in this discussion.

Painting had been put aside, displaced from the center of
things. This had happened when artists could no longer use paint-
ing to tackle their problems, the problems of art itself. By the
1960s, this is what art, vanguard art, had come to be about, by
and large: a problem posed, a solution proffered, a new question
raised. It was a kind of distilling, and perhaps this is what art
has always been about, or so it must have seemed to those in
New York in the 1960s, looking back. Perspective solved, then
debunked; representation made "scientific," then abandoned al-
together; art stripped of everything it couldn't claim as its own
(narrative, illusion, *everything*), the boundaries between it and
all else made sharp and clear, only to have the boundaries—
between fine and popular, word and image, art and "life"—again
blurred, then finally (think of Happenings, Earth Art) effaced. In

the bars downtown in the mid-1970s, places with funny names like Barnabus Rex and Magoos, you could stand around and hear young artists talking about how painting had been pretty much "done," had been solved like a puzzle—how as far as they were concerned, the last painting had been painted. It seemed so strange to me, this talk. I couldn't imagine a young writer saying the novel was dead (although I knew that in the 1960s, several writers had). What had drawn these young artists to art, if not the traditions of art, traditions that included—exalted—painting? But I drank and listened. There was no anger in their talk of painting being done with. Nor was there much remorse or melancholy. It was just mentioned, talked about from time to time, talked about matter-of-factly, when it was talked about at all.

Then, so quickly—1977, 1978—there were new paintings everywhere—not in the important galleries, or in the art magazines and newspapers, but in the studios, and in some of the "fringe" galleries. And then all you heard was talk of painting. It was a particular kind of painting that you saw—but why? Why now, beginning in the late 1970s? The new paintings were imagistic, figurative, metaphoric, allegorical, expressionistic; they had a certain sense of memory and ruin, and hinted of narrative. It was everything, exactly everything, that painting—that art— had not been for some time. In the bars, people spoke of a sea change, and it was true.

Why all this new painting? I didn't have an answer, or I didn't have a new answer. Plenty of others did, or seemed to: It was one of the reasons for writing about art just then. But the new answers—ones about the new conservatism and new money and young male painters acting like movie versions of heroic painters—these seemed to fit only the failed painters, the ones who didn't matter anyway. Theories can work that way.

I did have what I would call an answer in part, and I simply operated on it. It was true—it had been for a very long time— that people no longer looked at paintings and wondered, looked to paintings *for* wonder—as they once had. There had been the shop window and the photograph, then the movies, then TV. Painting had lost its place, had been somehow diminished—who could deny that? Whatever its importance to art, its importance to the broader public had eroded; whatever problems it had

solved (and might continue to solve) for art, there was much in society it could no longer do. It no longer carried that conviction.

But then maybe not—maybe it could have a place, could matter, beyond mattering to the discourse of art. That was my answer. This is what I thought the new paintings, the best of them, were saying—saying warily, with an understanding of the risks and doubts. No heroics. Simply, "but then maybe not." A tentative, weary faith, but a faith. So much had been left unexamined by painting. So much had been foreclosed by abstraction, and then by cynicism. For a long time, painting had not recognized—and had been somewhat embarrassed by—its interpretive function. Charles Baudelaire, in his justly famous essay "The Painter of Modern Life," published in 1863, at the dawn of what we think of as the modern era—Baudelaire (a poet, not a theorist) thought he had arrived at a formula that would assure a place for the painter, a place in every era. Baudelaire believed that there would always be the next fashion to capture with line and color, the next place to go and see and render, the next man or woman— previously overlooked as inappropriate for art—to sketch and paint. "Every period has its deportment, its glance and its gesture," he wrote. So no painter, however great, could have the last word. There was no last word. It was the job of every painter of each generation to comprehend his world "and the mysterious yet legitimate reasons for all its habits."

The painter in our century, the vanguard painter, believed that to capture his own moment in this way was not enough— could not sustain him. He sought the role of the researcher and the scientist; he began to experiment purely, and he accomplished so much. And the new painters in the early 1980s, the good ones, understood this achievement, you could see it in their work. But so much had come and gone, and so much of it had not been painted. Was it enough simply to leave the world and its ways to the arts of mechanical and electronic reproduction? Was there, after all, nothing special or particular about the kind of thinking and making done not only with the mind but in a sense also with the body—done by someone utilizing his eye and hand? Was there no place for the painter laboring in his own room?

At some point in the late 1970s I began to see paintings that were demanding a bigger place for themselves—ambitious paint-

ings, paintings that held meaning about life lived. There quickly came talk of a "movement": neoexpressionism, the new figuration. But it was not as simple, as neat, as that. All that was clear was that a number of painters had perceived—mostly on their own, each of them, and at different moments in their careers—that painting had reached a kind of end game, and that this was no good thing, for painters or for society. And so in various ways, painters were working out of this; getting their footing, hitting and missing—but working.

Mostly they were younger painters, men and women in their twenties and thirties who had come to painting late—who had first understood art-making in their time as something else, something "beyond" painting. Neil Jenney was the first of these painters whose work I saw, in 1976 or 1977, in the Blum-Helman Gallery on the Upper East Side. In the 1960s Jenney had done installation art—sculptures created specifically for their sites; then, in the 1970s, or perhaps as early as 1969 (no one seems sure of the dates of Jenney's paintings), he had begun to paint. On smeary, fingerpaint-like grounds, Jenney painted, with the touch of a child, figures, animals, objects—one got the idea that he was "starting over." And his habit of exhibiting the paintings in black frames (with their titles stenciled on the frames) lent a dignity and pathos: He was starting over for everybody. By the late 1970s, Jenney was painting not simple kid-paintings but fragments of landscape subjects that have the detail and finish of nineteenth-century American landscape painting—painting these, placing them in weighty, funereal frames, and giving them titles like *Melt Down Morning*.

These later paintings by Jenney are allegories, "political" paintings—paintings reaching beyond the discourse about art to touch upon (however gently) issues of the global environment and the threat of nuclear destruction. Many of the new figurative and expressionistic paintings were not "political" in this way. But almost all of them, good and bad alike, asked to be looked at as something more than a solution to a problem of art. Simply put, beginning in the late 1970s, this new painting set aside the question of the problems of art, and took up again the greatest of subjects—the look and mood of things, life in our time, men and women, the objects and subjects of history.

9. I THOUGHT OF the new painting, figurative and expressive, when I looked at Golub's big pictures. In January 1982, it was this new painting that most excited me. I had a sense of a "moment," and, visiting the galleries, my mood, my eye, was informed by this.

I thought Golub might be one of the young, new artists; it made sense. I took notes to this effect: There was his hinting at narrative, the presence of the human figure. And like most of the young New York painters, Golub painted big, mural-size—a scale at which you, the viewer, sense that the picture is less a window on the world (as you might sense viewing an easel picture) than a site for an encounter. You step up, then in; and the painting comes at you, crowds your real space, intrudes and insinuates—works on you. Golub painted his figures on monochrome fields, and these vast, void-like spaces reinforced that sense of site, of a place cut off from the wall the canvas was hung upon, of a "big picture" rather than a glimpse. The monochrome field was developed and used by New York painters of the 1950s and 1960s for strictly formal purposes—the smooth, single-color backgrounds would reinforce the "objecthood" of the picture, its lack of illusionistic space, the pure materiality of pigment and canvas. The new painters, however, were marking their fields not simply with shapes and color but with figures, incidents; or with shards of imagery half-recognized: the canvas as palimpsest. The new painters had re-invented the monochrome field as a tool for carrying time. It could evoke a graffitied wall, marked by many hands over many years; it could evoke consciousness or memory.

All but one of Golub's six paintings were done on red surfaces—dry, worn fields of earthen red, the red of the great Pompeii frescoes of Roman antiquity. These fields didn't say "wall" or "memory," but they were evocative. Summoning Rome, looking so time-worn, they spoke of history.

Golub's paintings shared a good deal with those of the new, younger painters; he might be one of them—but probably not. For the longer I looked at his paintings, the harder I looked, I saw there were things about them—the way he approached his subjects, his way of coaxing them out, rendering them—that

seemed not at all like the new painting. I had settled in front of a painting titled *Mercenaries II,* the earliest painting of the six in the show, dated 1979. I had been at the gallery perhaps twenty minutes—moving from painting to painting; taking notes about political associations; getting the titles and dimensions right; getting down my thoughts about Golub's similarities to the new painters—and then, after a time, I had decided that *Mercenaries II* was the strongest painting in the show. By which I mean it was working on me strongly, I had to stay with it, "get" it.

It is a huge painting, ten feet high and nearly fifteen feet long, and it was hanging limp, unstretched, unframed, like a medieval tapestry, or, better, a circus tarp—there are grommets at the top of the canvas for big nails. The painting is of three figures, men in their forties, I would guess; they're bigger than life, their presence looming, their legs cropped at the calf, this working to shove them to the very surface of the picture plane, perhaps right into your space. (And here the red background has a formal role, too; red, the warm red Golub uses, rushes at you, closes off pictorial depth, so the entire painting insists on resolving for you somewhere in front of the canvas's surface.) Two of the mercenaries have guns, the new, lightweight assault rifles; Uzis, maybe. One of them, the one on the right, is in khaki shorts, and his companions are shirtless: It is a hot country. The men have tough good looks, but an easiness, too; they have the cool of TV heroes, and maybe television is where they've picked up their gestures and attitude. They are filthy; their pale-pink flesh looks as if it's been rubbed with coal—you can almost smell them.

There's no raid or battle going on. The mercs are talking, shouting, laughing it up. It's not a moment (a pre-dawn assault on a peasant village, say) when we might easily judge them, define them: They are not like me. (In front of most paintings you are looking for ways to break down the distance between them and *you;* in front of a Golub painting, it struck me then, you can find yourself working to create some distance.) One of the mercs, the one in the middle, might be looking right at you—with his aviators on, it's hard to tell. But they're not tense, not tense about you for sure. Maybe you're taking their picture. Maybe they'll tell you a few stories if you come a little closer. Tell you about the day they've had.

I was getting *Mercenaries II:* In some hot country, in 1979 (when the picture was painted), men like the three portrayed here were working as mercenaries. They were Americans. They were— and this was the important part—so at ease with you. The smiles and gestures and casualness: so much like you, like me.

10. IF YOU GET sensations and recognitions from looking at paintings—if you find pleasure in this, no matter how disquieting the sensations, how dark the recognitions—there is only so long that a new painting, a good one that's held your gaze, remains strictly "contemporary." You take its measure, get a sense of it—looking to see if it holds together for you formally. You "locate" it: align its subject matter with the world as you understand it, situate it in the art of its time. . . . Then, if the painting really matters to you, you find yourself drifting somewhere else.

Looking at Golub's paintings, I had begun to think not of each painting's "presence" or of the United States's role in Latin America or of the new expressionistic painting of the moment, but of Painting—that is, of the traditions of the medium, of the painters of other subjects and historical periods, of their pictures and the resonances Golub's pictures had with them. In the gallery, after a time, you recognize what is before you—canvas, color, shape, line, texture—and you eventually find yourself asking: How did he or she get it done? Make it work? And you look to the past, to other painters, for answers.

An aphorism written by the painter Georges Braque: "Progress in art does not consist in extending one's limits but in knowing them better." The painter looks to the edge of his canvas, and over his shoulder at the painters who have come before him, and he knows he is always up against limits. To understand paintings, a viewer must also look in this way. You go to the edge of the canvas, you work your way in: You ask yourself how the painting works. And then you look back: What traditions has the painter worked in, worked up against, pushed, extended?

The questions you pose to the painting, the answers you expect in return are no longer of the moment. You enter a kind of a timeless time.

I knew that looking at paintings in this way was a means to understanding now under attack. To make associations among painters and paintings across decades and even centuries, to "bracket" Painting in this way from all that had been *of the moment* in its making and viewing—this was a precious and even dangerous game; I knew the argument. To make such associations was to rely only on a knowledge of art history; and art history was a fiction, an invention of the nineteenth century. Knowledge of it was simply false consciousness. A picture by Giotto and one by Picasso are different things, made for different reasons, at different times, for different publics. They are bound together only by the organizing principles of something called art history. That was the argument: Art history is a story the art historians made up. It didn't happen that way. It happens that way only in the art books, and in the galleries of the great museums.

And there is truth to this argument. The question is: How much truth? And that's what happens with arguments like this. The voice making the argument is absolute, but the truth is not, never is, cannot be.

In Padua, in his frescoes of the lives of Christ and the Virgin, Giotto was making pictures for his time—for God and His believers—but also for those who would come later, those to whom he wanted to say, *I am Giotto, and I am the best in my time at making pictures. This is not only how men and women looked in my time, but this is what I learned about painting and expanded upon.* I have seen these frescoes, the flourishes of technique and the specificity of each face he painted, and I think he, Giotto, wanted to say all this, that he had that kind of self-consciousness, and self-confidence. And Picasso: In painting so many pictures, in so many styles, in pushing at painting and pulling from it, he was of course declaring these same things: He was showing us how the world looked just then to him; and telling us he was a painter, as fluent as any in the language of painting, and he was going to take it to its limits, but he was going to be there to rescue it, to keep it alive.

So there is another truth to consider, another truth about art

history: The painters, the great ones in the West over the past five hundred or six hundred years, have understood a "history of painting," have known what came before, have felt the responsibility to keep Painting alive, and the ambition to make themselves part of its tradition. It is the language they speak, painting. "Art history" sought only to codify it, to let us in on it. It is a way we understand pictures now, make meaning.

Looking at *Mercenaries II,* I did not think of great paintings of war or soldiers. It is never simply a matter of a picture's content calling for old pictures with similar content. I thought of Edouard Manet. Not of his famous *Execution of Maximilian,* a picture you might think of in connection with Golub if you were thinking simply of similar soldierly "images"—the workaday casualness of the Mexican soldier reloading his rifle, readying his weapon for the next firing-squad victim. But Manet came to mind because I recognized in Golub's painting of mercs something of Manet's way of revealing things.

Standing in front of *Mercenaries II,* I thought of Manet's *The Old Musician,* which I had seen only once, at the National Gallery in Washington, D.C. *The Old Musician,* painted in 1862, is one of Manet's earliest large-scale paintings. It is done mostly in sullen browns and grays, and has a somber, Spanish feel, as do most of his paintings of this period. Manet seems to be showing us a road, on the outskirts of Paris, perhaps, but there is no firm sense of place. The focus of the picture is an old man, haggard, mustering his dignity; he is seated on a carton or cheap suitcase, holding a violin, staring out at you, surrounded by others—family members? friends? strangers?—who may or may not be paying attention to him. A barefoot girl in a worn blue-gray skirt clutches her baby; there are two boys who seem to be wearing hand-me-downs—their pants and blouses droop and sag. A young man behind the old musician sports a dusty top hat, so out of place here (where?); and the cuffs of his pants are badly frayed. A withered old woman, nearly cropped from the picture, is bundled and scarved against a chill no one else seems to feel. Is she ill? Mad? A sad shoulder bag in the foreground reinforces for us the notion that these are people slowly on the move, with few possessions. There is a sense of dislocation, of old ways no longer suitable, of unspoken loss.

The figures in the painting don't look anything like Golub's mercs. They have nineteenth-century faces, or what we think of as nineteenth-century faces. And they are not threatening, as Golub's mercs are threatening—just poor people, estranged, keeping to themselves. But *how* Manet chose to show things— that's what made me think of him, looking at a Golub picture. The figures in *The Old Musician*—Manet is said to have found his subjects in the old "little Poland" ghetto near his studio in Paris—are specific, concrete, in no sense generalized "poor folk." This has nothing to do with overall exacting detail; Manet's figures have been established somewhat provisionally, without finish, and much of what he paints here might be considered "bad painting" by some—"artless" lozenges of black say "shoes," a flat area of brown is enough to suggest the young man's cape. What matters to Manet, and thus to us, the viewers, is the telling detail: the frayed pants cuff, the boy's bunched blouse, the way the old man's hands gently finger the violin, even as he stares out absently at you, his mind (and heart) somewhere else—these are the places where your eye settles. Here, in these few details, one gets to know Manet's people. His figures, like Golub's figures, are *standing* for nothing; they simply *are*.

Manet arranged the figures in *The Old Musician* loosely and rhythmically, as Golub did with his figures in *Mercenaries II*. Neither is a formal portrait; these subjects did not commission the painter. They don't have that kind of status—you can tell that just by looking at them. Nor do they assume for the paintings a viewing public. Who, exactly, is supposed to see poor immigrants and mercs?

But we do see them, large and detailed. Where, exactly? Where have they been placed? In the Golub, we have no idea; the mercs rest uneasily on a dry field of red. In Manet's *Old Musician*, there is a "background," but it is plain and flat, leached of all but the vaguest detail: a dark sky, the hint of a horizon line, a dirt road— or is it simply the floor of a studio? With Golub we are not in Honduras or Nicaragua, and with Manet we may or may not be in the outskirts of Paris. In both cases we are in a painting—only that much is certain. The mercs, the old musician and those around him—they, too, are only in paintings.

But both *Mercenaries II* and *The Old Musician* are big paint-

ings, public paintings—and thinking about this, standing and looking at Golub's painting, things began to click for me. If either Golub or Manet had chosen to paint small pictures, they wouldn't have worked as they do. They work—work on you, the viewer; create the kind of tension that can hold your gaze—precisely because within each picture there is a tension between what is "contained" (the subject matter), and the picture itself, the scale of the "container." In each picture, the Golub and the Manet, we are beckoned grandly by the scale—and also by something more than the scale: the grand tradition of public portrait painting. What is the pictorial space of the public portrait? It is usually no specific place, but rather a flat, plain, simple space. The emphasis, after all, is on the subject, not the space.

But let's look more closely at it. Think of the great public portraits, the space behind the subject (or subjects). It is an odd space. It is an unknowable. There tend to be few or no details. It can seem vast, and at the same time cramped, claustrophobic: Such is the result of there being no specific background. It is a space that throws the figures set in it, against it, into a kind of dramatic relief. It is the space of the theater. The pictorial space in a public portrait painting functions as a stage.

Manet and Golub have brought their figures onto this stage. (Chillingly, former torturers interviewed by human-rights monitors have often referred to the interrogation room as the "theater," or, in the jargon of Chilean torturers, the "lit stage.") They both painted their subjects monumentally. But grandly? No. There is the lack of finish. And there are the arrangements of the figures, their gestures. They are not posed as painters posed kings, royal families, and, later, burghers and their families—posed to look at us from on high, with assuredness, with the sense that they should be painted. Why are Manet's figures and Golub's mercs not posed in this way?

Until Manet painted his poor immigrants, and Golub his mercs, these figures had not yet been on the pictorial stage of public portrait painting. Finish and grandeur would consecrate them in a way that their times—the old musician and the others in 1862; the mercs in 1979—had yet to do. Formal poses would signify that they were ready to be on the stage, that history had arrived at a certain point, had recognized them; but this was not

the case. Golub's mercs, Manet's poor and perhaps homeless—the subjects of these paintings—existed, at the times they were painted, at the margins, out of sight. They were there, but they were not seen. Manet and Golub had coaxed their subjects onto the stage, into history. They had painted them, so they might be seen, recognized. As they painted, they were saying: This is how it was.

11. I MUST HAVE spent nearly an hour in the Susan Caldwell Gallery that afternoon—a long time to look at six paintings. I had taken many notes. But I was not going to write about most of the ideas I'd had. A paragraph, three or four sentences—that was all. I put my notes in a drawer.

But not before I had found out more about Golub and his work—and taken even more notes. The day after I saw the show, a Saturday, I went to the library—the big Bobst Library of New York University, on Washington Square not far from the *SoHo News* office. I wanted to read what had already been written about Golub, if anything had. It was something I always did—a way of learning more, and of covering myself.

And there I got another jolt, not as strong as the one I'd had in the gallery, from the paintings themselves, but a surprise nonetheless, and an embarrassing one. There is a reference book called *The Oxford Companion to Twentieth-Century Art;* it was always the first stop in my "research," my weekly gloss. Golub was in it—and he was an old man! That was my reaction, clumsy and exaggerated as all reactions to surprises tend to be. He wasn't an old man; he was born in 1922, was fifty-nine or sixty, simply older than I imagined. I think I wanted to believe he was my age, or closer to my age—that we shared that. Now I knew he'd had a life, a long career, and I didn't know a thing about either.

He was born in Chicago, according to *The Oxford Companion,* and had studied at the University of Chicago in the years before World War II. After a hitch in the army, from 1943 to 1946, he'd studied for four years at the school of the Art Institute

of Chicago. About the early 1950s there was nothing, but it did say he'd spent a year or so in Italy (1956–1957), taught for a short time at Indiana University (1957–1959), then moved to Paris. He'd returned to the United States in 1964, but this time to New York, where he now lived.

There was nothing about his family: Was there a wife? Children? Stranger still to me, there was nothing about the paintings I'd just seen, nothing about paintings of their kind at all. The book mentioned only a *Gigantomachy* series. (Later I would learn there was a *Gigantomachy* painting hanging in the back at the Susan Caldwell Gallery; I hadn't seen it.) According to the entry in *The Oxford Companion,* these paintings featured "totemic images of our plight," and had an "existential spirit."

I was confused. I poked around in *The Art Index,* a kind of *Reader's Guide* to articles in periodicals about art, found a number of entries, then headed upstairs, to the bound volumes of art magazines. From old reviews and articles and interviews, I began to piece things together a little. Golub had had a long career, but from all appearances, it had not been an especially successful one. His earliest paintings, I read in reviews of the 1950s, were inspired by "primitive" art. In the few, fuzzy reproductions I found, the paintings looked to be small, pained, despairing pictures of near-abstract figures in terror or deep spells or psychological shock. These were followed by heroic portraits of stony heads and figures, works that drew on (again, according to the reviews) the art of antiquity. Eventually, these paintings evolved into the *Gigantomachy* series of the early 1960s, paintings across which figures—naked, like old sculpted gods, but battered and flayed and horrible—lumbered, battled, and fell. And then, from what I could find, nothing.

Golub had shown promise, he'd had shows, he'd even (according to the reviews) had his paintings included in big group shows at the Whitney Museum and the Museum of Modern Art in the 1950s. Then what? Where had things gone wrong? His work appeared to have no connection to other American work of the time, not in the 1950s or the 1960s, not in New York. In some of the articles I'd read, he was still called a Chicago artist, even though he had lived in New York since 1964. A "Chicago artist," with all that meant, not much of it good.

A few days later, at my office, I phoned the Susan Caldwell Gallery, just to find out when Golub had last had a gallery show in New York, and if the paintings in the show then up were similar to those in his previous show. I guess I was hoping to reach someone who wanted to chat for a while; someone to help me fill in all the gaps. But as soon as I identified myself and began fumbling for my words, I could tell this wasn't going to be that kind of conversation. So I asked simply, "When was Golub's last show at the gallery?"

The woman on the phone, a receptionist, I assumed, said, "He hasn't had a gallery show in New York for twenty years."

"Twenty years." Such a long time, so simply stated. It was then, when I heard "twenty years," that "Leon Golub" began to take the shape of a narrative for me. It wasn't that I saw a simple story, an "artist" story—the years of solitude and work and (perhaps now) triumph. I had a romance about painters, but not that kind. I didn't buy the "struggling artist" story.

What interested me—what continues to interest me as much as anything was how a painter could get on with things, get his work done. Paintings don't just happen; there are ideas and feelings, and then an act of will, and then lots of hard work—work of a special sort. The product of the work, the finished painting, is a product of the very act of painting; ideas and feelings—and knowledge and technique—go into the making of a painting, but these things also come out of the act of painting. The painter takes the painting someplace, or tries to; but the painting takes him someplace, too. And when we look at paintings, we get a glimpse of this endeavor, this accrual of human thought, perception, feeling, work. I believe this; it is this I am romantic about. By which I mean it is this I am willing to pronounce in the face of cynicism. I have not come to this belief blindly; I know something now about painting and painters. But it is a belief, I accept that, and I'm willing to formulate it that way, as a belief: Painting, great painting, is among the most significant human acts. And to me, already, the Golub paintings I had seen at Susan Caldwell—two or three of them, anyway; I could fix them already in my mind's eye—were memorable paintings. How had he come to make them? How, over time, had he "arrived" at them?

Making a painting, this takes time. And there is something

more: A painter's career unfolds in time, with the fullness of time. Twenty years, the woman on the phone had said. And that was but a part of it. Golub had been working, painting for thirty years or more—this much I had learned at the library. He had painted one way, then another, then maybe not at all. Then suddenly there were the paintings I had seen, the *Mercenaries* and *Interrogation* series. How had one thing led to another? In getting on with things, in getting the work done, what were the desires and contingencies? How had they been pressed or abandoned, and why?

Working, in the studio, over time: That is the painter's life. There are other things now, things that sell a painter's work along with the books about painters, or so it's believed: the loves, the money, the gossip and madness and wild living. People read about the private and often sordid, get caught up in all this. In their way, they, too, are looking at the "production" of art, or what they imagine to be the production of art. The see the making of paintings as somehow the result of living wildly, recklessly free.

People have their passions and wild ways wherever. This doesn't make them painters. What people don't have by and large is the work, the work the painter has. They don't have work that demands from them thinking and feeling, the daily bouts with something big, the sense of craft, the hard, meaningful work, day in, day out. Most people don't work at something that engages them in a tradition, a tradition they need to take from and hope to give to. Most people can't watch their work grow and evolve from previous work, mark their lives in this way. How many men and women can look back at the work they've done and measure themselves by it, find mirrored in their work what they consider the best of themselves, or at least their truest selves? And how many can see in their work their times, the history they have been party to?

Painters interested me. Despite their time (a time of photographs, films, and TV); despite the traditions that weighed so heavily upon them; despite the sheer hard work, they continued to paint. Golub—without a New York show for twenty years— had continued to paint. It fascinated me.

12. I KNEW I wanted to know Leon Golub, but that would have to come later. First I would write my few sentences about him in *The SoHo News:*

> *Why are Leon Golub's new paintings so horrifying? The guns his mercenaries wield are threatening, of course, and the agony of interrogation victims is here presented in excruciating detail. But the real horror of these works is something else, something Argentina's Jacobo Timerman writes of; it is the very casualness of the soldiers' acts, their* humanity, *that truly terrifies. The way they joke and smoke and carry on like assembly-line workers—dogs of war are men.*

It was published, my "art pick," on January 20, 1982. And a few days later I got this in the mail:

> *Dear Gerald Marzorati,*
> *Thank you for the write-up in this week's* SoHo News. *In a few words you met the work head on, terse and exact.*
>
> > *Cordially,*
> > *Leon Golub*

My connection to Golub was no longer only with the work. I was not going to leave it at that, a small write-up and a thank you. I was going to get to know him—that was my reaction to his short note. I was going to sit in his studio, talk with him, ask of him, one way or another: Why paint what he did? Why paint? And eventually, over the next seven years, one way or another, in his studio and elsewhere, too, I did.

II
GOLUB'S
STUDIO

FALL · 1984

RIOT III,
1984

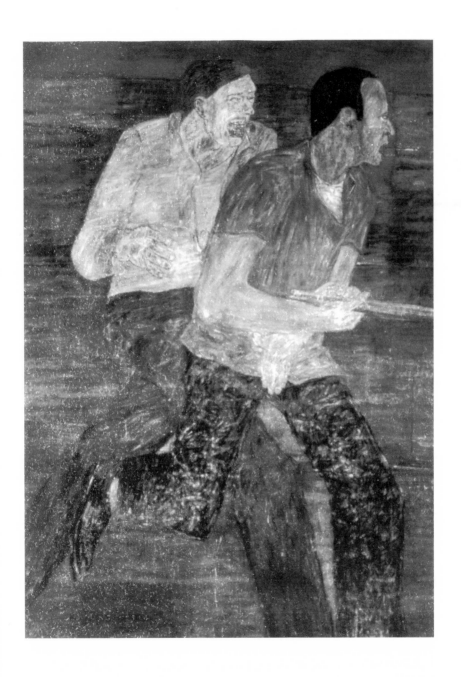

GOLUB AND I did not meet until nearly a year after the show at the Susan Caldwell Gallery. It was on Christmas Eve of 1982, at a small party held by the art critic Peter Schjeldahl at his home on St. Mark's Place in the East Village. Schjeldahl was writing for *The Village Voice* at the time, and in early November he had written a review of a second show of Golub's paintings up that month at Susan Caldwell's. Schjeldahl's review was not so much a rave as a declaration: Golub, he argued at length and effectively, was a major artist of the moment. (It was what artists call the "breakthrough" review.) The paintings Schjeldahl wrote about were strong, and in much the same vein as those Golub showed earlier in the year—a friend of mine, visiting the November show with me, joked that Golub "could get work as a human-rights monitor." It was clear now—quite suddenly—that Golub would not need the work if it were offered to him. The art world was taken with his new paintings: He was talked about and written about; there were a number of sales from the two gallery shows; he was, like so many painters in the early 1980s, "hot."

It was Schjeldahl who introduced me to Golub. Golub had arrived at the party late (with his wife, Nancy Spero, though I never saw her), and had never made it into the living room, where most of the guests were sitting and quietly talking. I met him as I was about to leave. My first, somewhat startled reaction was: He looked remarkably like one of the soldiers of fortune in his painting *Mercenaries IV* (except the merc is a black man!)

Painters had been inserting themselves into paintings in this way at least since Fra Angelico painted himself as a scriptural bystander. But as a merc? Eerie.

Golub, of course, was much older than his portrait of the artist as a soldier of fortune. He is not a tall man, but a slight stoop makes him seem smaller than he actually is. His arms, his entire upper body, hint at a power once there, now slackened; he wears his years. He is bald, and this of course is part of it. But it is also that his face and neck are deeply lined, and his eyes—his eyes look almost bruised.

We stood for a while by the dining room table and talked. It struck me that he took talk seriously, that in a way—and this is true of very few painters I have met—he talked to make things clear to himself, to think. His voice threw me at first; it is all Chicago, lunch-pail rough—it is the voice Saul Bellow must have been hearing when he wrote *The Adventures of Augie March*. And it didn't seem to fit Golub's turn of mind, which clearly was not coarse or bossy or even anecdotal in that workingman's way. Golub right off showed himself to possess a speculative mind, comfortable with the general and the abstract—a trait he appeared to drop, to judge from his pictures, once he picked up a brush and began to paint.

"I think I would have liked to have been an art critic if I didn't paint," he told me that night, something you don't often hear from a painter. And I felt at times as though I might have been talking with an art critic—a critic pondering the fathomless questions. His talk was not party talk; it was beyond even art-party talk.

I had complimented him, said how I thought it was important that painters tackle the subjects he does. "Photographs are not enough," I'd said with mock seriousness, and smiled (though I meant it).

He agreed—well, I think he did. He began an impromptu disquisition on painting and photography, touching on a broad range of social, aesthetic, and philosophical issues raised by the different media, and leaving me somewhat speechless. When I got home that night I took out a notebook and tried to recall precisely what he'd said. Among the remarks that came back to me: "Information access and global communication are at once more simultaneous and speeded up than when I began painting, and our perceptual systems have adjusted to react more quickly to this." And: "Photography has altered what we

mean by conjunction, disjunction. The key word is contingency."

Before I'd left the party, he had extended an invitation: "You're welcome to come by and see the studio when you have a chance." A casual invitation, one artists frequently extend to those who write about them—but then how do you follow up on it? It isn't like an invitation to dinner. It was just an expression, a way of saying you were okay, and I thought that was fine. I did not see him again for some time.

Then, in the summer of 1984, a year and a half later, I took him up on his offer. I was so curious about him; he was different from other painters, and different, too, from what I'd imagined him to be. And he was continuing to make pictures—there had been an important third show of new work at Susan Caldwell's in January—as ambitious and powerful as any new work I was seeing. I'd received a press release announcing that in September there would be a big retrospective of Golub's paintings in New York at the New Museum of Contemporary Art. The show would also travel: to the La Jolla Museum of Contemporary Art in southern California; the Museum of Contemporary Art in Chicago; the Montreal Museum of Fine Arts; the Museum of Fine Arts in Boston; and to the Corcoran Gallery in Washington, D.C. Here was a pretext: I wrote him—congratulating him on the museum exhibition, and mentioning how much I'd like to see his studio, see how he worked. He called me not long after and said this was fine with him, but that I should know that if I really wanted to see how he worked—see a painting through, start to finish—I had better have some time on my hands, since a painting often took months to complete. I was working full-time now as a magazine editor, but there were weekends, evenings, lunch hours—I would find the time.

2. WE MET AT the New Museum, on lower Broadway below Houston Street, late one morning in September. He was standing in the middle of the main gallery of the museum when I arrived; there was a knot of young people around him, and the

talk was of lighting, heights, and placement—the nuts and bolts
of installing an art show. "I've just got a few things to take care
of here," he said when I walked over. "Take a look around."

There were to be forty-one paintings in the exhibition, a sur-
vey of more than thirty years of work. A few of Golub's newer
paintings were already hanging. In his latest pictures, those he
had shown earlier in the year at Susan Caldwell's, Golub had
mapped new territory upriver. From the *Mercenaries* and the
Interrogations he had moved on to a series called *White Squads*,
having to do with the Salvadoran death squads that were going
about their awful business with particular ferocity in the early
1980s—sixty thousand murders and "disappearances," accord-
ing to reports. Labor leaders and their families; students and their
families; legislators, journalists, priests, and nuns. In all quarters
of Salvadoran life, the death squads managed to find and intim-
idate and often horribly kill those accused even blithely of un-
dermining the national security, or aiding the leftist guerrillas in
the mountains. The death squads appeared in the night, in San
Salvador, the capital city, as well as in the villages: wild, morbid
in their violence, lawless in the profound sense that they showed
no signs of being bound by the most basic of social contracts—
the "natural" right of a civilian to justice, and to freedom from
bodily harm. But the death squads weren't lawless in the sense
that they had no authority for carrying out their atrocities; and
this made them all the more terrifying. The torturing, killing, and
kidnapping, when not actually sanctioned by the government
and its military, was quietly accepted. No one in the Salvadoran
government raised a loud objection—to this day there has not
been a prosecution of even one death-squad leader. There was a
civil war raging; there were abuses on both sides: that was what
those charged with seeing that justice was done and civilians were
protected were likely to say. The death squads operated with
impunity.

There is no way for someone like myself to comprehend truly
the fear that the Salvadoran death squads inspired (and continue
to). But one might begin to grasp how such fear is dealt with.
The defense against tremendous fear—a prolonged and not un-
reasonable fear of disease, violence, or death—tends to take a
familiar shape. Faced with the horribly inexplicable, the seem-

ingly random but surely dreadful, each of us tends to rationalize: I am not like those who have been victimized. They must have done something to deserve their fate. It cannot be that they are innocent. It cannot be that they are in any way like me.

In one of Golub's *White Squad* paintings, *White Squad (El Salvador) IV*, a death-squad goon looks over his shoulder at you as he stuffs someone into a car trunk—a terrible image, not only in the way it captures what had become an all too common act in Latin America, a typical "disappearance," but in the way it implicates us, the viewers: Is this any business of mine? Do I want to know who's in that trunk? Have I just happened upon this kidnapping, or am I an accomplice? Am I responsible? God, he's got his pistol drawn: *Should I do something?* Looking at the picture, you take stock of yourself.

There was also a painting hanging at the museum from a series Golub called *Horsing Around*—one titled *Horsing Around III*, dated 1983. It is of a black man in a kind of *après* paramilitary outfit; he might be a mercenary knocked off for the day. The background in the painting is pastel blue, with patches of creamy white and rose: The colors are equatorial, the mood is Caribbean, but in no way sunny. (This is the Caribbean of V. S. Naipaul's novels.) And the black man, huge and blank-faced, is posing— as if for a street portrait artist in some port town—with what I took to be prostitutes (but women? or young men in drag?) on either side of him, his hand working its way into the pants of one of them. A steamy painting, steamy in a way I had thought Golub neither interested nor capable; and a haunting painting, too, one that gets at some other part of the soldier of fortune, a dim corner of his consciousness where sex and death have crossed and sparked some new and terrifying range of the possible.

There was another recent painting, pictorially a real departure, titled *Riot II*. In all the Golubs I had previously seen, I had sensed a stillness, an airlessness: The figures were posed, their gestures somewhat stiff. More than one critic had called Golub's paintings of mercenaries and torturers David-like—a good point; the stillness, like the worn red backgrounds, says to us "history." *Riot II*, however, is a volatile painting. A hilarious picture, too, in its own anxious way. And the three figures in the painting are clearly addressing us, so we feel what we feel immediately.

A hefty woman, middle-aged with lots of makeup and long, sharp red fingernails, is gesturing, taunting with her hands, coming toward you openmouthed—her face is that of an overextended Latin soprano, midnote. Her anger has taken her someplace, and she is not alone. A big tough—bald with blue shades, dressed for Saturday night in a pair of mint-green slacks and yellow sport shirt, and wired—is shaking his big fists in our faces. And a second guy, in a cheap-looking leather jacket—the big tough's sidekick, you think, the mouthy one—is clenching a length of pipe in one hand, giving us the finger with the other. We're not in Central America or South America here, not necessarily. You ram into the back of a big, showy car on the wrong side of town, and it's late and lonely, and this is what you see charging at you in the headlights.

"It has to do with action in the street, that kind of violence, people getting caught up." Golub had walked up behind me. "I had in mind the riots in Chile against Allende before the coup brought him down—the middle-class riots." In 1973, the democratically elected president of Chile, Salvador Allende, and the Marxist government he led were overthrown in a military coup. "From what I'd read, the riots were 'augmented' by street punks put up to it. That's the mix I'm after here. There is fear, you might say, but it is fueling their excitement. They're keyed up, okay? Ready for action. And there are more of them than there are of you—get what I'm saying? So for them, there is this expectation of a little fun." He laughed. I did, too, a little.

"I've just started a new *Riot* painting," he said now. "Let's walk over to my place. It's just around the corner. We can talk about it."

3. GOLUB'S LOFT IS on La Guardia Place in Greenwich Village, a couple of blocks north of SoHo. On the brief walk over, he told me that he first rented the space shortly after returning to New York from Paris in 1964. At first he only worked there. "It had been a gallery way back, one of the first downtown, and there was burlap on the walls—that was how they hung paintings here, then," he told me. But now he lived in the loft as well as painted there; it was his home.

It is a fairly large space, three thousand square feet, up one flight of stairs on the second floor; and when we arrived, shortly before noon, it was quiet and dark. The only natural light would come from the east, through big windows overlooking the street, but the sun was already too high. Golub reached for the light switches, flicking on numerous floodlights that glared down at us from the high ceiling. Just inside the door, right in front of me, was what appeared to be a work area; but the work—on a long table, I could see what looked to be prints—was not his. This was where his wife, Nancy Spero, did her work, he explained.

I knew little about her—I had not known they were husband and wife. I had seen her pictures only in reproduction, in a copy of *Heresies,* a feminist art journal. It was as a "feminist" artist that she was known. "Nancy's asleep," Golub said, leading me toward the back of the loft, into the kitchen. I could see now that the loft was split evenly front to back by a freestanding wall, and that this provided each of them with a more private area in which to work. To the front of the loft, off Spero's studio, was a door—"our office and study," Golub said—and to the back were the kitchen area and bathroom. At the rear of Golub's work space were two more doors: two small, monkish bedrooms—one for each of them. No sofas, no living room, no family pictures around—nothing, to me, that didn't speak of work. "Nancy tends to stay up late working," Golub said. "I mean, she doesn't begin to work until late, past midnight usually. We'll have dinner, then maybe watch the news or talk, and then, when you think she might be ready for bed, she has all this energy. I've heard people say that she started having to work late at night when she was

raising our three kids"—three sons, grown and out of the house. "It's true, she did work at night when they were growing up. But actually she's preferred to work at night ever since I've known her, which happens to be a long time. We've been married more than thirty years."

Golub brewed a pot of coffee, and while waiting for it we sat at the kitchen table, piled with books and periodicals, asking and answering the introductory questions. When the coffee was ready, he offered me a cup, then ushered me into his studio, where he made straight for a gray-metal file cabinet toward the front of the loft, near the windows.

"This is where I keep my photos," he said. "It always begins with the photos." He pulled several manila folders from one of the drawers and opened them; in each of the folders there were dozens, perhaps hundreds, of photo clippings—not actual photo prints, but pictures cut out from books, papers, and magazines. The files had names: "Gestures," "Tattoos," "Heads," "Guns," "Mercs." "I cut most of the photos from things I read," he said. "If I'm traveling, and I see unusual magazines, or photo books, I buy them. I like to visit the bookstores in foreign cities, and when I'm there, I look for interesting items. In the *Interrogations* I even used pictures from sadomasochistic magazines—in the case of torture, this is as close as you can get. There are no photos of torture that I've seen."

"But the paintings," I said, "they don't seem to be done directly from photos. You don't use them that way."

"Almost never. I say 'almost' because I just finished a painting, *Mercenaries Five,* that is based on a photo more or less directly. When I had my third show at Caldwell last January, a photographer I didn't know—his name is J. Ross Baughman—left a photo for me at the gallery. It was taken in Rhodesia, during the civil war. Now, in the picture there's a guy crouching down holding his pistol to the head of this guy who's in a kind of push-up position, on hands and toes. There are three other prisoners in the same position. Mercs—and the guy with the gun is a merc— go in for this kind of thing. It's a kind of conspicuous terrorizing they do, theatrics, a lot of nasty self-dramatization. I decided to go with the photo. I did a painting that sticks pretty closely to the image. It had this power.

"Normally, though," he went on to say, "when I use photographs, I'm after something else."

I was feverishly taking notes. I stopped him and asked if we might sit down—I had a tape recorder I could use.

"Sure, sure." He got a stool and an old chair that were against one wall and placed them in the center of the room. He perched on the stool and offered me the chair. "Okay? More coffee?" I thanked him and declined. "Okay. Now on to my interest in photographs. I've thought a lot about this over the years."

I reminded him that the one time before when we had talked, at Peter Schjeldahl's place on Christmas Eve, he had told me of his notions about the speeding up of media information and our access to it.

"Yes, that's right. Now, what really interests me is how we understand this. I mean, there are people who will say that because there is so much coming at us—newspapers, magazines, TV, and so on—the result is that nothing makes an impact, that we are just numb to it all. I disagree. I think it completely alters the way we see the world. All of this stuff—all of these images—results in our seeing nothing in its precise totality. Everything jitters, is fragmented, contingent. We look at the world through images, there is no other way. What we see as a result is a sort of atomized chaos—all these fragments and flickerings. And what we sense seeing this is not numbness. If anything it makes us anxious."

Golub spoke very quickly, as if he couldn't wait to hear what he had to say next. I struggled to stay with him.

"The other effect photography has, along with the fragmenting, is a sort of flattening, or what I call a deadening. It can be seen especially in gestures when they are frozen by the camera, and in close-ups. The camera fixes action, stabilizes a gesture, and this stability works somehow to exaggerate the gesture. This exaggeration is with us now, it is part of the way we experience the world visually, so it's important for me to get it into these paintings I do."

He was plunging deep into his theories and observations now, and the further he did, the more antsy and elfin he got. He scratched his head, opened and closed his knees—he was heading off somewhere. (Every so often he would end a sentence with

what I was beginning to recognize as a characteristic, upturned "okay"; it is pedagogic, I think, a way of letting you know you have been told something important and are about to be told more, so pay attention—and also perhaps a signal that he is prepared to alter or enhance or even take exception to a point he himself has just firmly stated.) Eventually he lost me, and I put up my hand and asked: *How does all this actually find its way into the paintings?*

"Well, you see, what I am doing in the paintings is constructing figures from this flood of images—a leg here, an arm or gesture or facial expression there. I am trying to get down on the canvas fragments of experience, telling fragments caught as if by chance, as when a figure is altering a gesture. I am in that way representing this atomized view of things. And also I am painting in a way to get at this flatness. It is there in the space in my paintings, and also on the surface, where by the time I am done with a painting there is actually very little paint left. The contingency, the deadness, too, it's there in the painting."

"So it's not a matter of your having been there, in Latin America, to see what you paint, make sketches, take your own pictures?"

"What?"

"You don't make sketches of actual men and women? Take pictures of models and that?"

"That's not the kind of thing that interests me. I've never done that kind of work, really."

"Well, how about this painting right here? Could we talk about how you went about it?" I gestured toward a canvas directly in front of me, the only one hanging in his studio—a huge length of canvas, similar in size and shape to the paintings he'd been showing at Susan Caldwell. It was at this point little more than a big, big paint sketch. He told me he had begun it only a week or so before, when he thought he had enough of an idea to cut a piece of dun-colored linen several yards long and hang it unstretched.

"And there I begin," he said.

On the left side of the canvas there were two bigger-than-life male figures. White-chalk and brown-crayon lines—quickly set down, smudged, corrected—gave the figures what rough shape

and volume they had; and these lines were now partially covered with thin, brushy swipes of black and white acrylic paint. The men seemed to be in their late twenties or early thirties, but somehow "boyish"—"boyish" in a way that scares you in men. (In a bar, which is where you are likely to meet men like this, you may find yourself indulging them, agreeing with them too often, perhaps, and then you're in too deep.) Like all of Golub's thugs and bullies, these two had faces that looked to be carved as much as drawn. The expressions were somewhat wooden, the features roughhewn and somewhat exaggerated. Golub's hand, a heavy halting hand, turns faces goofy, even innocent, in an ungainly way. But this tends only to increase the edginess and dread: Do goons always look so casual? So approachable? In many of Golub's pictures, the horror has to do with the fact that they—the thugs and torturers and rioters on the prowl—don't seem to know, don't have a clue, of the horror.

In this painting in progress, the figure closer to the center of the canvas was carrying a big stick or length of pipe. Both figures were running, left to right, and seemed poised to turn off into the distance. Golub, uncharacteristically, had established a provisional landscape with a few thick horizontal bands of black. In the upper right-hand corner of the canvas I could make out another figure, smaller, in the distance. He was wearing a wide-brimmed hat of the kind forest rangers wear. But there was a more frightfully distinctive detail—he was dragging a body on a length of rope.

"This is *Riot Three,* or I should say it will be," Golub said. "When I started thinking about this painting—it must have been a few weeks ago—I had this idea that I wanted to show a victim being dragged. I've actually had the general idea for a long time. It was more that now I got around to it. I've had the photos for years. I don't remember if I clipped them or they were sent to me or what. Anyway, the photos are from the student riots in Bangkok. Remember them? I think it was 1976."

The riots Golub was referring to lasted only a day. On October 6, 1976, on and around the campus of Thammasant University in Bangkok, forty-one students were killed by police, by army troops—but mostly by mobs of vocational-school students called Red Gaurs, after Thailand's wild ox. On the previous day,

a group of Thammasant students had staged an anti-government protest on campus during which they'd hanged in effigy a member of Thailand's royal family, Crown Prince Vajiralongkorn. Photos of the "hanging" were published that evening in the Bangkok papers; by dawn the following day, thousands of Red Gaurs— at whose instigation remains unclear—were roaming the university grounds, doing some hanging of their own.

The photos Golub pulled from his files were small, grainy, amateurish. My guess was that they came not from American newsweeklies but from foreign magazines, or maybe from one of the numerous small journals and reports devoted to human rights (Golub told me he looks through these.) The rough quality of the pictures only enhanced their luridness. There were terrible acts recorded: In one photo, smooth-faced youths, just kids, really, chase others older than themselves with sticks and pieces of pipe; in another, there is a truck with a crowd of onlookers to either side, and dangling from the truck's rear bumper, in the dirt and dust, is a battered body. In the most shocking picture there is a calm, even friendly audience for a kid who is beating a student with a folding chair. The student, hanging by the neck from a branch of a small tree, has been dead for some time.

What struck me about the photos, and I mentioned this to Golub, was how young the rioters looked, innocently young, and how comfortable they seemed with beating and killing—and how, too, the killing was not quite enough.

"Absolutely."

"And is it usually the case that seeing photos like these of the Thai riots gets you going?"

"Well, in many cases no, because there is no photo—there are no photos I've seen from inside torture centers, as I said. You get the idea from reading and so on. And then you cut a piece of canvas and hang it and prepare it and begin. But in the case of riots there are photos, sure. It's not that I wanted to make a painting of any of these photos, though. It's that I wanted to get at the mood, the action in the street—and at the people who get caught up in this. These guys here in the painting—I mean obviously they're not young Thais. I've Westernized the features, made the figures older—these guys have what I would call a

nervous intoxication. You know, the fighting starts and the numbers are in their favor, so: Let's go!

"And there's one other thing: this almost ritual display of the victim. It has always gone on, I think, but we'd like to think this kind of thing is no longer around. Forget it, okay? I have somewhere these two photos taken during the Vietnam War, incredible pictures. There are in each one two South Vietnamese, and this dead Vietcong. In one of the pictures, this South Vietnamese guy—he looks like an official, actually—is holding up the dead guy's penis—you know, the guy is dead, he's on the ground, and here, for the photographer, he's got the tip of his cock in his fingers. All right?

"So here, in *Riot Three,* there's a body being dragged. Maybe for hours. And maybe these guys in the foreground I've sketched are going to run over to the guy behind them dragging the body and have themselves some fun with it."

Golub walked over to the file cabinet and came back with yet another manila folder. In it were more photos, clips he'd used specifically in sketching out the figures in *Riot III.* One, from *Sports Illustrated,* was of a basketball player racing downcourt. Golub liked the muscles in the player's legs, "the shape and gesture," and gave them (along with a pair of slacks of his own design) to the figure at the center of his canvas.

"I put the picture of the figure directly on the canvas with an opaque projector, then traced it, very loosely."

There was also a small picture in the folder of a man's face, tense and strained. This one Golub had not traced, but rather taped to the canvas while he was sketching, using it as a more traditional aide–memoir.

"I don't do preliminary sketches on paper—you lose a certain involvement that way. If I don't like what I sketch on the canvas, I just get rid of it and start over." He looked at the picture of the face. "It's from the movie *Alien.* I found it in a book I bought of film stills from the movie. I like the way the light is hitting the guy's face. The face has that nervous intoxication I mentioned. The guy—the one without the club in his hand? I want him to have that wildness to his expression."

The last photo Golub showed me before I left that afternoon

was another from the Bangkok riots. He didn't so much draw this one as draw *from* it, as one might draw from a portable generator. It had that kind of power to jolt. The body of one of the students is being dragged on a rope. A few of the Red Gaurs are trailing behind it, kicking it—kicking a dead youth's head as casually as they might a soccer ball.

4. I SAW GOLUB again the following Sunday. His retrospective had opened at the New Museum, and he had invited me to a brunch held for him in the museum's rear gallery. The tables were set up right in front of the paintings, a strange thing to see. I tried to imagine a collector finding a place on the dining room wall—actually, the entire wall would be required—for one of Golub's *Mercenaries* or *Interrogations*.

I spoke with Golub only briefly, but long enough for his wife, Nancy Spero, to appear at his side: Someone, she said, wanted a word with him. Golub quickly introduced us. Spero is a slim woman, almost fraily so, and fashion-conscious in a way Golub is not: Her clothes were loose-fitting, Japanese chic, and she had a punky haircut—short, very blond, spiky. Her "look" made her seem much younger than she is (she is only four years younger than Golub), but it is more than that, too. She has high cheekbones that have lost very little of their firmness, a girlish smile and laugh, and a way of carrying herself that is lighter than her years. I lit a cigarette, and she went on a little about how smoking is so bad, then lit one of her own, coyly—and laughed.

I knew no one at my table; there were museum trustees, and a staff member or two. They talked in twos and threes, among themselves; wider table conversation was polite and perfunctory. It was just as well. I ate and spent one long stretch of time listening to a conversation at the next table. The guests seated there were my age, critics and editors from the art magazines, and they were talking about Golub. They seemed to know a good deal about him.

I had heard someone say something about Golub and his

dealer, Susan Caldwell, about how she wasn't going to be his dealer for long—and that had caught my attention. The conversation had proceeded from there: Caldwell might remain his dealer, or might not. She was going under, or she was going in with Anthony d'Offay, a prominent London dealer who was planning to open a New York gallery. Or he wasn't. Or, Golub was leaning toward signing on with the Mary Boone Gallery— now, in 1984, the most glamorous of new galleries in SoHo— and wouldn't that be something, a scandal! There were those at the table who thought that the subject matter of Golub's paintings would be compromised if the works were hung on the walls of Mary Boone's gallery—that the spare elegance of the gallery, and its association with brash young painters like Julian Schnabel and David Salle, would undermine the grave political nature of Golub's pictures. And there were others who thought that should Golub decide to show with Mary Boone, he would eventually have to change his work, abandon his images of political violence—he would himself be compromised, sooner or later. A scandal either way, it seemed.

A young woman at the table assured the others that Golub would not be showing with Mary Boone. It was true, Boone was leaning toward taking him on, but her new partner, the German dealer Michael Werner—"who was her lover, too!" "Yes?" "Yes." "No!"—Werner couldn't stand Golub's paintings.

"That's what Eric said."

"Eric" was Eric Fischl, who had only recently joined the Boone gallery. Fischl, like Salle and Schnabel, was one of the young, new American painters, though formally he had little in common with either of the two. He did not layer his canvases, palimpsest-like, with fragments of elusive imagery drawn from photographs, cartoons, and the paintings of other artists. Like Golub, he had evolved an expressive realist style, and with it he was painting—with striking frankness—the American upper middle class in its high self-absorption and wan luxury. Fischl had been lobbying for Golub's inclusion in the Boone stable, and Boone had been listening, "because she listens to all her young artists." Or maybe not. But with Werner not interested now— "He had actually gone to Golub's studio." "Looked at the work?" "Said right there he didn't care for it." "Really?"—that was that.

The conversation went on like this for maybe ten minutes. Other dealers were brought up, discussed. Someone mentioned the price Golub was getting for a new painting: sixty thousand dollars. "Maybe he could do better with a bigger-name dealer." Maybe not: "The market for expressionist painting has helped his prices, and it can't last."

The talk continued to churn: art talk, eighties-style. Among critics, the conversation revolved increasingly around money. Art had simply become a business—that was what critics were writing and talking about more and more, angrily and a little hysterically. Much of what the critics were saying was true. Little of it, however, was in any way new. The art business was pretty much what it had been since at least the seventeenth century, when painters in Amsterdam and elsewhere began to sell what they made—made of their own choice, on portable canvases—to anyone willing to buy.

But in the mid-1970s, the art business had not been much of a business. The economy, weakened by inflation and slow growth, was a factor: There wasn't money around for artworks. A greater factor was that serious young artists, many of them, were experimenting with conceptual art, video art, performance art, sculptural installations and environments—media that did not lend themselves to sales as readily as unique objects such as paintings. (A good deal of this work did sell, however, or at least was supported within the traditional gallery network, and little of it was made with a particular aim not to sell, as would sometimes be claimed when it failed to.) It was difficult for these artists to find a public willing to venture downtown to view their work, let alone purchase it. At times it seemed that only the critics were showing up, dutifully charting developments and attempting to gauge what mattered. If sculptors such as Richard Serra and Bruce Naumann were perceived during the 1970s to be important younger artists, dealers and collectors had little to do with it. An essay in *Artforum* was the measure of value.

The role of the critic was great in the 1970s. Now, in the 1980s, however, the critic was once again but one part of the public for new art. There were new, wealthy collectors; there were new dealers, too. The economy (as perceived by those with the money to buy art) had recovered. The young artists were

painting again, the work appealed to a larger public, the media were attracted by the money and the crowds—the art world was back to business. And less than ever, it seemed, did this business require the services of critics. The special place critics had had in the 1970s was no more. The "discoveries" were being made without them; young new artists had a "buzz," had other artists talking about their work and collectors buying up their work, before their first show could be reviewed. The critic could always continue to do what the critic does first and best—write about art, the work itself, and for the most part ignore the business. And there were critics, the best of them, who did just that. For them, power was not the issue; it wasn't what drew them to art. But there were others, many others, who so resented the new big money—resented, really, what they perceived to be their diminished role in the art world—that they could seldom keep from talking and writing about it. It was money—the art market, individual careers, the role of art in "late-capitalist America"—that critics increasingly were interpreting, evaluating, and theorizing about.

The table conversation I was listening to furtively, attentively—how did they know what they knew, or thought they did?—drifted to one of Golub's biggest collectors, Charles Saatchi. Saatchi was mysterious, powerful, the most important of the new collectors. With his brother, Maurice, he ran Saatchi & Saatchi, a huge London-based advertising company known in Britain as the firm that devised the ad campaign that helped to elect Prime Minister Margaret Thatcher in 1979, and in the United States for its high-price acquisitions of New York firms (Compton Communications; McCaffrey and McCall; Yankelowitch, Skelly & White)—acquisitions that by the fall of 1984 had transformed the agency into a transatlantic giant. (By 1986, Saatchi & Saatchi would be the world's largest advertising agency.) But Charles Saatchi was especially known in lower Manhattan for spending his money, lots of it, on contemporary art. There was no collector of his ambition.

Back in the summer of 1982, Saatchi had seen a show of Golub's *Mercenaries* and *Interrogations* at London's Institute for Contemporary Art, and now he was buying Golub regularly; he'd already purchased two, three, four paintings or more—no one at

the table knew for sure. Maybe Charles Saatchi was getting a little discount—his was such an important collection to be in— or maybe he was not. Saatchi collected the work of particular artists not by purchasing a painting here and there; he collected in batches. He seemed to be collecting Golubs if not in batches— there weren't that many Golub paintings to be had—then deeply. Maybe this interest of Saatchi's was going to affect Golub. "You paint what they want—whether you think that's what you're doing or not," someone said. And no one argued the point.

There were many in the art world—especially critics, but artists, too, particularly those whose work was not selling—who thought the high prices being paid for new paintings corrupted not only art, by which it was meant the experience of an artwork, but those who made art, especially the painters. Money was mediating the experience of artworks for many, corrupting this experience for them—who could doubt that? The outrageous prices paid for new and old works of art in the 1980s—a reflection not of art's "commodification," as was argued by numerous critics, but of a consumer society's continued need for objects that transcended the material, objects that bore some greater, incalculable value—was placing an enormous burden on artworks. How many images, even remarkable ones, are repositories for such ultimate meaning, can carry such a weight? A painting bought for hundreds of thousands of dollars, or millions of dollars, cannot pay off, not for the viewer.

But to argue that the inflated market for art necessarily corrupted painters seemed to me not only cynical but oddly romantic. Hearing "you paint what they want," I sensed a longing (couched in respectable cool) for things as they had been only briefly in the history of art, in the first moments of what we came to call modernism, if even then: the painter, pure and free. By which it is meant: free from the corrupting ties of money. But what does this mean, exactly? That a painting, once sold, necessarily loses all meaning save that of the price it brought? That any work of art capable of being purchased never was intended to have a public, only a market?

It is true that in the 1980s the galleries were frequently visited by men and women simply ogling the expensively priced works, with next to no concern for other possible sensations and mean-

ings. And it is true as well that the market for the work of young painters in the early 1980s made painters of many who would have probably done something else—and are by now doing something else, or soon will be. But the serious painters I knew were not in it simply for the money, or mostly for the money. They'd started painting before they'd understood what money could do for them. When the money came—as it did in the 1980s, with prices for new paintings by young painters reaching fifty thousand dollars, one hundred thousand or more (in a few cases, much more)—when the money came, it did change lives. (What kind of money are we talking about here? Not the money earned by true celebrities in the entertainment business.) The young painters, men and a few women, had finer lofts now, and summer homes by the beach; some of them wore expensive clothes, sat in restaurants until all hours, did drugs for a while, ran with Wall Street people and movie people. There was a different style to being an artist; it wasn't the 1970s anymore. They'd been to art school in the 1970s, the young painters, studied with teachers who made conceptual art or did performance pieces or video, made the money a professor did. Sometimes deep into the night, a little high and talking, a young painter might wonder how he got there, feel a little electric, a little outside himself: *Who were those people at the opening tonight? How can this thing last?* But mostly, I think, the money assured painters, the good ones; it would not always be like this, they would not always have this kind of attention, but they could continue to paint. And a sense of security—in a world where painting, despite the sudden money, still maintained only a fragile place—is no small thing.

5. I BROUGHT UP the topic of money—money's role in and around art—when I dropped by Leon's loft a second time, a couple of weeks after the brunch for him at the museum. And the topic made him uncomfortable, uncomfortable beyond the fact that no man is comfortable, nor should he have to be, talking about the money he makes. The kind of money he was making—

sixty thousand dollars a painting, which Golub, like most paint-
ers, split fifty–fifty with his dealer—was new to him; that ex-
plained part of his discomfort. But he also had a certain view of
himself, and a certain perspective on how the paintings he made
fit into the world, and money clouded that view a little.

"It's a funny thing," he said. "People will ask me—usually
in public, like when I'm taking part in a panel discussion—they'll
ask, 'How can you sell your paintings to Charles Saatchi? Don't
you know he ran the campaign for Margaret Thatcher?' Or there
is this whole South Africa thing." (In 1983, the South African
office of Saatchi & Saatchi Compton Worldwide was hired by
the governing National Party of P. W. Botha to promote the
adoption of a proposed change in the South African constitution
that the party was seeking in a national referendum; the party
sought to provide South Africa's Asian and mixed-race "colored"
people with nominal legislative representation, while ignoring the
rights of the black majority and leaving in place the miserable
system of apartheid. The referendum—which blacks, of course,
were denied by law from voting on—was passed.) "In some ways
I understand this kind of questioning," Golub went on to say.
"But I am not a pal of Saatchi's, and he has never shown any
interest in being a pal of mine. He has been to my studio exactly
twice, for ten, fifteen minutes or so. He does not tell me what or
what not to paint, okay?

"But it is more than that. The fact is, I'm not a purist, and I
never have been. I don't particularly like purists—I mean, you
have to be some kind of hypocrite to think you can be a purist
and be an artist. If painting is corrupt because paintings are sold
to wealthy people who make their money in not-so-nice ways
. . . then painting has always been corrupt. It has always had this
relationship to power, served it in this way."

Golub fell silent for a moment; he seemed to be thinking hard.

He then said, "In my paintings I can locate power, designate
power—at least to some degree. I am like a reporter in that way.
But I cannot control—nor do I want to—how these images get
distributed. In fact, unless my paintings get into these so-called
corrupt networks for distribution—dealers, collectors, and so
on—they will not be widely seen. And then what's the point?
Mine are public paintings. I want them out in the mainstream."

He told me it was true that he might be going with a new dealer, but he didn't really want to discuss it just now: "The situation is very muddled." (Not long after, he signed on with the Barbara Gladstone Gallery in SoHo.) He then mentioned that he hadn't had much time to paint lately, nudging me, himself, too, on to a new topic. But he could not seem to let it go.

He said of Saatchi, "He's a lightning rod for a lot of dissatisfaction in Great Britain, and that carries over to the U.S. But what about American museums, which appear so detached from moneymaking, the art market? Is their money really purer than Saatchi's?" And before I left that night, he said, "I'm a painter, I need the art world in that sense. The money has not changed the way I live all that much—Nancy and I don't get invited to rich people's houses for parties. I don't even have a car. But I do need to sell paintings to buy the time to keep painting. And for that I do appreciate those who buy my paintings, the few who do. Although I don't think the only public for my paintings is those who buy them, okay? But selling a painting is a good feeling, don't kid yourself. I've known what it's like not to. I've made paintings in this loft that never left this loft."

6. WE HADN'T TALKED much about painting that night, and I hadn't seen *Riot III*, how it was coming along, so I dropped by Golub's loft again the following afternoon. Nancy was out. The loft was quiet and dark; the only lights on were a couple of the floodlights he has in his studio. We sat before *Riot III*, as we had the first time I came by. The two main figures in the foreground had been colored in, the paint applied thick and even. The only lines visible now were those formed by the separation of the flat areas of color; the drawing Golub had done in chalk and crayon, and then had gone over with a light brushing of paint, was buried somewhere beneath layers of acrylic. The arms and faces of the two men were a pasty pink. The figure on the left had on what I imagined to be dark blue jeans and a pale blue workshirt, unbuttoned to his belly; and there was a gold chain

dangling from his neck, a thick neck. Golub had given him hair the color of straw. The guy running with him (thinner, more nervous-looking, wielding a club) had dark hair and was wearing black slacks and a red shirt with its tails out—the red was more saturated than the red he utilizes for the backgrounds of his paintings, a loud, vulgar red. "A couple of small-town sports," Golub said.

He then went on to explain: "When I paint, I try to remain very conscious of what I call 'types.' For example, when I paint an interrogator, I'm after something different than when I paint a mercenary. They are different kinds of men in real life, perhaps—different classes, different ways of carrying themselves and handling themselves. This has something to do with status. A merc is a pretty desperate type, unstable, working for a few hundred bucks a month maybe, and for the fun and games, too, of course. An interrogator is something else. He may have a certain status, or perceive himself to have a certain status—to be a little higher on the social scale. A military officer, okay? Or a doctor. Doctors are often present at an interrogation to make sure things don't get out of hand, that the torture victim isn't visibly bruised or killed. In a detail, a piece of clothing, a posture, a gesture, I try to convey this kind of thing.

"Now, the gold necklace: sort of ostentatious, garish. This says something about the guy, his sense of himself, his ideas about being macho, a certain vanity, this kind of thing. To me it says he's the kind of guy who might be a little loud, who might get swept up when something breaks out on the street."

Leon pointed to the figure holding the club—specifically, to his free hand, which angled, fingers extended, across his groin.

"I really like this hand gesture. Now, it didn't come specifically from any photo. When I'm drawing, a lot of freehand is involved, especially once I begin to get into the character. And in fact I hadn't paid too much attention to the gesture at first, hadn't seen it, really. His other hand with the club I understood right from the start—I planned it, so big and aggressive. But with this free hand of his, I began to see—it was only a couple of days ago—that maybe he's trying to cover himself, protect himself, with his free hand. Or maybe it's something else. I do think, though I should say I have no proof for this, that these guys who

participate in street riots of this sort get a kind of sexual excitement. So in this gesture there may be signs not of vulnerability, or not only of vulnerability, but of something libidinal."

Listening, I was beginning to understand this: Golub took great care to control certain things in a painting—the scale, the colors, the signs and gestures of social position. To get this kind of information "right," he read about human rights, covert actions, paid attention to the news, was involved in the world in this way. He utilized photographs; he thought that the photographs in his files were crucial to his work, to his "way of seeing" as a painter at this time. But other things—this hand gesture he was talking about now—he expected to come from some other place and to manifest themselves in the very act of making the picture.

I asked him: Was there a way he consciously went about balancing these tendencies in his art-making? Was there a particular moment when he loosened his grip on the picture, let his eye and hand drift, let the work take him?

He thought for a moment. Then he said, "Well, I would answer it this way, which may or may not be what you are after. I would say that I am not a realist, in the sense that—and I've said this before—the totality of all the visual facts one can see and understand, all the shapes and colors and details we see walking down the street, does not equal what there is of the world, reality. It's not all there on the surface. And so, because I believe this, I am not simply interested in recreating that visual world in a painting."

I brought up the Marxist literary critic Georg Lukács. Lukács had made the distinction between naturalism—the belief that the artist can recapture a sense of reality by accumulating and enumerating, a belief behind Soviet social realism—and what he believed to be true realism, wherein the artist condenses, grasps insights, selects, interprets.

"Well, maybe we could get hung up on terms all day. Because I would say I have an expressionist bias. Not in the way many of these young neoexpressionists do—they're into brushy paint, fast paint, as a hip thing, a style. It's a style that's supposed to convey to you, the viewer, that they, the painters, have emotions. I'm not interested in that, okay? What interests me in terms of

what we call expressionism is that in the process of painting, some things may come out, certain recognitions or certain contingencies. They're accidents in a way, but they're not.

"Now here's something I noticed right from the start." Golub stood and walked up close to the canvas. He ran his hand up and down the left thigh of the figure holding the club. "It's too thin. In terms of scale, perspective, this thigh looks like a mistake. I didn't make it too thin deliberately, and it has nothing to do with my having drawn it from looking at a photo and then having distorted it. And to tell you the truth, I could fix this thigh up in about fifteen minutes if I wanted to. But I like it. I like it this way. It's a point of tension in the figure, a kind of gap or break, I call it—it works for me pictorially.

"In almost all my paintings, you can find such a moment. My sense of the paintings I do is that they are not harmonious. Just as my own sense of myself is that I am not harmonious."

Later after we had talked a bit longer, and I mentioned it might be time for me to return to my office, he came back to this: "You know, what I was saying about not being harmonious—I'm not trying to come off like the crazy creative artist. There's not much to that—the myth of the mad artist. But I do think there is something about me—and my work in a way has always reflected this—something that is awkward, disjunctive."

7. I SAW GOLUB often in the next few weeks. I was feeling I was beginning to know him, and that we were becoming comfortable around each other. He and Nancy and I would go to dinner, usually to Chez Jacqueline, a small Provençal-style bistro on MacDougal Street, not far from their loft. It was not an art-world spot, which was one of the reasons they liked it; and they liked the atmosphere. The diners were mostly young, and many were French, and Nancy would note this, then tell a story, maybe, from the time they spent in Paris years ago, a time special to her. We would eat late and linger. We were becoming friends, in our way. And I was noticing things. I began to glimpse a certain

delicacy to Leon—a slight lisp, and a way he had at times of turning down and away when he was talking with you.

And I noticed, too, listening to them talk, how much the day-in, day-out life of the artist—the life built around Valéry's "old-fashioned labor"—meant not only to each of them, individually as artists, but to what they had between them. Art, like marriage, was something they were in together. It meant that neither of them went off to the office each morning, that they were there in the loft with each other—that they had a special intimacy born of this proximity. But it also meant that solitude—which their work demanded—might be harder to come by. This, too, explained Nancy's working at night. Making art allowed for much thoughtful, sensitive conversation between them (works of art ask to be talked about in so many ways), but also frankness (there is so much one does as an artist that asks to be judged). Art wasn't their profession; it was very much their approach to life. One night at dinner Leon said, "Nancy and I, right from the start, we were each other's best friend and first critic. It's been an ongoing conversation. After I've been working all night, as happens sometimes, and she's been working on the other side there, and we come to look at each other's work, and comment, no beating around the bush, okay? After everything, family and so on, that's what it comes down to." And how many married men would look at their marriages *that* way?

After we'd leave the restaurant, I'd usually head back with them to their loft. Nancy would sit at her table and work, and Leon and I would sit in his studio for a while, discussing the progress of *Riot III*. One night, when he turned on the overhead spotlights, the canvas looked as though it were ready for the movers. The two big figures in the foreground were completely covered with brown wrapping paper, taped carefully to the canvas to create what looked at first glance to be big silhouettes. The smaller figure to the upper right—the one with the hat—was similarly covered, as was the body being dragged on the rope. Over the canvas that remained exposed, the ground upon which Golub had drawn his figures, there were wide, watery slashes of black paint zigzagging every which way. It was as if the abstract expressionist painter Franz Kline had been brought in to do the picture's ground.

Leon explained that this was the last stage before he soaked the background with red oxide. The red acrylic, which he would apply with a wide brush attached to a long pole (like a broom handle), would mask all this graffiti-like black, but only temporarily—only until he began scraping it away. Then the black would come through, creating a certain texture and shimmer, activating the canvas. "Actually, I'll get a little white down first, maybe another color or two. I mean, just a few slashes, like the black you see. It took me a long time to get this right—figure out what would give me the effect I wanted. And now it still takes me a long time, all this preparation for each painting, the layering and so on. But I think there is something to the slowness, the way I have to spend so much time with each painting, that fits in with what it is I am painting. This erosion: a buildup, then erosion."

8. A WEEK OR so later—the slashes of paint in the background gone now, hidden under coats of red paint—Leon talked with me about how he came to use the essentially monochrome grounds he does in his big paintings. Already in his *Gigantomachy* paintings of the 1960s, he explained, he was seeking to "universalize" his pictorial space, purge it of any detail that might lead the viewer to read it as a particular place. He called his backgrounds "no spaces" in those years—"the space of existential action," space emptied of time, history, any realistic mooring. Man, as represented in the *Gigantomachies* (uniform, faceless, battling to survive), was to be understood as estranged, alone in the deepest sense. The space in which they ran, stumbled, fought—a washed-out brown, the color of bare, dirtied canvas— was nowhere, or maybe everywhere.

The one adjustment he did make to his backgrounds when he made the transition in the 1970s from the *Gigantomachies* to the more realistic, detailed *Mercenaries* and *Interrogations* had to do with color—he filled in the bare backgrounds with bold red. He had used red in a few smaller paintings in the 1960s. He

liked the idea of using the same color the Romans in Pompeii and elsewhere used for the backgrounds of their great frescoes: "I've been attracted to Roman art since the fifties, when I lived in Italy, and really got into the stuff," Leon said. He also liked that red is a heraldic color—big and pronounced—and that's what he wants his art to be. But mostly he liked the way it worked once he tried it, the way the mercs and torturers and goons seem at first to float on the red, then to muscle forward into our—the viewers'—space. "With the red, the figures intervene," Leon said, "much as they intervene in real life, in history."

9. GOLUB BEGAN TO scrape paint from the figures in the foreground of *Riot III* on a cool afternoon in late October, and I was there to watch. The canvas was stretched out now on the floor of the studio. Areas of the red background had already been scraped down by his studio assistant. The assistant's scraping had given the background the texture of a fresco; the red looked patchy, worn—and the horizon line that ran across the canvas and turned the background into a deep illusionistic space was all but gone.

Leon said, "I can afford to pay a studio assistant now." And because he had been operated on not long before for a hernia, he was letting the assistant do the work on his paintings that required little nuance, but real physical strength. Scraping was tough, he said. He worked only on the figures.

The exhaust fan in the studio was whirring. Golub walked over to a cabinet near the front of his studio and returned with a pint bottle of rubbing alcohol—this to dissolve the acrylic paint, make it possible to scrape it away. He opened it, and I caught a whiff of the fumes. On a big painting, he said, he might go through thirty, thirty-five pints. (It was clear to me why the noisy fan was on.) He went off somewhere and brought back a small foam cushion; he would use it to kneel on, or to rest his elbows on, while he scraped. And then another stroll, this time to his work-

bench, from which he retrieved his scraping tool, an eight-inch meat cleaver.

It crossed my mind: This might be a performance for me. Golub might have reasoned that if I was watching, I might want a ritual, some drama (there was still another exit, and an entrance with a roll of paper towels and a pair of leather work gloves). But I doubt it. What I was watching, I think, was that hesitancy you glimpse in people—in yourself—before any big task, provided the task itself allows for it. Taking all this time with the preliminaries was a way of giving himself time to think, or was perhaps a habit associated with good luck, or an exercise in control before he turned his attention to the canvas, where he did not have complete control. Golub had been working on the painting for about two months, no small investment. And now it was time— he would begin to see, as he could not until now, if the painting was going to work. Maybe he already had intimations that there were problems. He was talking to me as he prepared to scrape, answering my questions about this or that, but he wasn't loose, I could tell. Maybe he was wondering what I was doing there, why he had invited me to watch. There was something quite intimate about what he was about to do. And I had this thought: How many of us want someone in the room with us when we are doing something we really care about?

He walked onto the canvas in his stockinged feet, slipped the gloves on, sat on the cushion, and began to work. "I won't know until I put the painting back up on the wall if this first round of scraping is a preliminary step or the last one," he said. He smoothly brushed some alcohol on the blond-haired figure's face, then waited a minute or two. I could see how the alcohol was beginning to cause the paint to blur and dissolve. At the sight of this, Leon took the cleaver in his right hand, held the figure's face flat and taut with his left (think of an old-fashioned barber giving a shave), and made one long, clean swipe with the blade. He wiped the knife on a paper towel and made another swipe. And another. He patted the face with a paper towel, soaking up the paint-muddied alcohol puddled there. He brushed on more alcohol, waited, scraped, pressing firmly and evenly.

With each scrape the face revealed more of itself. Through the layer of pink, chaffed now and gaining translucence—Golub's

way of "getting" flesh, its certain, indeterminable texture and substantiality, is extraordinary—I could glimpse the drawing and underpainting he had done weeks before, showing through now as puffiness under the eyes, deep lines in the jowls. And yet there was this, too: The face—the image—was actually retreating into the very tooth of the canvas. Strictly speaking, there was very little substance and pigment remaining where Golub had scraped. Up close, you saw nubby fabric dusted with color. It was as if the image Leon wanted had been there a very long time, and he was digging, like an archeologist, to find it and bring it up.

It took him about a half hour to finish scraping the face. That was enough for now, he said. He stood up; and then he said, "It's a little too cartoonish, the face." And it was. The mouth, open wide, was clownish; and overall the face looked somewhat like that of a rodent.

In art for centuries there has been this type of face, the face of man caricatured, made animal-like, as he sinks into what we seem content to call "animal-like" behavior—though what we in fact mean are those beastly acts of which man alone is capable. You can see these faces in Goya's *Disasters* and then—stunningly, horrifyingly—in his Black Paintings, the ones he did for himself on the walls of his farmhouse outside Madrid (they are now in the Prado). You can see the animal faces in much earlier Italian cartoons and, in our century, in the drawings Picasso made in the 1930s to protest the Franco regime in Spain. Today, these are the faces you see in so many works of protest art.

But part of the power of Golub's paintings, I thought, was that he had avoided this now tired convention of art, of political art especially—that he had used his cartoon-like figuration to give each of his political thugs and goons a full and particular human presence. "It looks like a weasel but I can fix it," he said. "In the faces especially I do a lot of reworking after I scrape. What I call the 'openings'—the mouths and eyes—I get in there, work to get them right. These are the parts of a man that reveal so much."

While Leon washed up, I went to the kitchen for something to drink. On the kitchen table, propped up on a little bookstand with rimless eyeglasses resting nearby, was a copy of *The New York Review of Books,* open to an essay on the Reagan admin-

istration. And it struck me then: Golub seldom talked about politics in the studio. At dinner, yes, he talked politics, enjoyed it. But in the studio—and I'd been with him many evenings, talking for hours—it was the work, the stuff of it, that we talked about. Or it could be me, I thought: In the studio, around his paintings, the stuff of painting was what I asked about.

"Leon," I said, when he returned from washing up, looking a little tired to me now, "there is political violence everywhere, right? Poland, the crackdown on Solidarity. Lebanon. Uganda. Iran. The killing fields of Cambodia. Why not do paintings about these things?"

A reporter's question—one loaded with implications (as if he never thought about these things until I asked him), and asked only at an icy distance. He looked at me as if to say, *Now what are we up to?* And I felt uncomfortable, stiff. But before I could get us beyond this somehow—and my mind was racing to find a way—he said, "Okay, fair question." Then: "Look, in my work there is no pitch for a leftist society. Even when we have talked about politics, you have never heard me make such a pitch. If I'm anywhere, I'm more on the left than the right. But I'm skeptical of government wherever. Power and control corrupt wherever. I'm an American—that's why I make the work I do. And I would go so far as to say that here, in the United States, I can get away with this work, by which I mean that no one is going to come and break down my door. Where else could I do such work? Western Europe—where else . . . ?"

Leon continued: "So, I'm an American, I can do what I please, okay? I have that luxury. At the same time, and maybe these things are not unconnected, we are involved in places where there is no such luxury. We are involved in putting mercenaries in the field, involved in training men who torture people, and so on. This is simply a fact.

"I would say this, too: Right now, as we talk in 1984—Orwell's year, and Orwell was on to these kinds of things—the victims of the most gruesome political violence are on the left, victimized by the right. Look at this riot in Thailand that I showed you the photos of. Read any human-rights report. I'm talking about the grotesque acts now: the killings and mutilations and obscene tortures. But political violence—you mentioned Poland?

Lebanon? It goes on everywhere. And my paintings, by extension, speak of these other places.

"Now, when I said there is no pitch, I mean, too, that I'm not in the business of getting people worked up, worked up to take political action. In the 1960s I was very involved in the anti-war movement—it was a huge part of my life—and today even I will from time to time get involved with a cause, loan a work or make a poster, whatever. But in the paintings, it's something else. What I am trying to do, what I hope I'm doing, is what painters have always done. In the figures I paint, you see certain acts, gestures, ways of reacting, power relationships. You see power manifested. You see the look of today's struggles." He paused for a moment, then continued: "And maybe—in the way the figures carry themselves, or glance at one another, or even at us—maybe in some more universal way they can tell us something about ourselves, a part of each of us. I don't know." Another pause. Then: "Now, in the new painting, I began with not only a political problem, or maybe not even a political problem, but a psychological one: action, the mob. And in all my paintings I am after this aspect of power, the psychological aspect. In the new painting there is this particular nervous tension I'm after: the skin of the street, I call it. And this may sound absurd, but I have this notion when I am working on the figures of these guys being truly real. They aren't just cardboard characters, standing for something. As I get to know each of them, my idea about how I want them to look or behave may change. I begin to have an understanding of these guys, which is another way of saying that in part I sympathize with these guys. And in the same way, I sympathize with the mercenaries, those types. Not with their actions: no sympathy there. But with their situation, their marginality, with how they must have gotten to this point. So when I paint, I am both outside working, and inside."

10.

I DIDN'T SEE Golub in the weeks that followed. I was especially busy at the office, and anyway, what progress he was making on *Riot III* was small and slow. We talked on the phone a few times. He was gradually reworking the face that had troubled him. And now there was something else: What really seemed to be bothering him was the victim, the body being dragged. "He seems a little small to me," Leon said during one of our conversations. "Too far away, insignificant." I couldn't tell; I couldn't even picture that part of the painting now. I could see only the foreground, the two main figures. "You know," he continued, "when I first started the painting—actually, before I started—I thought of doing it with the body being dragged up front, in the foreground. I still may do one of those. But then I thought it would be interesting to do a sort of landscape like I did, you know? Do it flat, but with a little more sense of place."

"So what now? Repaint the background?"

"I really don't know. There's all sorts of things to do. I'm not afraid to improvise if I have to. It's important when you paint, I think, to have the confidence that you can always recoup a painting."

11.

I CALLED LEON the day after Election Day to get his reading on Reagan's reelection landslide. Reagan had presented a view of the world largely at odds with Golub's: He, Reagan, was not concerned with ongoing political violence in the countries the United States supported. His first nominee to be Assistant Secretary of State for Human Rights, Ernest W. Lefever, had told the Senate committee conducting hearings on his nomination that he wanted to remove from the shaping and conduct of foreign policy U.S. legislation concerned with assuring the human rights of citizens in countries we support. The Republican-dominated committee eventually voted 13–1 against recommending Lefever's nomination, and his name was withdrawn; but his idea that

the U.S. should look the other way when governments friendly to ours violated the human rights of their citizens nevertheless became a cornerstone of the Reagan administration's foreign policy.

State Department reports on human rights mandated by law were fudged and delayed. Military aid to authoritarian nations curtailed or in some cases cut off by the Carter administration was renewed and bolstered by the Reagan team. A country's human-rights record was no longer a factor in whether or not the United States supported extending to that country a loan from one of the multilateral banks. In fact, the Reagan administration made a concerted effort to shift—or, better, to bring to a halt entirely—the very discussion of human rights, except with regard to violations in the Soviet Union (or in Soviet-backed countries). Congressmen who spoke of abuses in countries like Chile or El Salvador were accused of playing "partisan politics." Newsmen who reported human-rights violations were labeled unobjective "liberals." Human-rights groups like Amnesty International and Americas Watch were said to be peopled by "leftist sympathizers." It was as if the abuses and violations themselves simply were not occurring. It was as if the questioning of old truths in the 1970s had never taken place.

Golub and I talked about Reagan and human rights for a while, but really there was not much to say that he or I hadn't said before. Neither of us expected much change (and we were not to get it). Before we hung up, he said, resignedly, "For the next four years, Reagan will give the country exactly what it voted for. Let's face it. He will keep smiling no matter what. And he will tell the country that it is all really simple, uncomplicated, which of course it isn't. That's his biggest lie." Then he said, "We will continue to go about our business, doing what we have to do to remain a world power, our idea of it. And I'm sure Reagan will not change in such a way that I would feel out of it to continue the kind of work I do."

12. ONE AFTERNOON LATE in November Golub called me at work, and we talked again about *Riot III*—he'd been working on it now for three months. He said that he'd been slowly providing the blond-haired figure with good teeth, painting with a very fine brush. Then I asked him about the body being dragged in the background, if he'd thought any more . . .

"Gone."

"What?"

"Gone. I was looking at the painting the other night, I've got it back up on the wall now, and—I don't know. It just bugged me, I guess, simple as that. I got a pair of scissors and cut the whole thing out—the body, the guy dragging it, gone."

"So now what?"

"Well, it still needs some work, but there's no major problems. I'm going to work on the faces a little more. But I think mostly I might just look at it for a while—leave it on the wall and look."

13. I SAW *Riot III* again in January 1985, just after the holidays. Leon said that it was nearly completed. There is something about seeing a picture on the wall where it was made— seeing it surrounded by the materials of its making, and before it has been mediated by money and talk and criticism. Having watched its slow, and finally rather drastic, evolution, I felt a special connection to the picture. The time that goes into a painting—something you sense in front of every picture you view— was something I had actually clocked. This time was somehow not only the painting's but mine.

The painting was special to me, but I do not think it is one of Golub's best paintings. The face of the blond-haired figure was a problem and remained one (although Leon did fix the mouth; the clownishness had been worked out, and what remained was a mouth letting loose a laugh I could not share in). And the vertical shape of the canvas, rare for a Golub—this a

result of the cutting—worked to box in the men running, gave them nowhere to go. Looking at it, I thought of something Golub once said, talking about the history paintings of David: "The action of the figures frequently seems too radical, too extreme, for the probabilities of the scenes of occurrence."

Golub felt pretty good about the painting, or said he did. I think he liked the fact that he had cut up the painting, that he felt confident enough to do that. He had mentioned once—in passing, with no drama—this feeling he had that at his age, and at the rate he worked, there was only so much time, so many paintings left. It was a youthful thing to cut the painting; perhaps that was what he liked about it.

We sat in his studio, drinking wine from plastic cups. Leon said, "It still needs some work. I'll have to trim the bottom a little. The scale is off." He then said, "When I hang it, it will be a little lower than it is now. And this will help bring it into our space." Then: "I sense their mobility, their movement—and that's something. The arms and hands, too." He looked at the painting, looked hard, and moved his hand slowly, left to right, before his face, as if he were moving with them somehow.

I looked, too, and thought how the painting you start is not the one you finish.

III

GOLUB'S
STUDIO

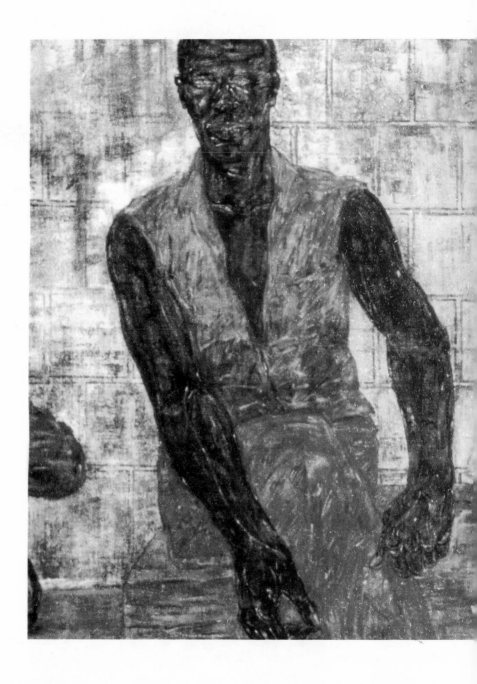

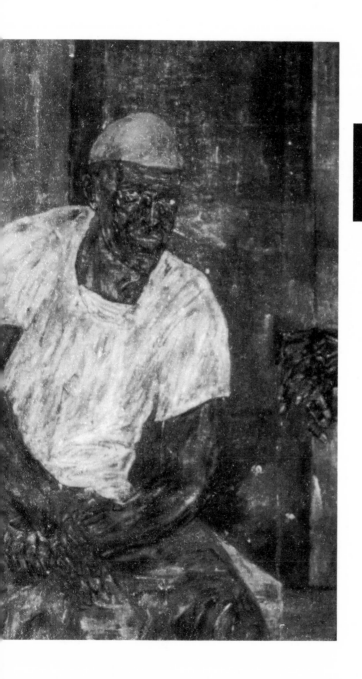

To BEGIN: THAT is what the painter desires. That is what he strives to do, again and again. That—at its most essential level—is the painter's intention. To find a way, a place, to begin.

There is not much talk today of the painter's intention. Formalism, which became a force in American art criticism beginning in the 1950s, was the first approach to works of art that did not bother to ask what the artist might have in mind. Formalist art critics—like literature's New Critics (John Crowe Ransom, Cleanth Brooks), from whom they seem to have drawn many of their aesthetic notions—sought to convert criticism into a scientific practice, and—to do so—the work of art into a solid, self-sufficient object, needing no further clues from its maker (or, for that matter, any subjective feelings of a particular viewer) in order for its meaning to be grasped. It was no longer necessary to worry what the painter meant to make, or what he thought of his finished picture. The meaning was embedded in the work itself, its structures and forms, even if the picture was not an abstract picture (although formalists tended to favor abstraction). Fine formalist analysis—of the kind Clement Greenberg was capable of, at his best—could be its own kind of poetry, sharp and airless and cold; but most strictly formalist criticism reads today as simply reductive, clinical, and more than a little perverse in its fervid denial that the painter's intentions had anything to do with the interpretation of his painting.

Intentions, as understood here, are the attitudes and assumptions the artist brings to the work he is making. These are messy things: Who, the formalists asked, could possibly sort them out? Surely not the artist himself. And even if we could know a paint-

er's intentions, what purpose would knowing them serve? We do not look at works of art to get to know artists. Painting is not a transparent medium through which we seek to observe the painter's psychological processes or political views. A painting, the formalists insisted, is not an autobiography.

Formalism by the 1960s had come to dominate the art magazines, the art-history departments, the important museums devoted to contemporary art: It was the established way of seeing. This is no longer so. Formalism's hold on criticism has been weakened in the last fifteen years and has perhaps been supplanted in the art-history departments by new modes of critical thought—most recently (and painfully, to the formalists) by post-structuralism. But the notion that the artist's intention is of little or no importance to the understanding of his work continues to be widely accepted even among the radically anti-formalist post-structuralists. There are post-structuralists who have sought to restore the work of art to the social or historic context from which the formalists disentangled it; these post-structuralists are in no way interested in an art pure and sublime. But the context enveloping an artwork's making or display does not, as these post-structuralists see it, include the individual artist—not, anyway, as a subjective force in the making of the work. Artists, like the works themselves, are looked upon by these critics and theorists for the most part as mere prisoners of their contexts, and of the language—the language of painting, say, if an artist happens to paint—of which they make use. A painter can do little at all that is original, even by accident, let alone "will" to *mean*. It is "painting," and not the painter, that paints, and thus imparts meaning.

There is truth to what the New Critics called the "intentional fallacy." We do not view a painting (or should not) simply to recreate in our own minds the mental state of the painter who made it. Or approach it this way: Are the wonderful pictures done in Renaissance Siena by the artist known only as the Master of the Osservanza "lost" on us because we know nothing of his intentions, or even his true identity? Paintings, the recognitions and sensations they afford us, are to be gotten from the works themselves, edge to edge.

But to make of this truth something absolute (and this, in

large part, has been the case) is to turn away from other truths. When you sever paintings from those who made them, you are in essence saying that there are no insights to be had from the specific circumstances of their making. You deny the picture a temporal existence; its existence now is wholly spatial. Even those who seek to place a picture within its social or historical context—within a general time, not the specific time of its making—ignore the temporal; in their minds, they simply take the object off the wall upon which it now hangs and hang it upon the wall on which they believe it originally hung. This increases our comprehension of a painting, but how much? Charles Burchfield, Stuart Davis, and Clyfford Still were contemporaneous American painters. How did the similar context in which they painted—political, social, and economic—affect their work? The answer, of course, is that the context did, but not absolutely. The works of these three very different painters were made at a certain time, but were not similarly of that time. Only the most general similarities among the three are explained by the context they shared. In each case, the painter's own understanding of and relation to that time—the unfolding of his life and career in that time—is what makes the difference. (The post-structuralists will acknowledge this, when it suits their argument. An artist who eschews all attempts at "originality"—who directly "appropriates" or copies the work of another artist—is praised for his self-ironizing intentions.)

Knowledge of the unfolding of an artist's life and career is crucial in another way. Imagine yourself in a large gallery of Willem de Kooning's paintings—a de Kooning retrospective. For some reason, the paintings are hung randomly, with no regard to the date when each was completed. With the moments of their completion lost to you, the paintings now on a white wall before you, stripped of all specific temporality, how do you explain the spaces between them? How do you explain change? The de Koonings themselves, though there are many, many available to you in this imaginary retrospective, cannot speak to you of this. Certain sensations and recognitions—of developments, breakthroughs, themes explored and abandoned, problems solved or not—are, like the dates, lost to you.

All that is to be gotten from painting cannot be gotten only

from the paintings themselves. There is meaning and feeling be-
yond the edges of a canvas. And by this I mean something more
than "context," though context surely is crucial. What I have in
mind is the practice of painting—there is this activity, a temporal
activity, upon which to reflect and wonder. There is also the
unfolding of a career. What a thing, a career: the plotting of a
life shaped by the work accomplished; the moments, some
charged and some hushed, when inspiration and will and the
occasional hunch encounter time, and perhaps (if the inspiration,
will, or hunch is ambitious enough) history.

Among the points to be plotted along the path of any career
are the points at which a new work, then the next one, and the
next one, were begun. And what we want to know—knowing
we can never fully know, but still asking, if we can ask—is not
only when, but how and why, the painter chose to begin what
he did.

2. ON THE NIGHT in January 1985 when I had gone to
Golub's loft to look at the nearly finished *Riot III,* I'd asked him
what he thought he might do next. "I've been thinking about
that a lot lately," he said. "It's what you do. You know, when
you work in series the way I do, you stick with that—do this,
do that. Now, there are some things, the *White Squads,* say, I
haven't exhausted. I'll go back to them. I have other pictorial
ideas, things I want to do with color and backgrounds and so
on. But the *Riots*—right now I'm not sure. I'd still like to do one
with a guy up front, being dragged. [Later, in *Riot IV,* he would
make such a painting.] But right now I've kind of got this image
in my head of something else."

I asked him what that was.

"Nothing certain yet. I have a picture in my mind of figures
sitting. Just sitting there, looking out at you. Maybe it's the middle
of the day, a kind of break in the action. They're arranged just
so. They're comfortable with each other, maybe, but not with
you, okay? You are the one who has intruded into their space.

Now what? It's got to do with their eyes. It's getting—my getting, in the painting—that they are not looking at whoever is doing their portrait but at you. What are you doing here? That sort of thing."

For the rest of that winter, and on into spring and summer, I saw Golub hardly at all. We had dinner twice and talked on the phone a number of times. He wasn't around all that much. The big show of his work that had opened at the New Museum in New York was now traveling, and he was spending a good deal of time traveling with it—attending openings in Chicago, Washington, and elsewhere, giving gallery talks, and participating in panel discussions. In April the show had opened at the Montreal Museum of Fine Arts, and Leon seemed especially eager to be on hand. Montreal had been the first museum to purchase one of Golub's paintings of political violence—a great one from the first show at Susan Caldwell, *Mercenaries II*—and this was no small or routine thing. Over the years Golub had sold few works to museums, but then this was as might be expected. He did not have a museum-level reputation, except perhaps in Chicago. The new work—the paintings he had been showing now for three years—was receiving the kind of attention that tended to lead to a museum purchase, especially today. The American museums concerned with collecting contemporary art were, however, shying away from Golub's paintings.

It was odd, really, that the museums weren't buying. One might naturally be inclined to think that the shaping of a museum's permanent collection, a collection of new art in particular, is a subjective, even haphazard, undertaking, influenced to a large extent by the tastes of the museum's curators of contemporary art and the influential members of its board, often collectors in their own right. In fact, museum collecting of new art has very little to do with individual tastes as such. Museums that collect contemporary art—whether devoted exclusively to contemporary or modern art, or general museums offering selections from all periods of art—no longer work that way. That would imply having an argument about art, its purpose and development, what was good and what was not. Today it is more a matter of taking the pulse: What's going on out there? What's new? If the reviews are good, if the artist seems to be making a place for himself or

herself at the moment, if an important collector or two is buying, then the museums buy—maybe only one picture or "piece," but something, a hedge, and usually at a nicely discounted price. (The artist, the dealer, too, are eager to have a work bought by an important museum. This has to do with sanction; it affects the next collector, the next survey-show organizer, and maybe, eventually, art history.)

There had been glowing reviews of Golub's New Museum retrospective by Michael Brenson in *The New York Times* and by Robert Hughes in *Time* magazine (these are the reviews that matter to museum people). Charles Saatchi was collecting Golubs, as was Eli Broad, a Los Angeles multimillionaire (Kaufmann and Broad, the company he chaired, was the largest builder of single-family homes in California) and a Saatchi-like bulk-buyer. Golub was surely, by museum standards of the day, "collectible." Something, it seemed, was "off."

One warm spring afternoon—this was two years later, in May 1987—I had lunch at the Barbara Gladstone Gallery with the gallery's ebullient director, Richard Flood. Over sandwiches in Flood's office, we got to talking about the reluctance of museums to buy Golub's work. (At that point, he had still not sold a recent painting to an American museum.) Flood spent a number of years as a critic; he knew a great deal about art and about the world around it as well. Round-faced, with a neatly styled beard, subtly fashionable, and puckishly opinionated, he would have been right at home in a Proustian salon. "The museums," he said, with a mock-sinister laugh. "What can I say about the museums? Not everything, of course."

He then began to talk, carefully, about the Whitney Museum of American Art, whose collection of contemporary American art is among the country's most important, particularly in the eyes of the artists themselves. The Whitney had yet to buy one of Golub's paintings, despite the reviews and the collectors, and despite the fact that the museum had included two big Golub paintings in its 1983 biennial exhibition—one of the art world's most celebrated (to many, notorious) indices of what is of the moment, and what is not.

"It's not as if we—and a number of people at the museum

who will go unnamed, if you don't mind—haven't wanted to have them buy something," Flood said.

I asked Flood why the Whitney had not purchased a Golub, and he didn't answer me directly. He said that there was a curator at the Whitney who liked Golub's work, felt strongly about it. This curator had gone to the acquisitions committee of the museum's board of trustees and tried to persuade its members to buy one of Golub's paintings. The gallery had arranged for one of Golub's paintings to be rolled up and trucked uptown from his loft; it had even arranged—this is not uncommon—for a private collector essentially to buy the painting and donate it to the museum.

"But there was a reluctance," Flood said.

"A reluctance?"

"The board. Somebody. Somebodies."

If Flood knew more, it wasn't for me to know. The painting was not purchased. Did he get a reason?

"The reason, as odd as it might seem, is the obvious one. It has to do with what Leon's paintings are of."

We talked of how oddly quaint this seemed. Could museum trustees in the 1980s actually worry about the "content" of paintings, be made uncomfortable—as the representatives of an institution—by a work of art's "politics"? But perhaps it was not so odd, I remembered thinking to myself later, after I'd left the gallery and was walking back to work. Perhaps the sense we have that "anything goes"—that all is simply fashion, that nothing can shock any longer, that ultimately any work is softened and absorbed by the system and, if deemed great enough, by the canon—perhaps this relatively new, and somewhat cynical, notion is in need of reexamination (an irony of sorts, since this idea was born of the reexamination of the notion that all new art has, since the advent of modernism, deeply offended the bourgeoisie.) Perhaps, in art as in life, it remains a matter of degree. Golub's paintings—what they depict, what they reveal—have not been easily absorbed, or softened, by the institutions that build our public art collections.

When I spoke with Leon not long after and brought up my discussion with Flood, he smiled a knowing smile. It must have

bothered him, the reluctance of the museums; but perhaps, too, he took some satisfaction from it—the museums were relaying to him the message that he was different, an "outsider."

"What gets me," he said, "is how they go about it. I'm not talking about museum curators now. On that level I've had my share of interest in the work itself. I mean, some of these curators I'm sure were really going out on a limb with their museum boards, and so on. What they say to the gallery is: It's just not the right piece for us. We want one, just not that one. Show us the next one. Of course, the same thing happens with the next one. It's never that they don't want to deal with what I'm painting. Never that, you see. I mean, in a way, I'd rather they say: 'I don't want your big ugly painting hanging in our museum, scaring away the big boys we need to run this place.' No. They want the next one."

3. INTENTIONS, BEGINNINGS: It was late in the summer of 1985, sometime after Labor Day, when I once again visited Leon's studio—it had been eight months or so since I had last been there. What had he done since *Riot III?* On the phone and at dinner, we hadn't talked much about what he was working on. When I'd ask, Leon would say that with the show traveling, and he along with it, he hadn't had much time to work. What he had been telling me was true, no doubt, but wittingly or not, he had misled me. For in what time he'd had, he'd managed something rather extraordinary.

On the wall that night were two canvases. They were large pictures, their surfaces were scraped and worn-looking, and the figures were bigger than life, monumental. They had the familiar "look" of Golub paintings. But the figures, those whom Golub had portrayed, were new. They were not political criminals; they were not what I had come to think of as Golub "types." Let me describe these new pictures, as I viewed them and began to take them in: In one, four black men sit in front of a whitewashed (but now stained) wall of squarish cement blocks. It is not clear

whether they are inside (a room in a prison, perhaps?) or out; the only detail is a bright blue door, thick and closed. Two of the men share a simple bench; one rests on what could be an upturned crate, and the other is seated, knees drawn up toward his chest, on the floor (or ground). The men appear to be in their forties, maybe a little older; their clothing is casual, as are their gestures: legs crossed, hands folded, elbows on knees. Two of the four men look right at you, one of the others looks beyond you, and the fourth—his eyes dart nervously off to the side, lending the picture a subtle air of trepidation.

The other painting was also of four blacks—three men and a woman, older than in the other picture, in their fifties—and they, too, are simply sitting before a cement-block wall. But there is a quickly palpable uneasiness to this picture. The woman, perched precariously on a green stool, her slip visible beneath the straps of her short yellow dress, might be about to fall forward, right out of the picture. (Golub had cropped these figures at the ankles. There is no floor or ground, no "space." He had even cut away one corner at the bottom of the canvas, perhaps to drag your eye down to the foreground, and thus to alert you to how little room there is in the picture, and between you and the figures he'd painted.) The black at the center of the picture— could he be sitting on a garbage can?—is shirtless (as is one of the other figures, a Buddha-like presence), and his jutting jaw is clenched on a cigarette. And the figure beside him is signaling out of the picture to you; his right arm is raised in a way that suggests he wants your attention. Why?

I didn't take in much more immediately. Mainly, I was struck by the fact that Golub had painted what he had—that I was staring at paintings in which black men (and a black woman) were depicted. He had painted not blacks but eight different blacks: particularized, individuated, distinctive. Their shared pigment—normally a sign of their difference, in art no less than in life—was in Golub's pictures not "shared" at all. He had varied the flesh tones, from inky black to leather brown to reddish chestnut. And he had struggled with eye and hand to "realize" each face; his drawing and redrawing, visible beneath the dark and varying complexions, are testimony to rigor and correction— and read to me, as I viewed the pictures, as grimace lines, age

wrinkles, scars. These blacks were not metaphors for the exotic, nor were they simply reducible to their status or social type. In a sense, Golub's figures weren't "blacks" at all, any more than most group-portrait paintings strike me (a white man) as being of "whites."

Golub's two new paintings were out of the ordinary—extraordinary—if only (but not only, I think) because there are so few paintings against which to measure them. Painting through the ages has produced very few convincing pictures of blacks. I felt very much on my own, viewing these paintings. What was Golub up to? What were these blacks up to?

4. CONSIDER, AGAIN, MANET (although I did not when I saw these new Golubs for the first time). Picture in your mind's eye his most famous painting, *Olympia* (1863). Can you see, against the dark, drawn drapes in the upper right-hand quadrant of the picture, the face of the black attendant? Perhaps you cannot—in truth, the face is not at all memorable. The face of the young black woman is as lacking in particular attributes, in presence and "character," as the face—or, for that matter, the belly, fingers, or rough-dark left heel—of Manet's prostitute is forthrightly, particularly real. Manet, who could bring a whore onto the stage of painting, shocking Paris (and shocking us still with her icy gaze), could not realize, or perhaps bother to, the simple contour of the attendant-girl's cheek and chin. In all likelihood, Manet couldn't "see" her as anything more than an evocative symbol. The girl, like the black cat on the whore's bed before her, is to be understood not as a subject but as a sign of sensuality, a little something to raise the temperature—and also as a formal device to play off Olympia's ghastly night pallor.

Manet's problem has been most every painter's problem—that is, a problem for the relatively few (historically, white male) painters who have even attempted to paint blacks. As the art historian Hugh Honour argues in his impressive two-volume study, *The Image of the Black in Western Art: From the American*

Revolution to World War I, many painters who have depicted blacks, at least since the last years of the eighteenth century, in fact *have* sought (unlike Manet in his *Olympia*) to particularize black men and women, to emancipate them from racial and social stereotype—stereotypes prevalent in earlier Western pictures no less than in white society at large. But it seldom worked, despite the good intentions, as the pictures reproduced in the pages of Honour's study make convincingly clear. (The intentional fallacy, so very true in this case. And Golub? What were his intentions in painting blacks? And would they, too, look generalized, stereotypical to a viewer years from now? To a black today?)

Perhaps the good intentions could not overcome the beliefs and fears embedded deep in the white painter's unconscious. Or it could be that facial features not shared (and seldom glimpsed in everyday life) by an artist, whatever his color, are routinely exaggerated. Or: As portraits were traditionally painted of those with power or influence, where was there space for black "subjects"? The failure of good intentions is there for us to read in the few ambitious attempts by Western painters to depict powerful black men. In these pictures, we are time and again reminded—once more, not necessarily consciously by the painter—of the fears aroused by the image of a powerful black man. I am not talking here only of the paintings that provide a powerful Satan with Negroid features (though there are a number of these). Even in such a dignified painting as Anne-Louis Girodet's *Portrait of Jean-Baptiste Belley* (1798)—Honour chose the picture for the jacket of one of his volumes—there is the unmistakable suggestion that a black man's power is tied up with sexual ardor. (This was a fearful belief of the time among whites—and now?) Looking at the picture, your eye is soon drawn away from the poised and determined face of this noble lawmaker—he was a delegate to the French National Convention, representing Saint Dominque—to his thigh, where long black fingers dangle before an enormous bulge in his tight white pantaloons.

One could hardly expect American painters of the time to do better than Girodet—a student of David, painting in a context where blacks were not slaves—and mostly they did not. Those who sought to bring blacks into pictures, to get beyond generalized stereotype, could not overcome slavery and the segregation

and mean prejudice that lingered after emancipation; racism blindly colors American paintings of the nineteenth century. Typically, a desire to show the "humanity" of black folk results in paintings either idealized or condescending (or worse). In William Sidney Mount's genre paintings of the 1830s and 1840s—the first important "integrated" paintings in American art—blacks enter into the world of white men, but marginally. Mostly his blacks provide music, entertain, and are usually physically separated from whites. In one of his best-known paintings, *Farmers Nooning,* a black field hand dozes on a haystack, while a white child teases him, and under a tree a white youth reads studiously. The indolence of the black man—an old "truth" (and still believed by how many white Americans?). In his diaries, Mount actually expressed admiration for what he perceived to be the black man's carefree living; his intention would seem to have been to depict an ideal.

And what are we to make today of Winslow Homer's famous *Cotton Pickers* (1876)? A post-emancipation idyll: Two black girls, beautiful and pensive, stroll alone through a high-summer field of what might be some rare hybrid of cotton and poppy. The weather is balmy, the work not too taxing—and for miles to the horizon line, there is no overseer in sight. Perhaps, as some critics have suggested, the girls' thoughtfulness and unhurried pace suggest resistance, a job slowdown—but I think Homer's rendering denies such a reading. He has sought to approximate the "look" of Millet, and the result (given that his subjects were not French peasants but the children of slaves) is a Reconstruction romance.

Of slavery and what followed—its horrors, and then its cataclysmic end—we can know very little from painting. The one great painting to limn slavery—or one aspect of it, at any rate—was not painted by an American but an Englishman. I have in mind Turner's *Slavers throwing overboard the dead and dying—Typhoon coming on* (1841), hanging now in the Boston Museum of Fine Arts. In a roily sea, thick with sharks, we spot a black hand or two, and a manacled black leg sticking up. An ingenious solution to the problem of representing black victims of awful political cruelty: Describe them as they were truly seen at the

time: faceless, "self"-less hands and legs to be used as farming tools. Chattel. Things.

The problem remains today: How to paint particularized black Americans? Few white painters have attempted it. Nor do pictures by contemporary black painters of our day come readily to mind. (The best black contemporary artists—I am thinking of the collagist Romaire Bearden and the young sculptor Martin Puryear—have eschewed painting.) America's finest black painter, Jacob Lawrence, who did his best work in the 1940s and 1950s, was never concerned with individuated black men and women—he had the story of a people to tell. He unfolded narratives from black history in his small, folkloric pictures. His figures are flattened, generalized, communal—they crowd his pictures. Lawrence's paintings are chronicles, not portraits. His blacks enter painting en masse.

This desire to paint blacks rather than "this" black, "that" black, worked for Lawrence: He not only had a sweeping narrative to depict, he had a particular audience in mind—not an "art" audience (although that did come later), but an audience of black viewers eager to know and see realized their struggle-filled history. However, it has worked for few others, black or white. The effect can be dehumanizing, especially when the scale of the work is inflated, and the narrative unfolded is not history, but that of some future time and place. This is precisely the formula utilized by many of the "community" mural painters in our inner cities. With the best of intentions, these painters too ultimately idealize or condescend (or worse).

5. THE QUESTION —HOW to paint pictures of particularized black men and women—opens onto a larger one: How do you paint particularized pictures of the victims of political cruelty? That is: How do you portray "selves" when the individuals in question have been denied the power to create such selves?

In the case of those most cruelly, criminally brutalized—

slaves, and also torture victims—it would seem that you cannot portray them at all, at least not visually. (Garry Wills, writing of men and women in the nineteenth century who depicted the lives of slaves in order to bear witness to slavery, has made the cogent point that those *writing*—broadsides or poems or novels—could "detach themselves from concrete perception," and thus *reimagine*, in ways that those *painting* could not.) These are precisely the individuals who have been stripped of the very things (respect for their person, control, esteem) we think of as constituting what is human. To attempt to tease out, in a painting, some undamaged core bit of humanity in a slave or torture victim is to run the risk of "painting over" his or her very real pain and suffering; to attempt to paint in graphic detail the pain and suffering of such victims is to risk luridness, sensationalism—and further, perhaps, to risk missing the whole point. As Elaine Scarry writes in her provocative study of literary representations of physical suffering, *The Body in Pain*, the victim of torture has lost control not only of his or her life-unfolding narrative, but of his or her body. In the way it reveals fear, loses strength, "causes" humiliation, the victim's body betrays himself or herself on behalf of the torturer, is made to be the enemy. The body, the face, is thus no longer truly that of the man or woman who was dragged into the torture chamber. A portrait of the resulting victim—humiliated, cruelly beaten—is not properly of that individual at all.

Golub has on a number of occasions attempted to paint pictures of victims of brutal political violence. And he has fared no better than those who sought to paint slaves so many years before. His depiction of a nude, bound woman in one of his early *Interrogation* paintings approaches the pornographic—the picture is one of Golub's real failures. In *Riot IV*, in which two goons drag a third figure on a rope, the bruised, flattened face of the victim is dead and lifeless *pictorially*. It summoned no feelings.

In his most affecting paintings, Golub would seem to have intuited the problem. The victim, in these pictures, is either painted not at all (as in several of the *Mercenaries* and *Riot* paintings); or, as in Turner's picture of the slave ship, the victim is painted without a face, an "identity" (as when Golub provides us a glimpse of only a death-squad victim's torso and legs in the trunk of the car in *White Squad IV*); or, the victim turns his face

away from us, as do the victims in *Mercenaries V*. In this painting, the three black prisoners strain face down to hold the withering all-fours stance they are being forced to maintain, at gunpoint, by the crouching, grinning white merc. They understand no doubt the humiliation of their situation, on toes and fingertips, before a soldier of fortune's pistol; they understand, too, the fear that will register on their faces. They struggle to hold on, and struggle as well—as victims—not to be portrayed.

6. GOLUB'S TWO NEW paintings were of subjects, not objects. These men and one woman were not victims, at least not any longer. They conceived of themselves differently; they *conceived of themselves*. They did not appear to have been trampled by history. Nor had history carried them along to some future time and place, as in so many of the murals I had seen in black neighborhoods. Golub's blacks were here, now. They had a solidity, an immovable weight. A little thing, but how right Golub was (pictorially, metaphorically) to portray them seated. The seated subject connotes control: *You, the painter, have my permission to paint me.* Moreover, the seated poses—hands and elbows on legs, weight shifted forward—hint at weariness, some ache of contained suffering, and also of time, the patience of the sitter. Golub's blacks are waiting; they are not going anywhere. They are here, insistent—insisting you recognize them.

I had been looking at the paintings for perhaps ten minutes— quietly, taking a few notes on my small pad—when I began to sense more strongly the sensations to be had from the pictures. Why was the one figure anxiously watching something out of the corner of his eye? Why were a few of the other blacks watching me, staring at me, gesturing to me? It was no longer a matter of figuring out what Golub had done, but rather what the paintings were doing to me. Working on me, the paintings were beginning to ask, as the paintings of mercs had asked a few years before: What was I, the viewer, doing there? Was I the political victimizer, and was I about to get mine? I thought: *You are in the wrong*

place. Then I thought: *Who am "I" to be thinking this? And this "wrong" place—where is it? Out there? In here, within me?*

I finally spoke up. Turning to Leon, who was busying himself at the other end of the studio, I said, "These are a little scary."

"Well, that's it to some extent," he said. "You're someplace you're not supposed to be, okay? Maybe you thought it was all right. Maybe you had that kind of confidence in yourself. It's not about being physically in danger. Not for me, anyway. It's more psychological, maybe. A recognition that the old ways are no longer to be taken for granted, but also maybe the new way isn't going to be so pleasant for you."

Looking more closely at the clothing, at the roughed-out setting—at the pale, squarish cement blocks that sealed off the shallow space of each picture—I thought these might be South African blacks in a shantytown. This wasn't Harlem or Detroit—or was this a defense, a way of distancing myself from the pictures? From the implications?

I asked Leon whether he had thought of these figures as being in a particular place.

"In my mind they are African blacks," Leon said. "But I think they work on other levels. They're about power, the dynamic—how it can change. And about resistance."

The blacks in Golub's two paintings were making their presence known—to us, to painting, to history. They looked tired—Golub had done some unusually fine work on the straining and, in a few cases, bloodshot eyes—but also (to me, now) irritable. They had a certain grave calm, but also maybe a smoldering anger—and this got to me, frightened me a little. There was a profound ambivalence: that was the paintings' mood. It was perhaps a white man's reaction, my mood.

I asked Leon how he had come to paint the blacks.

"Well, I think I mentioned to you when I'd finished that *Riot* painting, didn't I? I had this idea of guys sitting around. But there was something else—in a way it is a pretty simple thing. The fact is, I paint blacks better. Isn't that a weird thing to say? But it's true. I've noticed it for some time in my paintings. The black mercs and death-squad guys look more convincing to me."

I recalled the black merc I had seen in Golub's first show at

Susan Caldwell—the bald black who, I later thought, when I first met Leon, looked so much like him.

"It's weird, too, a white guy painting blacks like this," Leon continued. "I mean, I don't know how I'd feel about that if I were a black—a white guy painting these vaguely threatening or resentful representations. I don't know how I feel, exactly. It just sort of came to me out of the work, you know? But now that I've done them, I don't know what to think."

I suggested to Golub that the blacks—just sitting, staring at us—seemed to want to know what our role had been in their pain—that that was a claim made by many who had experienced cruelty, and now were taking control of their lives.

"Well, maybe," Leon said. "Maybe."

IV

THE·IRAN-
CONTRA
HEARINGS

JULY · 1987

WHITE SQUAD VI,
1984, detail

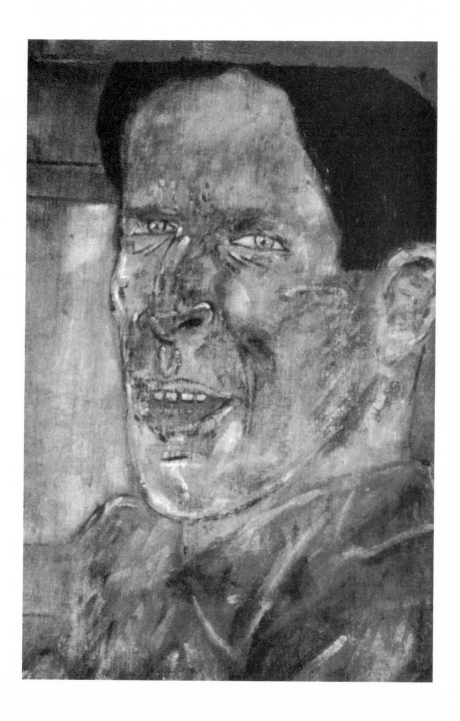

"**I** AM A PAINTER," Leon was saying, "and even for me it is hard to understand how it was in the days when it was the painter—the sculptor, too, but mostly the painter—who took control of and ordered the visual world. What was it like to live in the world and then paint it, before there was photography? And by that I mean, now, film and television, too. This kind of photographic imagery is everywhere. These images, we don't have to take them in: They permeate. They enter our perceptual systems in such a way that they form—the way I think of it—a kind of residue. We store these images in that computer in our head. Even when we are looking at somebody or something we know, an actual person or an object of some kind, we see them through a filter of photographic information. What we feel, okay? Desire? This photographic stuff to a large measure determines it. . . ."

He went on: "How was it when the only way to represent something or someone visually, fully, was in a painting or sculpture? When it was the hand, drawing, and the eye, of course, that captured everything? Can you envision that? It wasn't that long ago, really. The so-called Age of Photography is maybe a hundred twenty-five years old, a little more.

"You know you look at paintings in museums, old paintings, and you see extraordinary things. But hard as you try, you cannot see the paintings as they must have looked then, at the time they were made. I'm talking about paintings made several hundred years ago, when there was knowledge of myth, a belief in God, a comprehension of the power of a king. Imagine being alive and painting in an age when the painter creates the images of power, depicts how power is to be visualized. And when there is a

public—a pretty small public, sure, but a public—looking to painting for signals about how to carry oneself, how to look and act. Amazing to think about."

It was a mild evening in May 1987, a night to be out. Golub and I were having dinner at Chez Jacqueline—a late dinner, eating and talking. He and Nancy had spent much of the winter and the early spring in Europe, coming and going or getting ready to go. I hadn't seen much of them. That February, a show of Golub's paintings had opened at the Kunstmuseum in Lucerne, Switzerland. "Reviewed in all the Swiss papers," Leon had phoned to tell me when he got back after attending the opening. "So the museum sends me the clips and it turns out they're almost all written—maybe three-fourths of them—by the same guy. He just puts a different lead paragraph on each one." When the show traveled on to Hamburg in April, he and Nancy had flown over for the opening there as well. Leon, like most painters, is made a little uneasy about any stretch of time lost in the studio. But he looks forward to travel, especially to cities where his work is up, or where he can see the work of others he hasn't seen. He had managed while in Europe this last time to sneak in a side trip to Madrid, where he had visited the Prado, one of the world's great picture galleries, and home to many of the most majestic paintings of the seventeenth-century Spanish master, Diego Velázquez.

And that is what Leon was talking to me about now, more or less, at Chez Jacqueline—the grandeur of Velázquez's paintings. "There are extraordinary things we can see when we look at a Velázquez painting," he said, after we ordered a bottle of the house wine and settled in. "I mean, as a painter, what a job he did. Magical. What he did with paint . . . I couldn't touch him in a million years. You look at brocade he's painted, okay? He gets it, right? Rich. So material. The substantiality of it—you can feel it."

As I listened, Velázquez's portrait of Philip IV of Spain in the National Gallery in London—*Philip IV in Silver and Brown*—came to mind. I had spent part of one summer studying in London when I was an undergraduate; and I had become nearly possessed by this picture. It is about six feet high. Philip looks to be in his thirties. (There is some dispute about the dating of the work.)

He has developed a firmness, a resolve—or an idea that he should have resolve—that he lacks in Velázquez's earlier portraits of him. What intrigued me about the painting, however, was not Philip, his character and complexity, but the silvery embroidery that decorates his pale blouse and his brown tunic and breeches. Seen up close—as close as the museum guards will allow you to get to a painting like this—the brocade disappears; you see only, on the right sleeve of the blouse, tight crosshatchings of silvery paint, and, on the tunic and breeches, short and seemingly random brushstrokes—a tangle of strokes, some thick as paste and some chalk-dry. I had to get a certain distance from the canvas before the web of marks and blobs and smears would turn into "brocade," fine patterns of luminous silver catching light and flicking it.

I began to tell Leon this. I explained how I wanted to find that distance, precisely—wanted to know exactly at what point the material turned immaterial, the oil paint turned to "picture." I made numerous visits to the museum. I sneaked up on the painting. I even dragged friends along for their estimates. I paced. But the precise distance always escaped me—where the paint becomes "picture" I never could say.

"What you say is true—that's what you and I can see today, looking at a Velázquez," Leon said. "We see the surface, the effects, and so on. But what did the members of Philip's court see in 1630 when they looked at a Velázquez, fresh from the studio?

"Let's try to imagine it, okay? Now, the members of the court—not an art public as we know it—each might have personal dealings with Philip, and might come away from a meeting or an encounter with him with some individual sense of who he, the king, is. But that surely wasn't enough—not for Philip, and not for those at court. I mean, if you look at portraits Velázquez did when Philip was more a youth, or at portraits others have done of Philip, you get the sense—I do—that he was only incipiently authoritative, despite the intentions of the artists to make him so. Actually, Velázquez probably had a more complicated intention: to show not only Philip's authority, but also the making of a man. But either way, to look at these pictures is to notice a softness to him, okay?

"So what was needed was an articulation of Philip in what you might call his imperial aura. And those who would look at Velázquez's articulation of this—the greatest articulation of this; this was understood in his lifetime—they didn't stand around talking about brushwork. They were interested in Velázquez's brushwork only insofar as it was able—through this incredible vision of his—to lend power and nobility to the king. From a great painting by Velázquez, each would come away with roughly the same idea: The king is great and powerful. And then through copies by his workshop and so on, these images would become the images, the truth.

"And something more: Did Philip learn what royal aura is—how to embody the kingship—from contemplating Velázquez's portraits of him? In a way, you can imagine that he had to live up to them!"

We ate, and the conversation drifted for a while. I was trying to get a grasp on what Leon was really saying, beyond the fact that we were inundated by photographic images, that Velázquez was a great painter, and that he, Leon, could not paint as Velázquez did, not in our time.

I eventually asked, "Now your idea, if I have it right—your idea is that it is the photographers and TV producers and so on who lend the aura?"

"Well, of course it's more complicated than that. Power in the world of seventeenth-century Spain must have appeared more fixed and stable than it does in ours. One ruled, directly or indirectly, with power sanctioned by God, for one thing. And only a few people could have dreamed of having a hand in participating in the power structure, let alone changing it. What I'm saying is this: Even if there was only painting, and no photos or TV, it would be difficult today to paint power with the assuredness Velázquez did. I mean, Goya couldn't do it in 1800, *before* photos. It was already gone. Goya is at the moment where the possibility of a critical point of view begins. And Goya is critical, sometimes subtly, and often not so subtly. Goya hollows out his king, okay? He shows you the corruption—it's there in the faces. And that was before Marx and Freud, and the understanding they gave us of power, its corruptions and drives and underpinnings. There is a skepticism about power now that Velázquez, I

think, could not have imagined, though in a few of his late paintings of Philip—I mean, he had to understand that life at court was not all that it seemed."

Leon paused for a moment, then said, "It is impossible today—and this is connected, no doubt, to what I've been saying about power—to paint something with the unity, the sense of completeness a Velázquez painting has. We know the world we paint is a fragmented world, and we paint it that way. Power, especially, is fragmented, disjointed." He paused again. Then: "Here is what I would say: Velázquez's role as a painter, as the one who took control of his visual world, was to serve power. And I think that those in the mainstream today, the TV networks and so on, I think they ultimately serve power. Not every night. Not every minute they're on the air. But—through all the connections, refractions, self-corrections, self-censorings, and so on—regularly."

Later, over coffee, Leon came back to this idea of power and its visual representation. Earlier in the month the congressional committees investigating the Iran-contra affair had begun their hearings in Washington. Golub was engrossed. He watched the TV news, he told me, for taped clips of the hearings; he was fascinated by the way those who testified looked, their faces and gestures. I thought: *This is the closest Leon gets to the men he paints.* These Americans, many of them, had visited the territory Leon had mapped in his paintings; they knew how power was distributed, how it went about its business "upriver," at the soiled tips of the government's reach. These men had used mercenaries to mold a proxy "contra" army led by former officers of General Somoza's thuggish National Guard. They then sent these contras into Nicaragua (from undisclosed "sanctuaries" in Honduras and Costa Rica), where they mortared villages at dawn (their favorite method of engaging the "enemy"), "conscripted" young men from their cars and trucks along rural roads (that is, kidnapped—the contras represented no legally recognized nation), and abused and in numerous cases brutally tortured Sandinista soldiers they had taken prisoner. And, as was becoming all too clear, these American men in positions of power in this country had willingly and upon little reflection subverted the democratic process at home in the name of fostering it in a small, poor Central American

country—a country that, thanks in no small part to American involvement, had never known democracy in Elliot Abrams's or Oliver North's or even Ronald Reagan's lifetime. The Iran-contra hearings—like the Vietnam War debate, the Watergate affair, and the Senate hearings on U.S. intelligence abuses that took place in the 1970s—were exposing to the public yet again the shameful details of an administration's morbid fixation with "national security" and "international communism," a fixation resulting (yet again) in wanton political cruelties.

Leon was angered, but not really surprised, by what he was learning from the hearings. He struck me as more curious about the process itself, the bringing to light of the affair. Watching the Iran-contra hearings, he couldn't quite get over what he was seeing. "Now, what I was saying about the media and so on," he said, "all the short, silly clips that TV has served up of Reagan over the years, going along with the waving and rehearsed lines and that—if this is true, it is also true that with these hearings, we are witnessing something else. It's incredible, really. In what other country—even in the West; think of France or England—where else could there be such an exposure of power engaged in these kinds of activities? Exposed on TV, photographed in magazines and newspapers. Men who have participated in covert operations, been in the field with mercenaries." He shook his head and laughed sardonically. "You know, when I do the paintings I do, I am telling something real about the world we are living in—about power at the fringe and how it gets utilized. That, as a painter—somewhat on the fringe of my own society, as painters are—I can do. But the truth of these things has been pretty much kept in the dark, in the shadows, and I can understand when people walk into a museum, see my paintings, and reject them as not true, okay? Now I watch these hearings on TV, and I think: These guys are substantiating the paintings I make." He laughed, and then said, "Maybe I should feel vindicated. I'm being vindicated now by Oliver North."

2. WE HAD CONTINUED to talk that night about the Iran-contra affair; and then, just before leaving the restaurant, I had suggested we go to Washington for a day or two, attend the congressional hearings, watch for ourselves. I figured I could arrange for press passes. Could he get away? Interesting, he said. Sure. But it would have to be later in the summer, perhaps in July. At the moment he was still wrapping up the semester at Rutgers University, where he has taught since 1970, and where he was now John C. Van Dyck Professor of Visual Art. Once a week, he took the train out to New Brunswick, New Jersey, and held two graduate-level classes: one a traditional studio course, in which he essentially led a critique of students' work; and the other a seminar in art criticism. There had been a time when he had to teach and resented it, resented the time it took away from his work; but now he looked forward to the day "out," as he referred to it, the hours spent among young people and the chance to talk, as he so much liked to, about the new shows and trends and theories.

In early June, once school was done with, he was going to be headed once more to Europe to attend the opening of Documenta VII. First mounted in Kassel, Germany, just after the war, and now held once every five years, Documenta had come to rival the Venice Biennale as the largest and most prestigious of the international art exhibitions. It is also (like Venice) a ritual, with its days-long opening festivities attended by hundreds of artists, critics, collectors, and hangers-on. Golub had several paintings in the 1987 show, they were to be prominently hung, and he wasn't going to miss it.

Sometime in mid-May, after several phone calls with date-books open, we had settled on a date: Tuesday, July 7. That was the day the hearings would resume after a brief recess built around the Fourth of July holiday. We would have to get to Washington the day before to get press credentials, I told him, because on certain days, depending on the witness providing testimony, press seats could be hard to come by. By the end of June we knew for sure this would be the case. The congressional committees had decided that when they returned to work on July

7 they would begin hearing the long-awaited testimony of Oliver North.

We booked tickets on the Metroliner well in advance for the morning before the hearings, talked numerous times on the phone in the days leading up to our trip, and somehow managed not to talk each other out of it.

Greeting me at the Amtrak counter in Penn Station, Leon commented on my suit and tie. He was wearing his customary slacks and short-sleeve cotton pullover. "I brought a tie, too," he said, with what I took to be mock Bohemian disdain. "I don't like ties." I laughed, and was glad to see he was in a good mood—we had never before embarked together on anything like this.

On the train, settled in and comfortable and rolling through New Jersey on a hot and muggy morning, we read the papers and talked about the hearings. Eventually I managed to weave the conversation back to what we had been talking about at dinner in May—our discussion of the representation, in pictures, of those with power. I was intrigued by what Golub had said, or what I thought he had said. It seemed to me that, wittingly or not, he had arrived at a rough hypothesis: The most powerful figures of any historical epoch can only be represented—represented convincingly—in the most powerful visual medium of their time. Put another way, it seemed that Golub was saying that no painter today could paint a portrait of, say, Ronald Reagan—paint a portrait that mattered. Or, if a painter wanted to portray those with political power, he would have to do what Golub himself had done—move to the outskirts of power, to the world of mercenaries, torturers, and goons.

I tried this on Leon, and he said, "Well, for me this is true. I'm not really capable of painting a picture of power at the center, painting it in a way that makes you understand how that power works." He went on to talk briefly about the dozens of paintings he had made in the mid-1970s of world leaders: Leonid Brezhnev, Mao Tse-tung, Ho Chi Minh, Francisco Franco, Henry Kissinger, Chou En-lai, and others. These are small, hermetic pictures, done at a time when Golub had been deeply troubled about his work, not sure at all what and how he should paint. They would prove to be crucial for him—would provide him with a language with which he could begin to articulate the murky world of those at

the margins of political power. But these portraits are best understood as breakthrough paint sketches—in the sense that they taught Golub anew how to look hard, analyze the faces he was drawing (from news photographs, mostly), discover for himself a way of following his eye and then his line inside his subjects—paint sketches, and not large public paintings. They don't convey the power wielded by statesmen and dictators—looking at them, you don't feel that, or think about it. Golub himself talked of how they seemed to him today to be "about a certain emptying out" pictorially of the leaders he chose to portray. He was quick to add that that was not the kind of majestic painting Velázquez—or even Goya, in his withering portrait *The Family of Charles IV*—was doing. He was not, in his small pictures, "painting power at the center."

"I would not want to say that no painter could effectively do it," he went on to say. "Who knows? But a painting of a president, or a secretary of defense, a painting that truly conveyed the type, the character, the power? What would you do? Men in blue suits? Sitting at a table with note pads?"

Leon fell silent, and we went back to our newspapers. I tried to give some thought to what he had said. There was no arguing with it, really. There had not been a painting like the one he was trying to describe—a painting of power of that kind, or about it—for how long? Warhol's big Mao paintings of the 1970s aren't about political power, but rather about celebrity—the power that comes simply from being famous. They have to do with the sense Warhol seemed to have developed by the late 1960s that merely "Warholizing" any public figure was itself a form of understanding (it was not). I tried to imagine how a painter today might go about making the kind of picture I had in mind. It wouldn't be enough for a painter to have Ronald Reagan, or someone with that kind of power, sit for a portrait. Even if you had a portrait painter who might get "inside," like Oskar Kokoschka; even if you had one, like Alberto Giacometti, who, in his portraits of friends and family—anguished, worked and reworked pictures—revealed to you nothing so much as that a face can never be fixed, "captured"; what might such a painter get from a subject like Reagan? Those with political power, at least in the West, where such power was once painted, no longer embody power. Power

is theirs for a time, and then no longer. This doesn't mean that they do not wield power; they do. But it is not something that a painter's line and color can make palpable. It is not something that can be effectively portrayed—or even, as with Goya, betrayed.

I tried to imagine a portrait painting of Reagan—and then thought of one I'd actually seen several years earlier. At Documenta, in 1982, Hans Haacke, perhaps the most widely discussed "political" artist of our time, had exhibited an easel-size oil of Reagan that was actually part of a large anti-nuclear installation piece—a piece that to my mind confirmed Haacke's weakness on the big issues. His text-and-photo pieces on the art world—its hypocrisies and compromises; its dealings with millionaires and corporations who seek only to launder their reputations by rubbing elbows with artists and their work—can really get to you. Seeing my first Haacke, a work from his *On Social Grease* series— an engraved metal "plaque" quoting Chase Manhattan's David Rockefeller: "Involvement in the arts can provide a company with extensive publicity, a brighter public reputation, and an improved corporate image"—I chuckled, then grew indignant, then was forced, finally, to think through and knit as tightly as I could my argument for why art (despite corporate America's increasing and increasingly self-serving role in its exhibition) mattered as much to me as it did. (This was not Haacke's intention, I came to understand.) But when Haacke ventures outside the art world, when he addresses not art politics but national and international politics, he can't seem to find the means to jolt and jangle a viewer effectively. For Haacke, as for most artists, it's too much a knot out there. Pictures can illustrate complex stories you know by heart—this is the case with most religious painting— but pictures cannot *tell* complex stories. (Haacke would seem to have some recognition of this. Many of his pieces have as a major component lengthy wall-mounted texts.) They surely cannot tell "counter-narratives," complex stories told to undermine your belief in the stories you have been socialized to know by heart. There is just too much explaining to do. You wind up constructing a half-truth, a too-easy truth—political kitsch.

Haacke's Documenta installation is an example of such kitsch. Across from the portrait of Reagan, Haacke had hung a big

blowup, from a photographic contact sheet, of German anti-nuclear demonstrators, and in the photo, there's a big banner, on which you can read the words "Reagan Hau Ab" (Reagan Get Lost!). A length of red carpet led from the mural-size photo to the small Reagan portrait, in front of which Haacke had placed a pair of brass stanchions and a velvet rope. Reagan had visited Bonn a week before Documenta opened, and the piece seemed to be making the point that Reagan alone, in his cordoned-off little world, wanted American-built Cruise and Pershing II missiles to remain in Germany, and that "the people" did not.

Haacke's is a post-minimalist piece, but it nonetheless embodies reductionist politics. The story of the "Euromissile crisis" was much more complicated than relayed by Haacke's pair of images. It was German Chancellor Helmut Schmidt, a Social Democrat, who had asked the United States for the missiles in 1977. He feared that Moscow's recent deployment of SS-20 intermediate-range missiles in Eastern Europe had upset the nuclear balance, and he feared that the Carter administration (which was expressing no worries about the SS-20s) had decided to begin "de-coupling" its own defense from that of Western Europe. It was Schmidt and other European leaders, worried about a rupturing NATO alliance, who brought pressure on Carter (who was having a rough time all around with Schmidt), and it was Carter, not Reagan, who had agreed at NATO's urging to provide the missiles.

And what of Haacke's portrait of Reagan? Haacke is said to have hand-painted it from a photo, but photo-based or not, this isn't the Reagan who spoke in Bonn—or, for that matter, the Reagan who comes to mind when we consider his administration's positions on nuclear weapons. The portrait was a takeoff on heroic Soviet paintings of Stalin, dark and somber with academic chiaroscuro effects and a licked surface, and it was lost on me. Perhaps Haacke was constructing an easy visual equation: The resurgence of painting in the 1980s is to Reaganism what the younger tradition of news photography is to progressive populism. Could he actually believe this formula? In the production of the abominable Reich's grand illusion, in the "imaging" of Reagan himself, could he not see to what ends power has used the news photo?

The Reagan that Haacke painted—chin raised, face tightened, tough—is not the Reagan who embraced a dreamy plan for a space-based missile-defense system. It is not even the Reagan who stood before the Bundestag and defended the decision to station the missiles in Germany. The West German parliament saw the charmer, the pitchman for somebody else's agenda—"To those who march for peace, my heart is with you," he intoned, reading with practiced sentiment the lines another had written. Reagan was never fascinated by the nuclear "option" in the way Nixon was; the defiant Reagan portrayed by Haacke might have been standing up for tax cuts, or for one or another of his close aides under investigation for corruption—but not for missiles. Four and a half years after his visit to Bonn, at a superpower summit in Reykjavík, Iceland, Reagan would walk out of a meeting with Mikhail Gorbachev apparently having agreed to eliminate all nuclear weapons within ten years—an agreement his closest aides, panic-stricken, managed to talk him out of. (From the account of National Security Adviser John Poindexter: "But John, I did agree to that." "No, you couldn't have." "John, I was there, I did.") This "real" Reagan was not the Reagan portrayed by Haacke. Haacke had wanted to make a point, no doubt, about the arms race, had wanted Documenta visitors—whom he imagined, I suppose, were "escaping" the dilemmas of the real world by visiting an art exhibition—to confront along with the many new works of art a crucial political issue. Haacke and I probably thought pretty much alike on military and strategic issues; a few days before arriving in Kassel, I had spent an afternoon in London's Hyde Park participating in a huge anti-nuclear demonstration. The arms race, the Reagan administration's policies—these were extremely important issues. But Haacke had failed to represent them meaningfully. Sitting on the train with Leon that morning, trying to think of what picture I had seen that best portrayed Reagan, I could recall only one image, a widely reproduced photograph from the 1984 Republican convention in Dallas: Nancy Reagan, at the podium, waving at the president, who is not actually "there" but on a large video screen, waving from his hotel room, where he is watching his wife on TV. A photo of a staged "image" that itself depended upon TV pictures

for its "realization"—this was truly Reagan, if not the only "real" Reagan.

The train was moving slowly into Philadelphia's Thirtieth Street Station when Leon spoke up again. "Let me tell you something I've never mentioned to you. I tried to paint the strangest picture once. A big picture of power. Kissinger on one side. Brezhnev on the other." I cracked up, and Leon did, too. "No, wait, I'm not finished." He was laughing hard, gasping the words. "How am I going to do the power thing? Lions! I actually get photos of lions and draw them in, okay? Symbols of power, like in an Old Master painting. Now, I realized pretty quickly how ridiculous this idea was. I mean, lions. It's an advertising idea these days. But at one time it could stand for imperial power." He paused for a moment, and I imagined he was thinking back to the time when he had tried to make this painting. "It sounds crazy, right? But sometimes when your work is not working— and this was before I started the *Mercenaries;* my work was not working—when your work is not going the way you like, sometimes you'll do crazy things. You'll do almost anything."

3. IT IS NOT a long walk from Union Station in Washington up to the Capitol, but it was even more sultry there than it had been in New York; we hopped in a cab. The short ride gave me just enough time to brief Leon on how I planned to assure our getting into the hearings the next morning. The press office could guarantee us credentials for the hearings. However, a press aide I'd spoken with the week before had warned me that North's first day was sure to attract more reporters and photographers than could be accommodated in the Senate Caucus Room. Members of the press might have to be rotated in and out of the room, I explained to Leon; some might simply be turned away and politely asked to return when a less-celebrated witness was scheduled to testify. I told Leon that it just would not do to say we were down from New York to get a close look

at a man who hovered on the edges of his paintings—to sit and talk and muse on power and its representation. We would have to look busy. Perhaps he should say he was with me in order to do drawings for a story I was writing.

"Sure," Leon said.

But all the excitement was suddenly gone, or so it seemed to me. (Later, when I asked Leon about it, he said, "I never felt upset.") I felt as if *he* felt he had been led on, and was now catching on.

He said, "That was an interesting talk we had. You know, we could always just spend the afternoon in one of the museums if we don't get in."

He then looked away and out his window and said no more until the cab had dropped us in front of the Capitol, and we were up the steps and inside, roaming the cool, polished corridors in search of H304, the press room.

Eventually we noticed down one long hallway a cluster of noisy, milling men with cards dangling from their necks: There we were. It was a small office, and it was bedlam—there were stacks of forms and pleading journalists and incessant phone noise. I got the attention of one press officer and explained our situation. Leon hung off to the side. Maybe ten minutes had gone by when he approached the desk and asked for a *Yellow Pages.* He had had it, I figured, and was calling the train station or the airport to find out about New York-bound departures.

"I forgot," he said. "I forgot I need to find an art-supply store. Anybody know if there's a good one nearby?" Then, directly to the staffer helping me, he said, "I need some pencils. A good sketch pad and some pencils."

Somebody produced a *Yellow Pages,* and when Leon went to the corner of the room to sit and thumb through it, I followed him.

"Leon, don't worry about the supplies. Come tomorrow, if and when we get inside, nobody's going to be checking if you're actually making sketches."

"What—you think I can't do it?" He grinned, and I felt relieved. He jotted down the names, addresses, and phone numbers of several art stores, and as he did, he told me about how he still on occasion sketched from life.

"Little things. I did a painting not too long ago where I wanted to have the guy holding a gun just so, okay? I had it in my head, but I didn't have just the right photo. So I had my assistant buy a toy pistol and stand there with it in front of me, and I drew the gun and the gesture." He would call the art stores, find one we could stop off at on the way to our hotel. "I'll have a little fun."

It took me another half hour to straighten out the press-pass situation. We would both have to be photographed and issued press tags at seven the following morning. I would get a seat. Leon would be placed in the photographer's pool, and the press office would try to find him a spot up front in the room, where he could look at Oliver North and draw him. "We don't get many requests from people who want to draw," one of the press aides said as we were leaving. "That's more courtroom."

We found a cab and asked the driver to take I Street, where there was an art store open late. It was nearly six o'clock. "Not even much of a courtroom phenomenon anymore, really," he said, as we moved slowly in rush-hour traffic. It took me a moment to understand that he was talking about drawing, picking up on what the aide had mentioned. "A student of mine, for a paper in the art-criticism course, did research on courtroom sketch artists—went and interviewed them, some of the old-timers. They're disappearing like everybody else who draws. Most states are letting photographers, even TV cameras, into the court-room. And is this going to change the way trials are conducted? Are defendants and witnesses going to be coached for the cam-eras, told to dress for the cameras and so on? One would have to think things will be different. Have to be."

Later that night, after dinner, when we were watching the eleven o'clock news at the hotel on the lobby TV, Leon came back to this idea.

"The ability to simply render the world is not the job of the artist today," he said. "None of those who call themselves realists can do what a camera can do. No way. What an artist must do is see something else—something the camera cannot see. That is not something you do with your eyes only."

4. THE SENATE CAUCUS ROOM was much smaller than I'd imagined from seeing it on TV—it reminded me of the high-ceilinged dining rooms you find off the lobby in fine old hotels—and North himself seemed smaller, too. It was about ten minutes before his testimony was to begin, and I was with the rest of the reporters and photographers crowding around him. As I watched the news the night before, the stock footage that had become so familiar—North waving from a car window, speeding off; North walking briskly into or out of an imposing government building—he had appeared large and unapproachable. "When the camera is only glimpsing someone like it's glimpsing North here," Leon had said, as we watched the news, "it creates mystery—and that's a kind of power."

But now, minutes before he was to begin answering the questions of committees' counsels, he didn't seem mysterious or powerful at all. He looked nervous, boyish. The tunic of his olive marine dress uniform billowed a little too much below the belt, as if he were still growing into it. His complexion was that of a man forgoing fresh air and sleep. When he grinned anxiously, in a sudden flash, at a reporter's question—in the TV clips, I'd never seen him smiling—he revealed a goofy-kid gap between two of his front teeth. I scribbled in my notebook: *He looks like he's waiting outside the school principal's office.* . . . And when the committee members had found their seats, and the room had fallen silent; and then Senator Daniel Inouye of Hawaii, who was chairing the hearings, had asked North to rise and be sworn in; and then the hundreds of cameras all around the elegant room—hand-held above photographers' heads, on tripods, with their electronic shutters flashing and whirring countless times, the sound like that of locusts—at this point, I was sure it was the beginning of a long, sad morning for the lieutenant colonel.

I was sure that the cameras—the film and TV cameramen, as well as the still photographers—would take their revenge. They had been kept at bay and did not like that. They would probe, shoot, get North. In the cab that morning, as we'd skimmed the papers on the way up to Capitol Hill, Leon had said, "A guy like North is used to working in the shadows, behind the scenes. It'll

be interesting to see him in the light. In the light, just sitting there. He might wilt."

Leon was not going to get "rotated" into the hearing room until after the lunch break. There was a TV downstairs in a room set up for the press; I could find him there, he told me, after the morning session. We'd have something to eat and compare notes. Sitting on a folding chair, squeezed in with the other magazine reporters—North was maybe twenty feet from me—I was reminded time and again of what Leon had said about North's being brought to light. Leon's intuition had been keen. Wilting? North was cracking. The nervousness was there in the way in which he groped for a convincing-sounding "voice," veering from hokey slang (*like* me) to words and sentence constructions he must have believed would sound formal and efficient (*respect* me), but they struck the ear as awkwardly stiff: "[T]his is apparently one of the transcripts of tape recordings I caused to be made." The nervousness was there, too, in the boyish way he could not bring himself to say that he had lied:

> There is much of what is in the paragraph that is false.

> There is no doubt that the paragraph has several inconsistencies with the truth.

> [I]t wasn't made accurate . . .

But more eerie (and just then, of more interest to me) was his gesturing and tone, his way of carrying himself, the image he was projecting. He seemed to be trying out different attitudes, different ways of presenting himself, not to the committee members, not directly, but to the cameras that surrounded him. It was as if he realized that his real battle was with them. He was sparring with the cameras, punching, feigning, retreating, keeping them off balance. (Photographers I spoke with later outside the Senate Caucus Room had this sense, too.) He would look melodramatic, then cool, then angry, then hurt. He tilted his head, stared, bit his lip, held his head in his hands, pointed emphatically—all in ways that seemed to me, and to the members of the press around

me, exaggerated, wild, phony. (A reporter for National Public Radio whispered, "I think he's really losing it," and we all nodded and chuckled knowingly.)

This wasn't a role North had wanted to play—explaining his actions, and himself, to the public—and he was trying desperately to get into character. His entire morning's testimony, two and a half grueling hours, might have been for him one extended answer to this question: How did I get here?

I met Leon coming out of the press room, and he said right off, with a certain excitement: "He looks impressive. Impressive."

This wasn't sly sarcasm—that wasn't Leon's way. I didn't get it at all. "What do you mean, Leon?"

"Let's eat something and talk." We walked down the hall to the Senate cafeteria, where we grabbed sandwiches and found a table.

"I thought North was a mess," I said.

"He didn't look it," Leon said. "Not on the TV I was watching, anyway. Right off, you have him sitting there, and the camera, the one on him, is on his face from a low angle, pointing up. That's always a flattering angle—the heroic angle, okay? And then—then you've got this situation of one guy against the pack. North versus the politicians, who are ganging up on him, or siccing their lawyer on him. Okay, now you add to that a chest full of medals, the uniform—I'm just talking about what I saw now, how it looked—you add this up, and you have a pretty nice package. And I was watching on this old black-and-white."

"He didn't look phony to you?"

"Well, I could be wrong, but he didn't *look* phony. I mean, I think he is a phony, but he didn't look it. To look phony, you have to look nervous, defensive—like you have something to hide." Leon had pushed his chair back now and was gesturing with his hands, carving North's portrait in the air before him. "What I got is this odd mix of maturity and immaturity, and thought and action. A certain defiance, okay? But also loyalty. So he's complicated. Complicated looks good. You get a sense of how seductive he must have been in and around the White House. How Reagan must have admired him. He must have played Reagan like an instrument."

5. I WATCHED FOR myself that afternoon, sitting in front of the press-room TV, studying the images closely. Leon was right, of course, as the polls would confirm in the days that followed: North on TV was seductive. Being so close to him, seeing him "live," I had simply missed it.

It all looked so different on TV. The camera isolated North as the human eye—as someone watching him testify inside the Senate Caucus Room—would not. It turned him into a "talking head," with all the reasonableness we attach to such an image. And as Leon had mentioned, the camera had a way of constantly tugging your eye down to the busy pattern of decorations pinned to North's chest. (This was especially true if you were watching "in color," I noticed, when I tuned in later in the week.) North had faced fierce combat in Vietnam, had been wounded more than once, had earned many decorations, including the Silver Star for valor. However, most of the ribbons pinned to his tunic during the days he testified had nothing to do with combat, and the TV cameras had no way of sorting this out for you. North had chosen a fine prop, a "chest full of medals," to lend him a hero's "look." And it worked.

His wearing a dress uniform was similarly a prop, a costume settled upon. While working at the National Security Council— while secretly raising money for the contras, running their supply operation, at times giving them military advice in the field by phone—he never wore the uniform. A number of writers later made the point that the uniform was an obvious ploy by North to signal his loyalty, patriotism, and service to his country. But the uniform made another, less-pointed suggestion: Like the ribbons and medals, it asked us to remember Vietnam. These were the work clothes of a man who continued to fight communism. Fighting in the jungles of South Vietnam, secretly and perhaps illegally supplying the contras (among other things)—these were of a piece.

What the close-up shots didn't do to stir sentiment for North, the flow of pictorial juxtapositions during the coverage did. In effect, the cameras—or, more precisely, the news directors assembling the live feed from the various cameras positioned

around the room—seized the narrative thrust of the hearing from those doing the questioning. The lawyers, and later the committee members themselves, might have fared better if they had kept to a "script"; instead, they rambled, repeated themselves, and for the most part proceeded with no clear sense of direction. It was up to the pictures now to tell the story, hold the audience, and they did. In the absence of a narrative built on what North had done, there appeared the narrative of what, in the caucus room, was being *done to* North. It was the old story of the loner fending off the gang. Seeing a shot of North, up close, and then one of the committees, seated in judgment "above" him, I was witnessing an underdog beset upon. The question was not What did he know? or even (as I had thought sitting near him hours earlier) How did he get here? Rather, it was: Can he fight off the politicians? (Senator Joseph Biden, who was not a member of the Senate Iran-Contra Committee, made note of this. Later in the summer, preparing to chair the confirmation hearings of Supreme Court-nominee Robert Bork, Biden saw to it that the senators sat at floor level, not above those testifying. Bork, for his part, ignored the administration's media advisers who pointed out that his beard and rumpled suits might not go over well on TV. They didn't. Countless Americans complained that Bork looked "flaky," or "didn't look like a judge.")

The low camera angle on North not only captured him in the classic heroic upturn; it somehow managed to chisel his cheeks, and to pull your eye to his thrusting jaw—that is, on TV North looked not boyish but Hollywood handsome. Once I was able to get beyond my own "live" impressions of him and actually see this, I began to understand as well that he hadn't been simply wilting or cracking or looking for a "voice." He wasn't "there," responding to the committeemen, at all. North was talking in a way that led you, the TV viewer, outside the context of the hearings. It wasn't that his responses so often did not connect to the questions being asked—that was a response you would have only "live." Out there, in the bigger audience, I saw his answers connected to something else: the world of American pop culture, the world of movies, pictures, images. When he got mock polite with John Nields, chief counsel for the House Committee, it didn't seem "off," as it had earlier that morning; it conjured an image,

that of Clint Eastwood—and then, the sentiments one attaches to that image. When North did his hick bit—his saying his wife Betsy called him an "old buffoon" was a wonderfully resonant instance of this—he was Jimmy Stewart, homey and honest. He was Stewart as well in the long-winded lectures on patriotism and what the country stood for: Stewart filibustering in *Mr. Smith Goes to Washington.*

But mostly—and here the summoning of images was truly astonishing—it was Reagan, pure Reagan: the befuddlement, the shrug, followed by the anecdote that didn't so much answer the question as smother it; the timely catch in the throat; the references to himself in the third person (a locution that has this effect: Using it, you at once seem self-effacing and let your listener know that you are your own greatest fan); and most important—the elevation of sincerity to a high ideal. Reagan played sincere men in Hollywood; he learned the look and capitalized upon it in political life. Now North was taking the cue. How do you look sincere? You personalize. In North's case, you make sure each question registers on your face as having been felt, not simply heard; and then you answer with feeling—or, better, with mannerisms that will easily register as "feeling," as "sincerity," with your audience. (And it was an audience, not a public "out there"; North's act, along with the news editors assembling the montage, was assuring that.)

This is the kind of meaning the subject of a photo image can force a camera to create. North was fighting the cameras by offering them stock poses, flashes from old film stills—pictures from the great American narrative. And all of this, if only for a while, was accepted as "real." Later the public would spurn North as blithely as it had fallen for his TV personality and embraced him. But for long enough it worked. Committee members learned quickly how well North was "going over." By the end of the week they had backed off. Their pursuit not of the facts or the truth but of him—that was what it looked like; that was what it had become—was creating the wrong image.

6. LEON AND I had agreed to meet back at the train station for the six P.M. Metroliner. He was there in the waiting area when I arrived, and he was ready to go. He'd watched the hearings inside the Senate Caucus Room, but not for that long. "It was more fun on TV," he said. He'd spent most of the afternoon at the Hirshhorn Museum on the Mall. He was tired now and was looking forward to a nap.

We talked for a while on the train. Leon had been able to get closer than I had—he'd sat and sketched North, from a spot right near the TV camera, for close to an hour. He had done four or five sketches, but, he said, they didn't amount to much. "I had such a lousy vista—not even a decent profile, let alone a solid front view of his face. I found myself drawing because I'd been let in to draw. But it wasn't set up for someone to draw. It was set up for cameras."

He handed me one of the drawings, a side view that got the squarish line of his jaw, but little else.

"Really bad drawings," he said. "I know what you meant now about how he looked in there. But I couldn't get that in the drawings. If I had a photo to work from, maybe I could do something with him. Maybe drain him, you know? It gets back to what I was saying yesterday about conceptualizing. You get this visual information and then you look hard and you work at it and maybe you get something."

Later, after we'd had a snack, we talked more about painting and TV and the power of images.

"It's funny about TV," Leon said. "It's powerful and it isn't. It does have this incredible immediacy—instant impact, everyone seeing the same thing. TV cameras right out in the battlefield, okay? I remember the impact that had back in the sixties. And I don't believe you get numb to these images. I think they do affect us. They become part of who we are. But then what happens down the road? The thing about TV is: The pictures are at once intense and fleeting. They have impact, but they fade. They're gone. Do you go to a museum and look at TV footage made twenty years ago? Can you recall specific images you have seen on TV? It's like old news.

"In a sense that's where something like painting is still a plus," he went on to say. "There is the impulse in our society—the West, if you like—to preserve painted images. Does this have to do with paintings being worth money—with status and so on? Sure, sure. But still the impulse is there. And it's not just the money, or the museum system, institutions: For hundreds of years now, society has found a way—often against all odds—to preserve paintings. Not all of them. But many of them. And I would say many of the best. And the thing is, too: Every painter knows this. Is extremely conscious of this. And an artist who says otherwise"—Leon began to laugh now—"well . . ."

"How do you think about this, your paintings lasting?"

"Okay, if you're honest with yourself, and most artists are, you know that you aren't going to have the last word. I can hope to be collected, to have the work preserved, saved, not junked. But after that? There's so much beyond your control. You're gone. Taste and such changes. Your paintings may be ignored. Or, your paintings may get completely re-evaluated. They no longer see what you hoped they would see. Or people see things neither you nor anyone in your lifetime saw. Maybe the paintings are kept around long enough so that someone comes along and 'sees' them, gets what they're about, okay? Maybe. Maybe not."

Leon grew quiet; I think the conversation was edging beyond us. The painter—no longer at the center of things, as Velázquez was; working alone for the most part; making pictures society is not demanding—struggles to make a handful of inspired images. A few painters do; most do not. Every painter understands this. A painter's life is not haunted or determined by this (though some have been, and some continue to be). But this stark truth does make an impression on the lives of all painters. It is a weight, a private one—one painters talk about among themselves, or more often keep to themselves.

Now Leon said, "If you don't mind, I'm going to take a little nap." He got up and lay down on the empty seats across the aisle, knees raised to his chest, his cheek resting on his overnight bag. He looked vulnerable to me. And I told myself it was only because he was going to sleep, that we all look that way then.

V
GOLUB'S
STUDIO

AUGUST · 1987

SKULL,
1947

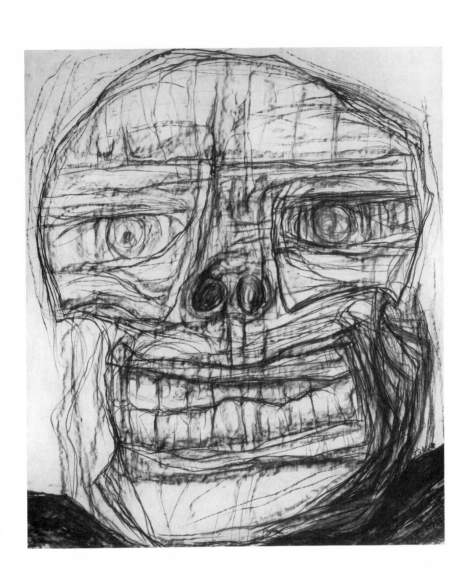

THE PAINTER SPENDS his days alone, thinking and looking and marking—and then, as often as not, erasing or otherwise obliterating that mark; this to begin again, to make it right (and he may not know for sure what "it" is until he sees it), to make it right for himself. The conversation is the silent, incessant one: the painter answering to himself. He learns to do this early on, when it is pretty much all he has. And if later, success or the sour lack of it gets him listening for other things, other voices—fashionable trends, the market—it is not that he is no longer his own man (or she her own woman); it is not a matter of having lost the way. The painter has simply made a choice, and when he is alone, in the studio at work, he knows this.

2.

LEON PHONED ME not long after we'd made the trip to Washington. I should come by some evening, he said. We should have dinner. I got together with him after work the following week, a muggy August evening. Nancy was taking a nap; he would wake her when we were ready to go to the restaurant. He poured me a glass of wine and ushered me through Nancy's studio to the small room, the office-study, at the front of the loft. It is the type of room—or, in some cases, simply a nook—that can be found in the lofts of many painters now, the successful ones, anyway. File cabinets; correspondence to be answered, and a scale to weigh it; a wall calendar scribbled with reminders—

there is so much to being a professional artist, so much to keep track of. In rooms like these, at times, as much as in the studio, you get a sense of what it is to be a painter today—a sense of what the world, that small part of it that cares about painters, wants from them.

I sat at the desk, modern and white, and Leon sat in a chair next to me. The blinds were drawn and the desk lamp was on; the room felt closed off, hushed. We talked quietly of this and that, and drank; I glimpsed a file tray on the desk labeled "Medical" and quickly looked away.

Leon, after a time, brought up the Iran-contra hearings. "It was fascinating for me, really fascinating, to see this kind of thing up close—to see that whole scene down there," he began. "But . . . well, I'd put it this way: Something like this is not what I'm about, when you get right down to it. What I mean is, I can't really get much from something like that. Not that I expected to, actually. It's just that the trip had a way of making this clear. . . .

"Now, part of this we've talked about—about how I can get more from a photograph, one of North or anybody, than I can from actually being there. But it's more than that." He paused, sipped his wine, then continued: "When I began painting, in the early fifties—the paintings I did when I first got out of art school—at that time I had no real understanding of politics and history and so on, the role of the United States in the world, what my role as a painter might be with regard to this. There were certainly political things going on—McCarthy, the witch hunt for communists—but I didn't take much notice. What I mean is, I didn't take much notice as a painter. I knew these things were going on. And I had a very definite take on them—I would read *The Nation* when it came in the mail, and I more or less subscribed to their world view, okay? But that had nothing to do with me once I began to make a painting. Painters in general at that moment were not concerned with political things. This is something that had been tried in the nineteen thirties—the depression-era murals, and so on—and abandoned. By the fifties, it was long gone."

I ran through my mind a personal catalog of pictures, mostly forgettable: "Political Painting of the Fifties." An Alice Neel

painting of the Rosenbergs. Fernand Léger, I seemed to remember, did the Rosenbergs, too. Picasso's disastrous *Massacre in Korea* (1951)—perhaps the most famous "political" painting of the time. The formal schema of the painting is lifted from Goya's *Third of May:* to the left, innocents about to be executed; to the right, the firing squad. But Picasso's picture has none of the careful particularities of Goya's (this face, this moment, this injustice), and, as a result, none of the tensions that convince. Picasso shows us a small group of mechano-brutes (naked, save for medieval-looking helmets) poised to fire upon four Picassoid nudes (two of them pregnant) and their babies in the kind of pared-down landscape (hill, road, sky) one sees in the distance in many sixteenth-century German paintings. It is a mess and, given its title, a pictorial lie—one of the worst pictures Picasso ever painted.

I asked Leon why he thought artists in the 1950s were, for the most part, not interested in politics, history, the world out there.

"Well, there's no one answer. I would just say that if you look at the whole picture then—society in the fifties—there's a certain insularity to everything. On that level, artists were no different from everybody else.

"But the thing is, I was interested in power—or at least it seems to me, looking back. Sometimes when you are painting you can only understand what you were up to later on. But I do think I was interested in power—not political power, but power as it manifested itself in individuals. And not only power, but what you might call its flip side, vulnerability. I was interested in the forces within us, the irrational aspect of life, that edge. And in truth that is still a part of me, this interest in the irrational. And it is something I don't want to deny. What I'm saying is this: In the fifties when I started out, I painted various kinds of 'monsters,' creatures part man, part animal. Monsters powerful in a not wholly human way, but still vulnerable the way a man is, sensitive to certain things, having certain weaknesses. And in the eighties I painted other kinds of monsters—torturers and death squads and the kind of guys that an Ollie North controls, or tried to control. You see, because these guys are in some ways monsters, have that edge, he never could control them fully. And

that's the case all around the world with our power—we need the services of these monsters, but can't quite control them."

I told Leon I wasn't sure where he was going with this. Was it that he painted pictures about political cruelties now, and before, in the fifties, paintings about more personal, existential cruelties?

"Okay. My point is that the monsters I did in the fifties, and those I've done more recently, are not that different. And beyond just what I do, I'd say that this human notion of the irrational— a fear of it, and a fascination—goes back to the very beginnings of man, pre-history. It has always fascinated artists. It continues to fascinate me as a painter. And though I see the paintings I've done over the past ten years as my most crucial work—what artist doesn't think his last work is the most important?—I may at some point take a break and return to painting the kind of monsters I used to paint: monsters that are more symbolic, less historical, you might say. . . .

"Now, if I were to do this, would it be to reinforce the idea that I've been up to the same thing all along in my paintings? Would I be doing these less politically specific monsters to create some great synthesis of my work? Sure, people might say that. People might say: 'Here this guy was finally after all those years making paintings that made sense. Now what the hell has happened to him?' "

I felt that Leon was holding up both sides of the conversation just now—that he was sensing my unease at the thought that he would abandon making the kind of paintings he had been making for the past ten years, paintings that were in some way at the heart of our friendship. Why was he talking like this? I knew that Leon, like all of us, managed to hold a large number of irreconcilable views simultaneously. I had never found him more paradoxical or self-contradictory than anyone else. It is just that—and I was seeing this now, so clearly—that Leon is so comfortable with contradiction, even revels in it. His paintings of the past ten years were different from those he had done in the 1950s, at the beginning of his career; he had a certain understanding of history now. But they were not so different, really; he had always painted monsters and their victims. If there is anything to the notion of an "artist's personality," and I am not

at all convinced there is, this would have to be a considerable aspect of it: the delight in, the cultivation of, paradox. And Leon and I were simply different in this way: I wanted him and his work—much as I wanted my own life and work—free of paradox. My inability to jump in and say something was my inability to vault a chasm. I nudged the conversation to a less personal plane.

"What about this synthesis you mentioned?" I asked. "Do you believe that you or any painter has this kind of career-long theme it can all be boiled down to?"

"Well, it is true that when I look back at my work, I see this duality: power and vulnerability. But day to day it's not something I think about. You don't think along those lines. You think of what you're working on today. You have to have something waiting to engage you, something you want to do. You just get down to work. You have to have ways of challenging yourself. You have to keep it interesting, have fun—it's a lot about pleasure, however disturbing the paintings you're actually making. It's probably about sublimation, too, okay? Working out my aggressions and so on, okay? I can handle that."

He paused a moment, then said: "Am I pretty much the same guy in front of a canvas now as in the fifties? Intellectually, I would say no. I know enough about what there is to know about personality, psychology, to say that we are multifaceted, that we are all different in different situations, different eras, around different people—that we are contingent, my favorite word again. But another part of me—the one that keeps painting these monsters, okay?—that part says yes. Why do I paint these ugly things? I don't know, or don't know if I want to know. Yet I do know, or think I do. The ugly, the irrational, in paintings 'explain'—that is, make visible to us for some sort of recognition—the unknowable, our fear of the unknowable, of fate. This is something we so often refuse to recognize. But in recognizing this, maybe we can squeeze out some solace, some hope, some beauty, even."

3. How DO WE know the lives of others? We don't, except in the rarest of instances—and even then, perhaps, what we are really saying is that we have certain assurances, without which we could not get by. Or approach it this way: Imagine a friend looking upon your own life, telling a story about the work you have gotten done. The motivations; the interactions of history and temperament; the desires and accidents—what could this friend of yours get wrong? What could he or she begin to get "right"?

"It'll be interesting what you make of it," Leon had said when I first told him, not long before we went to Washington together, that I wanted to write a book about him. I began carrying a tape recorder with me whenever we were together, began talking to others about him, turning up things in libraries and archives he had forgotten about long ago. I would be "making" something— it would not be his career and work, but my book about it. In no way could "Leon Golub, painter" be fully recovered, under- stood, narrated. Nor did I have an interest in doing this. I had seen a few paintings in 1982, and I had wanted to know who painted them, and why and how; I had gotten to know the painter, I had gotten to know how he painted—and, to some extent, why—and now I had a desire to tell a story about it.

But it wouldn't simply, wholly, be my story: Golub's paintings were at the heart of it. And Golub himself was shifting the nar- rative. He would start a new painting, or think about starting one. Or he would tell me, as he had now, that he had always painted monsters, right from the beginning. And so that evening, in August 1987, we got to talking carefully about things that up to this point we had discussed only in passing. We went back to the beginning.

4. "I WAS BORN in Chicago on January twenty-third, 1922," Leon began. "My father, Samuel, was a physician. He had a small private practice, and also worked for the city of Chicago as a public-health doctor. I think he liked the work. He put in long hours, I remember. He had wanted to study drama, I think, perhaps be a playwright. He was born in the Ukraine, not far from Kiev, in 1883—I actually know little of the family's history, but this I am pretty sure of. His parents had a shop in the pale. The family was extremely poor. And then there were the pogroms, and he came to the United States in nineteen hundred—he was seventeen. Our neighborhood, on Chicago's West Side, was mostly Russian and Polish Jews. Now, how my father had gotten this desire to be a playwright, I don't know. But given his situation, in Chicago now and so on, he wasn't going to study drama. He did manage to study at the University of Chicago, working his way through. And then he practiced medicine. It was him and two brothers here—that was all the family he had."

Golub told me that his mother, Sara Sussman, had come to Chicago from Lithuania.

"Her family was different—there was a long line of rabbis. Her father, my grandfather, was a *sopher,* the scribe who made the Torahs. And I can remember a big story in the family was how one of these rabbis—he was an important rabbi, from Poland or Russia—this fellow had been greeted in Washington by Calvin Coolidge."

I asked him if his household had been a very religious one.

"No, not at all, really. We were not very observant Jews. What I remember—what I have a picture in my mind of—were my mother's relatives sitting around the apartment. I have these vague images of aunts, cousins. It was a bookish home. My mother was a reader, and especially later in her life she liked reading about the experiences of Jews. My father was a reader. Me, too, of course. But it wasn't religious reading. I guess you could say we were secular humanists."

Any brothers or sisters?

"A sister, Gail. Older than me. She's no longer alive."

There were a number of different apartments on Chicago's West Side where they lived while he was growing up, Golub said. Roomy enough places, as he remembered them. His father's work in the 1920s, Leon said, enabled the family to live "a basically middle-class existence. But I can remember so little of that time— so little about a lot of things that have happened to me over the years. It is not simply a matter of getting older and forgetting. It's a real problem. I'm willing to grant to anyone who asks at any time that I don't remember because I don't want to. Selective memory. But it's more than that. There's a lot I should remember that I don't. So strange.

"I was introverted," Leon went on to say. "And indulged— not in the sense of having things bought for me all the time, but in the sense of there being an openness to and encouragement of my interests. I had little interest in sports and there was no pressure to play. If I was reading, I didn't hear that I should run outside, get some fresh air—that kind of thing. Now, again, this is how I assume it was, how I have reconstructed it, you might say. Specific incidents I just cannot recall. I was an okay student in grammar school, just okay, and that was indulged, too. Also, this being introverted, I suspect it had nothing to do with any shyness on my part—it was more a kind of superiority. I think I thought pretty highly of myself. The embarrassments we all remember from childhood? Mine have mostly to do with discrepancies between my claims and the results. Wanting to run the whole show—I remember a school play once when this happened—and then not pulling it off. And retreating."

What were his "monsters," then? What were his night fears? What terrified him in the dark rooms that terrify most children? I wasn't going to know. (And would he have told me if he could recall them?) I consoled myself with this thought: A man who paints big pictures of torturers, mercenaries, and death-squad goons—someone who paints at all—is not explained simply by what kept him awake long ago.

Leon did tell me of how his father had died when he, Leon, was twelve. "It was an infectious heart disease that is now curable," he said. "When he died, I had difficulty handling it." And when telling me of how his mother had died not long before I had met him, he called her "gentle," a word I had never heard

him use. And this has to matter, of course. It is just that to speculate as to how seems a diminishing act.

5. I DO KNOW that Leon was not a prodigy. When I next saw him, on another warm August evening at his loft, he showed me several schoolboy drawings he had saved, and they were typically stiff, rote. But then, few painters have been prodigies. The expectation that a painter might be a prodigy, or should be, owes something, I suspect, to Giorgio Vasari, who in the sixteenth century wrote the first "lives" of painters—his prose sketches of the great Italian masters. There is the story Vasari told of Giovanni Cimabue's idly sketching in his books instead of reading them, dreaming up pictures of men and houses and horses as if he'd been visited, been given the gift. And there is Vasari's story of Giotto, discovered in a field (by Cimabue!), a simple shepherd boy, innocent and possessed, sitting and drawing from nature with the point of a rock on a smooth piece of stone. Vasari established the "painter's childhood"; what he sought or invented, we seek or invent. In our own time the story of Picasso, the gifted child, looms. It is said (the source is his mother) that the first noise he learned to make was *piz-piz*—for pencil in Spanish, *lapiz*—and that he could draw before he could speak.

Leon remembered drawing at a very young age—is there any one of us who doesn't? But when he continued to draw, and to like it, and then asked one day if he could take art classes, his parents encouraged him. "There were Saturday drawing classes held at the School of the Art Institute of Chicago," Leon told me, "and while I was still in grade school, I attended those. And later, when I was twelve or thirteen, I attended drawing classes sponsored by the Works Progress Administration." During the Great Depression of the 1930s, there were four federal programs that employed artists to make works (the best known of these being the big social-realist murals painted in government buildings) or to teach. Of these four programs, the Works Progress Administration (W.P.A.) was the most important. "I was going

to these classes, so yes, there must have been something. And I seem to remember, too, that my father, who would from time to time bring me books from the secondhand bookstalls—it was something he liked to do after work, look at and buy books—at some point, the books he brought me began to be art books, special-edition books of reproductions. So you could make something of this, okay? But I had no idea then, as a child, that I wanted to be a painter, whatever that meant to me at that age."

A child may draw, but a child does not make art—this, I think, is what Leon was getting at. The decision to make paintings, to be a painter today, is a decision about life, how you will lead it. It involves commitment, the learning of a craft, an acceptance of solitude. And, if you are going to make the kind of paintings Golub eventually made—paintings that say something about the social and political fabric of one's time—it requires the cultivation at once of a certain intensity toward and a certain distance upon the life around you. This is not something a child decides to do.

Golub said that he was sixteen or seventeen when he first thought seriously that he might want to be a painter. "I was a student at John Marshall High School in Chicago, a big public high school with a pretty good art program," he said. "A lot of kids were interested in art, and I was, too. It's funny to think about it now. Many of the students were political types, the sons and daughters of socialists and communists. This is the late thirties, okay? You'd have, you know, fifteen-year-old Trotskyites and they'd be arguing up and down the hall with the fifteen-year-old Stalinists. And making their posters in the art classes all the time. I couldn't comprehend the differences.

"The other thing I remember is that nobody thought I was so hot. In a class, a drawing class or whatever, when art was picked out for praise or just discussion, it wasn't mine. Maybe my stuff didn't come across. And then there was the art club, the Portfolio Art Club. I guess it was affiliated with the school somehow. Some of my friends belonged to it. So I submitted some of my work to join, okay? And even these guys, my own friends, turned me down! That was a shock. And a preview of things to come."

What mattered to Golub, I think—what he talked about most

when he told me what he could recall of this time in his life—
was not so much what he was making, but rather what he was
seeing.

"It was at this time I saw modern painting and sculpture for
the first time," he said. "And I think right from the start I had
this recognition. It didn't seem alienating or off-putting. It seemed
fascinating. I would make frequent visits to the Katherine Kuh
Gallery, which was then the most serious art gallery in Chicago.
The shows were of the European modernists. I can remember
seeing Paul Klee's paintings, the sculptures of Henry Moore,
works by Rufino Tamayo, Picasso. And I can remember how I
liked to listen to people in the gallery—the ones who seemed to
be artists or art students—talking about the works. I also attended
lectures on modern art at the New Bauhaus, the school that Laszlo
Moholy-Nagy opened in Chicago in the fall of 1937 [it was later
to become the Institute of Design]. The members of the Portfolio
Art Club, their work had to do with realism, an impressionistic
kind of realism. And looking at this modernist work, attending
lectures, I was somehow separating myself from their kind of
orbit."

Golub also remembers seeing Picasso's *Guernica* when it was
exhibited at the Arts Club of Chicago in October 1939. The
enormous painting, Picasso's great anti-Franco, anti-war mural,
had been brought to the United States the year before, not long
after it had been completed, for a big Picasso show at the Museum
of Modern Art in New York City; it was then sent on a nation-
wide tour. Golub has no detailed memories of what he thought
of the picture the first time he saw it, in Chicago when he was
seventeen; he has stood before the painting too many times since
then—and thought about it on too many occasions—to remember
precisely what it was about the apocalyptic picture that initially
invoked the sensations he felt.

"It was just a tremendous picture, a tremendous experience
for me, like no other—I know I thought that right then," he
told me.

Nearly twenty years later, in 1958—a painter himself, by
then—he wrote a long and evocative essay about *Guernica*. It
has never been published. He found a copy of the manuscript
that night and lent it to me. When I got home and read it, I

imagined he was writing it for himself as much as for anyone else. In this passage, I think, you get what mattered to him about *Guernica;* and maybe, too, you get why, years after he wrote the essay, he came to paint pictures of the monsters not inside us somewhere, but of those "out there," in history:

> *Rhetorically,* Guernica *might be viewed as a vehicle for disseminating "news," as a visual metaphor of a newspaper, a super-photograph or comic strip. It is "read" urgently, and the viewer is assaulted by the tumult and violence—the crowded, sensual, discordant, and primitive ordering of ideas. Thus (like instances of the impact of exceptional news) the* Guernica *is stridently eloquent, tensely insistent on the reality of the events portrayed, utilizing the "news" to gain immediacy, to reenact the totality of the event as news.*

6. THE FOLLOWING WEEK Golub picked up the story of his early years. Our talks were becoming something of a routine: early evening, the loft quiet, chairs pulled closely together, a glass of wine, the tape recorder on, Leon recalling—or straining to— names and dates and events from long ago. He began this evening in the spring of 1938, when he was graduated from high school. It was time for a decision, he said. But he was not ready to make one. "I think I wanted to go to art school, really," he told me, "but my view of myself was that I didn't have what it takes. And what the hell did it mean to be an artist then? I would see these artworks, okay—but they were being made in Paris, not Chicago. How did you go about being an artist? I don't think I had a clue. It's not like now, when the media are writing about how artists live and so on, and when there are all these B.F.A. and M.F.A. programs for those who want to learn. And with a modern-art museum in every other town.

"Also, to get right down to it, there was the matter of money. After my father died, the city paid my mother a small pension—

twenty-two dollars a month, to be exact. And it seems to me now that my father must have left a little something. But mostly we were being supported by my sister, Gail. She eventually studied business and taught it, but then she was working as a social worker, and it was her small salary we were mostly living on. Art school seemed a real indulgence in that situation."

There was enough money for junior college—he enrolled at Wright Junior College in Chicago and continued to live at home. He was beginning to think that maybe he would study art history, he told me. He was still painting a little, but he could not remember what; and he had saved none of his work from those first years after high school, so I cannot think it meant that much to him.

"I would be an art historian—I thought I had it figured out," Leon said. "There would be the art and maybe the security of a job. When I say 'security,' I have something more than economics in mind, however. It had more to do, I think, with this inability to visualize myself as a functioning artist."

When I asked Leon how he had come to the idea of being an art historian, he mentioned, not surprisingly, perhaps, his keen interest in looking at and discussing the modernist art he had discovered a few years before. But there was something more.

"A teacher, an instructor in a German class at Wright, had showed me several books about German art of the Gothic period. I can't remember now if it was for a paper I was writing or . . . I don't even know what books, exactly. But I can still see— almost—the crudeness of the wooden carvings, depositions and crucifixes: their clumsy, rugged expressiveness. So modern, in a sense. And in making that connection, perhaps that's when I thought about art history."

In 1940, after two years of junior college—and after placing high in an extensive written examination—Golub was awarded a scholarship to attend the University of Chicago.

"It was at the University of Chicago, in the fall of 1940, that I began to pursue a career as an art historian," Leon said. "I was considered a third-year student, having spent two years in junior college, and I enrolled in the art-history department. It was a distinguished department. There were several professors who were refugees from Germany. Rigorous minds, okay? I took

courses with titles like 'Neo-Platonism and Michelangelo.' And the university was like a whole new world to me. I continued to live at home and to work part-time, mostly odd jobs through the art department, filing away the photo reproductions that had been used in classes—things like that. But there was still time to attend lectures, discussions. I met other students, people my age, who shared my interests. There was this atmosphere like I had naturally never encountered—the life of the mind. I also came into my own, in a way. In classes I could prove myself—I remember getting a one hundred in a course on Greek art. Now, that I can remember!

"By the spring of 1942, when I was to graduate, I had made up my mind to continue on in graduate school there—to study art history and get at least a master's degree. My idea was to do research, art-historical research, into some aspect of modernism. That spring, I had a number of meetings with the chairman of the art-history department, a man by the name of Ulrich Middeldorf, a great Renaissance scholar and a fine teacher—his classes in formal analysis and connoisseurship were fantastic. The meetings between Middeldorf and me were to discuss a thesis topic for my master's. He wanted to know what I would like to research and write about. And I said I'd like to work on Dada. Now Dada in 1942—if you are speaking art-historically—was still a pretty young thing, okay? And I loved Dada—its irregular and trenchant bite, its anger and its way of mockery."

I asked Leon if his love for Dada was strictly aesthetic, or something more personal. Did he feel in sympathy with Dada's mocking of society?

"Well I must have. No, I wasn't alienated or anarchic, if that's what you're getting at—or if I was, I was only dimly becoming aware of it. I didn't even know all that much about Dada. I'd done some research, read about it, seen reproductions—that's how it was to be in Chicago, okay? Now, my wanting to do graduate work on Dada—this was perhaps a provocation. Maybe I meant it, in part, as one. But I was genuinely interested. I didn't want to do anything too respectable or academic. Middeldorf wanted to get me into nineteenth-century German art. He suggested the Nazarenes. But I resisted. It was too academic, too

respectable. That was the main thing. I didn't stand up and say this, but this is what was on my mind."

He and Middeldorf never agreed that spring on a topic, and the issue was left unresolved. Golub was urged to apply to graduate school by the art-history faculty, did, and was accepted. He began taking graduate classes in the fall of 1942. But there was a war on, and after only a few months he enlisted.

"I served for three years in the U.S. Army Corps of Engineers," Leon said, "in the 942nd aviation topographic battalion. I was first based in Bakersfield, California, then in Nashville, and finally in Colorado Springs. In early 1944 we were sent to England, and later we were stationed in Belgium, then Germany. We prepared maps, assembled these documents called photo mosaics. We also did photo intelligence analysis. We did very little *soldiering,* which was fortunate for me. I was so awkward, so inept."

I asked Leon if he saw any combat in Europe, and he said that he hadn't, and that he felt some guilt about this. "Combat soldiers were often around, and during the Battle of the Bulge, they were brought to our encampment for food and rest." He paused a moment, then said, "The army showed me the real world. It enlarged my perspective, socialized me in a sense. Before I had known only home and school, really. Now I had seen things. I observed things. I saw power in action, and I saw some suffering, too."

7. "WHEN I GOT out of the army in the spring of 1946," Leon told me when we next got together, "I don't think I had a real clear idea what to do with myself." He was twenty-four when he returned from Europe to Chicago that spring. He did resume classes at the University of Chicago in the summer of 1946, but he said he was halfhearted about it—that he was just passing time.

"I had this tug again to make art," he went on to say. "There was this sense that I needed to test myself, in a way—to find out

once and for all if I had it. So I left the University of Chicago, and art history, and enrolled in the fall of 1946 at the School of the Art Institute of Chicago. I was going to study painting.

"A lot of factors figured into my thinking, as happens with anything of this kind. There was the fact that I was a little older now, you see—it's not the same as when you're seventeen. You have a little more confidence, okay? You've been on your own. And practically speaking, there was the G.I. Bill to pay for your education if you were a veteran like me—there were the resources to study art. And perhaps I—I'm trying to imagine what my thinking might have been like then. We're talking about forty years ago—perhaps the G.I. Bill got me over my insecurity about not being able to earn a living as an artist. On the G.I. Bill I had my tuition paid, plus ninety bucks a month. That fall I got a job teaching art at a night school: another fifty bucks a month. Not bad in 1946."

The fine-arts curriculum at the S.A.I.C. was a fairly traditional program, Leon said. For instance, students working toward a B.F.A. degree did a great deal of drawing from the model, as art students today often do not.

Even as it was expected that you might push away from classical notions of line, form, and proportion—a number of Golub's teachers at the S.A.I.C. were modernists—it was nevertheless understood that you had to know well and care about what it was you were pushing off from. Leon dug out a terrific photo of him taken in 1948 in a sculpture class, and it conveyed something of this ambivalence toward tradition that was imparted—conveyed something about Leon, too. He is standing next to a looming clay figure, his face so much softer and smoother than now, expressing the art student's quiet intensity and purposefulness. The sculpture is classical in its proportions and pose, but the surface is roughly worked, expressive. Leon and his work already appear to be heading someplace.

I mentioned to Leon that—from my vantage point nearly forty years later—I could already glimpse his "hand" in the sculpture. And by way of replying, he brought up one of his teachers at the S.A.I.C., a painter by the name of Paul Wieghardt, a German who before fleeing Europe in 1940 had studied at the Bauhaus with Paul Klee and had lived in Paris. "I liked him," Leon said,

"and I think he liked me, but in the classroom we did not get along. His painting was soft, delicate, French in that way. I was after something rougher, right from the start."

I recalled that at the Art Institute, there were still in the 1940s the fine twentieth-century French paintings of the Chester Dale collection. (The collection is now in Washington, at the National Gallery.) The paintings of Maurice de Vlaminck, Henri Matisse, Raoul Dufy, André Derain—the French painting one thinks of as "lyrical," reveling in the pleasures of color, surface, form— were "on campus," as it were.

When I mentioned these paintings to Leon, he said, laughing a little, with a mock-tough-guy voice, "That wasn't where I was at. "Let me tell you a couple of stories, okay? Maybe you'll see what I'm talking about. One thing I remember, it had to have been early on, forty-six or forty-seven—anyway, there's a first-year design class, a required course. Now, I was never much interested in design. And if I have it right, we were supposed to do form exercises and patterns, that kind of thing. But already— my first year, yes—I decide to make a little statement, mix it up. Silly now, maybe, but then I thought it was important. I wanted to show I planned to do things my way. So, remember those German crucifixes that teacher showed me in junior college? Okay, now instead of this ordered, patterned design, I do this wild, almost grotesque series of depositions from the cross. The teacher comes up to me at the end of the year, well after I'd handed in these designs, and says that she let me get away with it, but that she should never have—that I'd set a bad example. And she told me how important it is to do what you are asked to do, not to single yourself out like that, and so on. And it was true. But that I did get away with it—at the time it emboldened me in a way.

"And here's another item—about Jackson Pollock. It was 1948, in the fall. There's already a noise about Pollock, even in Chicago, at least at the school. And then it came down that Pollock was coming. Not Pollock himself—the Art Institute was going to show three or four of his paintings. People went crazy. We had talked about Pollock and seen the work in reproduction, I'm sure, but no one I knew had actually seen a Pollock. Like everybody else, I could hardly wait."

The Pollock paintings the Art Institute showed in November 1948—in a large survey exhibition of new art—were not his signature "drip" paintings, but the pictures that directly preceded these, known as the "all-overs."

"As I remember it," Leon continued, "the students were allowed in one morning before the show opened to the public. And we literally ran up to the galleries, if you can imagine. But when I got there and looked around . . . I mean, they did nothing for me. These big canvases—big by the standards then. And what I saw were patterns of color. They looked decorative—that's what I thought. Now, in some ways I see them differently today. Maybe I'm more interested in the surfaces, okay? But in a certain way I haven't changed my mind at all. I was after something different then, and I still am."

What he was after, he said—what he sought to hone—was a painterly language that he could employ to make pictures about the world around him, and the feelings he had toward it.

"Paintings about my situation," he said, speaking more slowly and carefully. "My recognition of estrangement, of domination and violence, of existential fatality."

I asked him where he thought these feelings had come from. When had he begun to feel this way about the world?

"Well, I guess there is no way to know for sure," he said. "But the war. I'd been in Europe. And then the concentration camps—when those pictures started coming out. I'm a Jew. Many of my friends were Jews. It was a shocking, incredible thing. But that's not all of it. It also had to do with this sense I had of myself as *estranged*—as marginalized. Why? I'm not sure. I'm not even sure now how strongly I recognized this. It may have been something I recognized only when it began to appear in the work."

I then asked Leon who these friends he mentioned were, and how he and they had gone about this search for a style to express the near-inexpressible horror of which he was speaking. He explained that at the S.A.I.C. in the 1940s, there was a small and closely knit group of students—Cosmo Campoli, George Cohen, and Golub, among others—who were exchanging ideas, working along a similar path, coalescing. They rejected "Chicago painting," what little there was of it. They did not join the Chicago Society of Artists or the Palette and Chisel Academy.

But more crucially, they rejected the School of Paris-influenced painting being made in New York in the late forties—the painting that came to be called abstract expressionism. Abstract expressionism, Leon said, "was, as I saw it developing in the late forties, bad for art and the artist. The imagery became unindividuated. And the meaning had more to do with the painter's encounter with the canvas than with anything going on between the viewer and the work. These painters were essentially turning away from the world in their work. And they were giving up on the idea that an artist might have a social role. Contact 'out there' no longer seemed to matter to these artists. Contact was something they made impulsively, almost unconsciously, with the paint on the canvas. I didn't want to paint unconsciously."

What, in the world "out there," did Leon think the abstract expressionists were turning away from?

"Well, as I would say then, there were things missing. And not only in abstract expressionism, but in much of modern art. History is missing—this sense of things beyond any one of us, but which involve us greatly. Also, man is missing. Especially man in action. Now, these are things I myself didn't come around to make paintings about until later, in the late fifties and sixties. But they are things that disappear from art when the artist relinquishes a social role."

Leon said that from the start, he sought to paint pictures about the "horrors" of the world, paint them with a "directness," a "bluntness," a "toughness." These words—direct, blunt, tough—evoked for me the Chicago we know from Carl Sandburg's poems, and I found myself wondering how much a city itself might determine an artistic temperament and pictorial style. I recalled reading a book on Chicago art by the critic Franz Schulze—who had studied at the S.A.I.C. in the 1940s, and was a friend of Golub's—and a long quote from the painter George Cohen, who, like Leon, had talked about how "guys in Chicago" didn't think New York painting had enough "toughness."

But more important than any geographical imperative, I think, was the conscious desire on the part of Golub, Cohen, and the others to find a means to speak visually of what Nietzsche—in writing of the realm of the "tragic artist" in *The Will to Power*—called "the terrifying, the evil, the questionable." These young

Chicago art students could find little in Chicago itself—its art or life—to help them in this quest. They looked, as young artists must, to art's own past for the marks and gestures with which to articulate mankind's "horrors," the darkness, the long night. Like all serious young artists just then, in New York as well as in Chicago, they found Picasso—the Picasso (for Golub and his friends) of *Guernica*. And they also found, for themselves, expressionist painting, northern painting: Edvard Munch and James Ensor; the German painters Emil Nolde and Max Beckmann, in particular; Alberto Giacometti, a Swiss; and then the French painters who went their own, rather northern way, Georges Rouault and Chaim Soutine and, a little later, a new French artist, Jean Dubuffet.

The night we talked about his days at the S.A.I.C., Leon pulled out a few of his student works to show me. He had them in drawers and in a storeroom next to the front door. From one of the drawers of the big table in his studio, he pulled out a lithograph about the size and shape of an opened magazine, and he placed it on the floor at my feet. "This one, it must be around 1946—it's called *Charnel House*." The title is a clue to its inspiration. The year before Golub made his print, as the war in Europe was ending, Picasso painted his *Charnel House*, a horrific grisaille pendant to his *Guernica*. When asked about the source of his image of stacked, twisted bodies—an image made even more grisly by the cubist armature he employed—Picasso alluded to the first photos from Dachau, published late in April 1945. (Actually, Picasso had pretty much completed the painting by then, certainly its basic imagery and composition: Beware, once more, the intentional fallacy.)

Golub, too, mentioned the concentration-camp photographs. "I think the first paintings I was doing when I started school were concentration-camp scenes. There is one around called the *Evisceration Chamber*, and there were others based on Buchenwald. It was something I guess I had to get at." The title may have derived from Picasso, but as I looked at the print, it was Munch I saw. The skulls in Golub's print were gourd-shaped, like the head of the figure in Munch's most famous picture, *The Scream*. And the space was Munch's as well: The skeletons and corpses

in the print drift in and out of the picture's ground, as if to bad dream and back.

I mentioned Munch, and Leon nodded. "Of course. Influences are so obvious at this point. When you're starting out, okay? But the drive I was talking about—that's important, too, I think. I mean, why did I want to paint such ugly things? This is a question that troubled me a good deal when I was in school. And the answer was: I wanted to connect. I believed there were people who would look at images of this kind and connect."

Leon walked back to the storeroom and emerged with a small painting titled *Carnival*—masked, Ensor-like figures cavorting; inert in the way that a painting inspired too much by a repro-duction of another painting is likely to be. Golub and the students he was close to at the S.A.I.C. may have reached this conclusion themselves. For, by the late 1940s, they had turned away from this kind of work—looking directly to European expressionism—and embarked upon a new, if related, path. The source then (they continued to search for inspiration in other art) was Chicago's Field Museum of Natural History, specifically its ethnographic halls.

"We kind of discovered the Field Museum," Leon said. The strategy of looking to ethnographic objects for direct inspiration was not exactly a rejection of modernist expressionism; this was, after all, precisely the strategy of a number of German expres-sionist painters in the first years of this century. As Robert Gold-water writes in his landmark study, *Primitivism in Modern Art*—a book published in 1938, and read by Golub and his circle—"Africa and Oceania were 'discovered' by Ernst Ludwig Kirchner in the cases of the Dresden ethnological museum in 1904." Emil Nolde—who would later travel, Gaughin-like, to the South Pa-cific—made similar museum "discoveries."

Goldwater called this type of painting "emotional primitiv-ism." What fascinated a number of the German expressionists were the power and immediacy of the ethnographical object, what Nolde called "its absolute primitiveness, its intense, often gro-tesque expression of strength and life in the very simplest form." This might have been Leon talking. "Intense," "simple," "gro-tesque"—these are the qualities that attracted him. It wasn't for

Golub, as it had been for Picasso, a matter of formal possibilities and affinities.

"There was a way in which these things were extreme," Leon told me. "Uncanny. They opened up avenues—different conceptions of the body, different materials and techniques, and always this directness."

Chicago's Field Museum is one of the world's great ethnographic museums, especially rich in tribal art and artifacts from Africa and Oceania. Masks, fetishes, figurines—these became a new and captivating source of inspiration for Golub and his friends. Leon talked about this, the excitement he had about the Field and its contents, the fascination evoked by the non-Western objects. Listening, I sensed Leon was summoning the spirit of another moment, one that has passed. It is difficult today to feel the excitement and wonder Westerners once did in our ethnographic museums. At certain moments, in certain moods, one may come upon a tribal object and be simply, strangely, purely fascinated—as a child might be. But this is rare, I think. We tend to understand ethnographic museums differently now. They seem not so much exotic, or even "enlightening," as sad, gloomy places. The disorder; the mustiness; the vitrines—such a musty word, *vitrine*, redolent of a time when all of humankind "out there," all it made, seemed worth taking and keeping, "authentic" and classifiable. Where Leon (and so many other artists) had found inspiration, I find now mostly indications of bad faith; where Leon once glimpsed alternatives, new possibilities and directions, I see now mostly the cataloged and labeled evidence of plunder.

What can we know of a painter, of his past, when we cannot intuit the sensibility, the *mentalité,* of the time in which he worked?

I asked Leon if he had a work around from those days. He went back to the file cabinet, and after digging around for a while he pulled out a big drawing. "This is *Skull.* I did several of these during one summer back then. I was really into skulls at the time—a number of us were. I can remember going to the Field Museum and examining them—ancestral skulls from New Guinea, stuff like that."

"And you would sketch them there, in the museum?"

"No. Mostly it was a matter of seeing them, then doing your

own thing—using them in that way." He looked closely at the drawing. "Actually, this one I think I did from a photo. You know, there was the French art magazine *Cahiers d'Art*—they'd do documentation. This one here looks . . . I think this was pre-Columbian—I can remember *Cahiers d'Art* did all kinds of things from the Musée de l'Homme."

The drawing is blunt, insistent. It struck me how Golub's rough touch and inelegant contouring, the way these lent the skull an awkward obstinancy—it struck me that these traits are still with him. The teeth in *Skull* are worked and emphasized; the set of the eyes is slightly "off"—one sees "Golub" here, too, as one doesn't in the paintings he'd shown me earlier. It's not even a "skull," really, when one puts out of mind the source for the picture. Golub has provisionally given it big shoulders, and the gnashing quickness of several of the boldest lines brings it somehow to life: It's a monster.

"I have a story about my *Skulls*," Leon said, as he put the drawing away. "At the time I was doing them, a few friends of mine came by, and I showed them the drawings. Actually, one was a guy who later, in the sixties, went on to write for *Artforum*. He would write about my work then, in the sixties, and say how he didn't like it as much as my earlier work—forgetting that when I knew him he never liked the goddamn early work, either! But anyway, these friends come by, and I bring out these drawings, and as you can see they're big ones—three feet, four feet, huge. And I'm showing them, okay? And everybody is just being as polite as can be: 'Very nice, Leon, it's really headed somewhere,' and so on. And then one of them starts: 'Good black-and-white relationships, the line really sculpts the space'. . . . So finally I kind of explode: 'Goddamn it! They're fucking skulls!' And then this guy who became a critic—I'll never forget it—he says: 'It doesn't matter.' Just like that, calmly: 'It doesn't matter.'

"In a way, if I could boil down my art to one phrase—everything I've ever done—it's that it does. It does matter."

Leon and I talked a while longer that evening about his art-student days. He had moved out on his own, and he described the place he shared with his friend and fellow student, Cosmo Campoli.

"It was a cold-water flat, really run-down. It was one of those

buildings behind buildings in Chicago at the time. They dated from before the Chicago fire, they were off the street, quiet, and there was space to live and work—at a cheap rent. Artists and art students would take them, like artists in New York took lofts in SoHo in the sixties. To save money we didn't heat the place one winter. The pipes froze and we froze."

He told me how he had tried to read *Finnegans Wake,* and how for a time he underwent Freudian psychotherapy. And before I left that night, he showed me one more thing, not a painting or drawing, but a catalog for a show called Exhibition Momentum.

"Now, this item is from 1948," he said, handing it to me. "It was produced by us—by the students—as was the show. When I think back about the Art Institute, getting this show together was as important as any painting I made."

In Chicago in the late 1940s, he explained, the most important exhibition for Chicago artists was the annual Chicago Show, sponsored by the Art Institute. It was a juried exhibition with cash prizes totaling around six thousand dollars. The show also attracted the press, and the few, active collectors of contemporary art in Chicago.

"It was where you made your reputation in Chicago then," Leon told me. "Today, maybe, it is a little difficult to imagine such a thing—the game now is getting to New York, establishing a reputation, getting written up in the magazines, going international. But back then it was more insular. It was a time—it would change in just a few years—when Chicago critics cared pretty much about Chicago artists, Chicago collectors collected Chicago artists, Chicago artists cared about making it right there, in town."

Leon went on to explain that the Art Institute had traditionally allowed students—its own students, and those studying at the Institute of Design—to exhibit. But after the war the student work had for the first time begun to dominate the show, win the cash prizes, get the write-ups in the city's papers. Moreover—and Leon said this seemed particularly to irritate a number of S.A.I.C. faculty members—the students were for the most part modernists.

"In a way," Leon said, "the paintings and sculptures the

students were doing—whether abstract or expressionistic or what have you—were shattering that cozy insularity, were a threat."

In the spring of 1948, the board of trustees of the Art Institute ruled that student works would from now on be excluded from the show. It was to be for "professional artists." The students thought otherwise and reacted swiftly, angrily. And Golub was in the thick of it. He met with several S.A.I.C. students to discuss how they might protest the board's decision; and when the group agreed that the Art Institute should be petitioned to abandon the new policy—to reinstate the right of students to show their work—it was Golub who wrote the petition.

"Around eight hundred students signed that letter," he said. "Now, there were students from both the Art Institute and the Institute of Design, but that is still some number—this was 1948, not 1968. Maybe two-thirds of the students signed. I think this had to do with so many of us being older, being veterans and that. We weren't nineteen, twenty, and we couldn't be treated as the board might have treated students that young."

The petition was presented to the director of the Art Institute, Daniel Catton Rich, and there followed what Golub described as a large and boisterous meeting at which he and other students "exchanged views" on the matter with members of the school's administration.

"You know what kind of meeting I'm talking about," he said. "They figure you'll be satisfied if you get to air your grievances, get something off your chest. This is what the artist wants to do, okay? That's the assumption. Artists would get that again and again in the sixties. It didn't work back then at school. They refused to change their minds, we refused to change ours—and we left even angrier."

The leaders of the protest—including several Institute of Design students—held a second meeting and mapped a new strategy. A decision was reached to organize a "protest exhibition," one that would be open to any artist and any work. Space would be found, money raised, jurors selected, a catalog written and produced.

"It's pretty amazing that students were able to get this kind of thing together," Leon said.

The show opened in July 1948 at the new Roosevelt College—

now Roosevelt University—in Chicago. There were works by ninety-one artists. (Golub's drawing, *Monolithic Conversation Piece,* was awarded an honorable mention by the jury, which included the painter Joseph Albers, who was brought in from New York. There were no cash prizes, but the drawing sold for one hundred twenty-five dollars.) Exhibition Momentum eventually became an annual event, attracting artists not only from Chicago but from throughout the Midwest. The last one was held in 1957, and by then Golub was no longer involved.

"I worked on the first three," he said. "I chaired the show in 1950. But there is only so much of this kind of thing you can do—I learned that again in the sixties, too. You get to where you are always in a meeting." He paused, collecting his thoughts, then continued: "But those first Exhibition Momentum meetings were important to me. The way I saw how you could take something into your own hands like that and make it work. The way you could have ambition for something. The jurors over the years included Clement Greenberg—at the time he was doing his *Nation* columns—and Motherwell, Guston, Kline, Alfred Barr, even Pollock.

"And something else. In the meetings for that first show, we would talk not only about organizational stuff, but about our ideas—endlessly, over coffee, you know? The students from the Institute of Design, they had their ideas—they were full of ideas. They saw the artist functioning socially in society, fitting in. And they were purists: everything aesthetic and clean. And I was the mirror opposite. I wasn't pure. I was ugly. I didn't feel at all like I fit in. I didn't buy the whole Bauhaus thing—although I have always loved constructivist art. It's like it was that part of me that I didn't know how to be. The Institute of Design students would come at us about how we were stuck on painting—those of us at the Art Institute—and why weren't we working to really do something, design a better environment, stuff like that. They were so rational. And we weren't. They were social, and we were for the outsider. Or maybe I had a different idea of what was 'social.' "

Leon found another Exhibition Momentum catalog, this one from 1950. Actually, as he explained, it was an "insert" from the 1950 catalog, added by the S.A.I.C. students after the Institute

of Design students responsible for designing the catalog refused to include it in the catalog proper. The insert was comprised of artists' statements.

"Here, take a look—my first manifesto," Leon said, and handed it to me.

That night I read the statement Golub had written for the 1950 show. This was his last year in school. He had received his B.F.A. in 1949, and then, in 1950, his M.F.A. A "professional artist," I thought to myself. Golub's statement is called "A Law Unto Himself." And it is a manifesto, a declaration of his views, motives, proposed course of action. Reading it, it struck me how little he had wavered from it:

> *The contemporary artist is a law unto himself. His inverted, fragmented concept of reality rarely coincides with that of others.*

And:

> *In its most significant aspects, contemporary art is ugly . . . a threat to the ordering of society and man's concept of himself.*

8. AMONG THE MANY painters to show in the first Exhibition Momentum was a twenty-one-year-old third-year student at the S.A.I.C. named Nancy Spero. She was from Winnetka, a lakeside suburb north of Chicago. Then, as now, she was slim and intense—"really something," Leon said one evening, as the three of us had dinner in early September. "She had the messiest paint kit of anybody, and she herself was immaculate. Real style. We met in a painting class. It must have been 1947, second year. She was several years younger than us, the guys I was close with. But eventually we were part of the same crowd. Coffee, talking, then going out."

LEON: "Nancy went to Paris in 1949—"

NANCY: "To study at the Ecole des Beaux-Arts. . . ."

LEON: "And I remember you sent me a French journal, *Art Aujourdhui*, with a section about the art of the insane. Very big in Paris. Dubuffet was into it, and we were interested in Dubuffet. Art brut. Nancy and I were interested in the same stuff, right from the start. That was a lot of it. Of course, there were divergences, too."

NANCY: "I came back when . . . sometime in 1950."

LEON: "Well, let's see. We were married in 1951."

NANCY: "In fifty-one. In the summer of 1950, I worked at a theater in Connecticut. I was thinking then I might want to do set design. That finished that. And then I went to New York—was it that fall?"

LEON: "And I came to New York. We lived for a while in a basement apartment. And we were married in December fifty-one."

Later that night, Leon described for me their first years after being graduated from the Art Institute.

"Let's see now, I'd taken a job teaching at Wright Junior College, where I'd gone right after high school. I got this job as an art instructor. There was no question but that I'd have to work to make a living. No way I was just going to be able to paint. George Cohen, my best friend at this time, was teaching at Northwestern. We weren't selling paintings. And even if I did sell something once in a while, to a friend or whatever, the prices were not remotely such that you could live off the sales."

"Where were you living?"

"At first, right after we got married, in a converted garage behind a building. You'd go down an alley to get in. No rooms—just a ground-floor studio and a living quarters upstairs. No insulation. We lived and worked right there, the two of us. I really wasn't getting all that much work done. I painted mostly in the summers. Twenty hours at the junior college—twenty hours in the classroom. Then there was the time taken up by administrative work and travel, the hours between classes. Then our oldest son, Stephen, is born in 1953, so around then I start teaching nights as well at Northwestern, a job George Cohen helped me to get. I can make perhaps a dozen paintings a year. Maybe

eight, nine, during the summer, another couple during holiday periods, on weekends."

"You made a decision to stay in Chicago?"

"It wasn't like we made a decision. Chicago was where we were. A few months after Stephen was born, we moved to a two-bedroom apartment on Addison Street, on the West Side. Then in 1954, our second son, Philip, is born. So I'm teaching all these hours, including courses in ceramics and architectural drawing, okay? I must have been making around four thousand bucks a year. That's just teaching. Neither of us sold our work, or could anticipate doing so. It could be depressing. There was so little time for anything. Working, reading a little, the kids—and then summers for painting. Now my friend Cohen, he's in the same boat, actually a little better boat—he taught at Northwestern days. And he seems content—content to me, as I see it. And his being so content, this frustrates me a little, too."

I brought up the close-knit group Leon had been a central part of at the Art Institute. Did it continue to develop? Were their galleries in Chicago to support them?

"Not really. There is still at this point not that much of a gallery scene in Chicago. In 1952 Allan Frumkin opened his gallery in Chicago—the first real gallery, in a way. He showed Matta, Kline. But of course these weren't Chicago artists. And then I went with Frumkin, but that's a little later, in the mid-fifties. That's about it in Chicago. So I was frustrated with this, too, you see. Several times in the early fifties, Nancy and I tried New York—headed there with our work rolled up. And we tried to show our work around, but nobody was very interested. I remember one dealer asking me when I'd studied in Africa!"

"So it is to New York that you looked."

"It was in 1952—I had my first show there. An exhibition of prints at a bookstore run by George Wittenborn. A great art-book store. Wittenborn and I became friends, and during the fifties we struck a little deal—I traded him a painting for credit at the store. I got some great books from Wittenborn's. There's nothing like it in New York today. The Museum of Modern Art bought one of the prints. It was priced at twenty-four dollars, and they wanted a third off—I got twelve dollars and George got six. It was my second sale. I had sold a painting to a colleague

of mine at Wright for, I think, one hundred twenty-five dollars.

"You wanted a New York show."

"Absolutely. A show of my paintings. That's what it was all about."

"Ambitious."

"Ambitious? Yes. I think, however, that there is a part of me that likes not being accepted—being on the fringe. But of course this other part of me wants acceptance badly." He paused, then said, "I couldn't have been easy to be around. Not in Chicago. This *discontentedness* of mine must have made others nervous."

I had seen reproductions of the pictures Golub made in the early 1950s, and from them I could see that his painting made no drastic stylistic break with what he had been doing in his last years at the Art Institute. He continued to look to tribal art for inspiration. The imagery and texture of the paintings he made during this period say "primitive." On easel-size canvases, in brooding grays and muddy browns—the paint applied thickly, the surfaces smeared, gouged, dense, eventful—he painted totemic images, frontal and centered and often barely discernible in the muck of oil, enamel, and/or lacquer. The mixing of different paints, the working of the surfaces, the "primitivism," brought to mind Jean Dubuffet.

What change there was from the late 1940s was subtle but important—important in the way it reveals Golub's search not just for a pictorial language, but for a place for the artist in society. The work of this period is perhaps best understood as a meditation on the question: What is the artist's role? Golub looked to tribal art now not so much for the strange and fantastical as for a clue to where an artist might—in his community—fit in. Specifically, he painted pictures of tribal priests, shamans, and mystics, drawing on images from tribal totems, and also ancient Assyrian objects. He wanted to depict figures singular and fierce; yet in the way he went about his depicting—in the way he dug and tore at the surfaces he built up, so that bodies and faces seemed physically brutalized—it would also seem that he wanted to show how vulnerable these figures were.

Priests, shamans, mystics, powerful but under attack and damaged: In a sense he was painting these figures to get an image of himself. He was reading about the tribal societies in which the

art that inspired him was made, reading Freud's *Totem and Taboo,* James George Frazier's *The Golden Bough,* and a good deal of anthropology. What role did the artist play in these societies? This question held a fascination for him as it did not for Campoli, Cohen, and the others. The critic Lawrence Alloway has suggested that Golub's paintings from this time—the rough, small, dark paintings of shamans and priests and seers, with their frontality and flatness, their worked surfaces and dead color—offer a kind of "mirror image of the painter before the canvas." That is, he suggests we read these paintings as expressionistic portraits of the post-war artist, set off from the rest by his knowledge and his sensibility, in touch with deeper, troubling truths—but pained and even tortured by his knowledge of these terrible truths.

I asked Leon about this. What was he after there? Did he think of himself, of artists, as having a special priestly role? As having deeper, magical insights?

Leon didn't answer me directly. He said, "For me, it was about the artist, and not just about art. I thought that artists were in a unique position to reflect in their work the havoc of the world, but many artists were not doing so. I wanted the artist to fight against anonymity. I was for individuated imagery. I was for an art that talked about man in a mass world. I was interested in painting that did more than deal with itself."

In December 1952, Golub, then thirty years old, had two of these early "primitive" paintings included in a group show at the Artist's Gallery on New York's Upper East Side. The gallery was then an important not-for-profit showcase for new talent, and Leon had written the gallery a number of times, introducing himself and his work in the hope of being invited to show. The offer to exhibit in the group show encouraged him, and after that show came down, he continued to correspond with the gallery. I had found the correspondence in the Archives of American Art in New York, which has on microfilm a good deal of Golub's papers and letters, and I was particularly struck by Leon's frankness about his goals and himself. In one letter he writes:

> *Somehow I am not the type to wait patiently for recognition to come to me. I believe in harassing—or should I say convincing—public opinion.*

Late in 1953, the Artist's Gallery offered Golub a one-man show. The gallery wanted to hold the show in the spring of 1954, and Golub quickly agreed, requesting only that it open in May, after his classes were out, so that he and Nancy could attend the opening. He wrote:

I find the prospect more exciting than anything I have yet experienced in the art world.

And when the show did open that May—eighteen paintings, done between 1952 and 1954—it was a surprising, overwhelming success.

How to explain this? How to explain how New York—where Golub couldn't get a show for three or four years—now suddenly embraced him? Taste in the New York art world in the early 1950s, as I had understood it, was firmly established: Abstract expressionism was the dominant style. To the serious critics and museum people involved with contemporary art, the dealers and collectors, the artists themselves, abstract expressionism was what mattered. And Golub painted in some kind of defiance of it.

But distance on a moment like that of abstract expressionism can blur things. Abstract expressionism in 1954 was not what it had been in 1951 or 1952. Its hold on New York was no longer hegemonic. There were now some painters, critics, and even collectors who were looking for something else. It was something like the crisis in Paris in the years just before World War I, when cubism seemed to be taking painting too far from life lived, from experience. There was a restlessness for imagery once more.

This was being satisfied mostly by European painters. The Anglo-Irishman Francis Bacon was showing his nasty paintings— of terrified (and when they worked, terrifying) men and women, in closed, barren rooms, experiencing unnameable acts, paying for things they cannot begin to comprehend. And there were the paintings of Giacometti, his worked and reworked portraits of his wife, Annette, his brother, Diego and friends, and also the work of Dubuffet: small, frontal, "primitive" paintings with roughed-up surfaces—paintings that had influenced Golub and others in Chicago. And then, at the Sidney Janis Gallery in the

spring of 1953, just a year before Golub's one-man show, Willem de Kooning—perhaps the most influential painter in New York in the early 1950s—had shown his fevered, violent paintings of women. In New York, in 1953, these were the paintings being talked about.

Golub's imagistic, "primitive" paintings could be seen in 1954 in a different context, a different light, from just two or three years earlier. And they were. Stuart Preston, writing in *The New York Times,* called Golub "a worthy challenger to England's Francis Bacon and France's Dubuffet." *ARTnews,* then the most important art journal in New York, published a review by Henry McBride, who wrote that if he were a museum director, he would buy one of the pictures in the show "at once." James Johnson Sweeney, then at the Guggenheim Museum, was organizing a big survey exhibition he was calling Younger American Painters; after seeing Golub's show, he told the gallery he would include one of Golub's paintings in his exhibition.

I asked Leon what this was like, this sudden attention.

"Well, it was incredible, okay? Really incredible. All of a sudden I was known in New York. I mean, there were the reviews, and Sweeney coming by, but that was just the beginning. One day Martha Jackson comes to the gallery, buys five paintings right on the spot. Now, at that time Jackson is running one of the hottest galleries in New York. Madison Avenue. And not only does she buy the paintings—it came to about thirteen hundred bucks for the five of them—she gets in touch with me and talks about signing up for her gallery. She says: 'Don't do anything until you talk with me. Wait and we'll talk in the fall.' "

Leon was telling me a story I sensed he had told many times. He was telling it with great theatricality.

"Now, here's where fate, or whatever you want to call it, comes in. I take her advice. I don't do anything. I wait until the fall. I spend the summer painting, I'm feeling fantastic. And I come to New York in the fall, and I meet with Martha Jackson."

Leon's theatricality began to falter. He was laughing a little, musing laugh; but his eyes were hardening. Beneath the story-teller's mask, I could sense real feeling, untempered by time. And he spoke more slowly here.

"I come to New York," he repeated. "And she says to me,

'You are an important artist, and I would like to show your work, but I have to tell you, I don't like it. I don't like your work.' I don't like your work. Okay? In other words, Don't do anything until you talk to me and I have the opportunity to tell you I don't like your work. Farcical, right? Now later, I hear that she didn't mean this, or that I had not understood her. But you don't misunderstand something like this. And I think: I can't show with someone who doesn't like my work, whoever she is."

I asked Leon what he did.

"I go with Feigl. But I suspect you haven't heard of Hugo Feigl. He showed German expressionists, Kokoschka, and so on. He liked my work, understood it. So I went with him. Big mistake. Feigl was not part of things, the scene. I wasn't living in New York, so I didn't understand. Had we lived in New York instead of remaining in Chicago, would things have turned out differently? Who can say? Maybe being present, being able to express your ideas and possibly influence people—maybe things would have worked out better."

Leon had two shows at the Feigl Gallery, one in 1955 and again in 1956. It is possible that Feigl simply could not get attention for the work, as a good gallery—or at least one "on the scene"—can do. But there was something else: Taste in New York, the "context" in which Golub's pictures had been viewed in 1954, was changing once again. Now it was more a matter of determining what would come after abstract expressionism—that was the conversation. And Bacon, Giacometti, Dubuffet, even de Kooning, were not part of this conversation. There was something else stirring in 1955 and 1956, a kind of neo-Dada: the first important paintings of Robert Rauschenberg and Jasper Johns, something so different.

Leon finished his story. "Two shows, and Feigl never sold a painting of mine. Nothing. By 1956—I'm talking about what? Two years later—by fifty-six I disappear from New York. And from my perspective, New York—the whole idea of making it in New York—that all but disappears for me, too."

VI

PARIS

MALE FIGURE,
1953

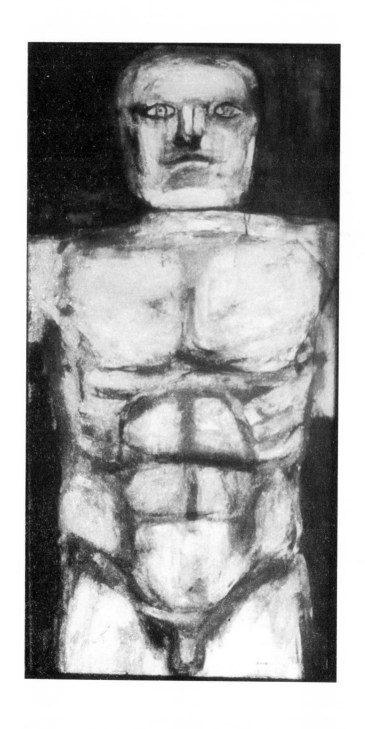

H

ONORÉ DE BALZAC writes, in his novella "The Girl with Golden Eyes": "The painter without connection has his heart gnawed." A short, sharp line, and one I recalled on an afternoon in late September 1988 as I thought about Golub, about how badly he had wanted to establish himself in New York, and how it hadn't worked out. It was the setting that brought Balzac to mind. I was on a train heading up through France toward Paris, leafing through several of the many small notebooks I kept on Golub, notebooks filled with things Leon had told me, transcriptions of our taped conversations, thoughts I'd had about him and his work, and also research notes from books, newspapers, interviews, and letters. I had a different notebook for each year of his life, and I was reading now of the time, beginning in 1956, when he "disappeared from New York." He had made a point of making this a funny story when he told it to me; he had been careful to be funny.

I had been in the mountains of the Haute Savoie, visiting the writer and critic John Berger, and now I was speeding through a fertile valley, fields baked golden in early fall, and on to Paris, where I was to see Leon. A show of his paintings was opening that evening in a gallery in the Faubourg St.-Germain, the Galerie Darthea Speyer. There would be the opening from six to eight o'clock, and a party after, and then Leon and Nancy and I would spend some time together over the weekend, and perhaps they would show me what they could of the Paris they had known when they had lived there for five years, beginning in 1959. It was in Europe—first in Italy, and then in Paris—where Leon had tried to find that "connection" Balzac spoke of: a place to work,

a place from which to draw inspiration, and perhaps a place for him to matter in a way he suddenly did not in New York.

I read, in one of my notebooks, this passage from a recent conversation we had had:

Leon: "I was frustrated, damn frustrated at this point. I was in this situation, and I didn't know how to get out of it. It was like this, okay? Back in the forties, I couldn't see how someone in my situation—in Chicago, so far away from it all—how I could live the life of the artist. And that was one kind of problem. And I had gotten beyond that, or thought I had. And then, in the mid-fifties, say, 1955, I was back in the same boat in a way. Only I'm older now, I'm thirty-three. And I have two kids. I'm teaching even more hours to support the family."

There was a frustration at not being able to establish himself in New York; and also the ongoing frustration, back in Chicago, with teaching. In the spring of 1955, near the end of the school year, a long-simmering disagreement between Golub and the chairman of the art department at Wright Junior College came to a head. Golub had explained it to me this way: "He was very hostile to contemporary art. And because he knew of my interest in it, because I was a painter, you see, he would go at it with me, and actually would irritate me, because he knew so little about it. So one day, we are standing and talking—there are some of the other teachers around, as I remember it—and I point to a drawing on the wall, one with a tree in it. And I say to him, 'No one in any of my classes would draw a tree that badly.' It was a student drawing. But you see, I knew he had drawn the tree, corrected the student's drawing in the way a teacher at this more introductory level will. A week later, the dean calls me into his office and says I won't be invited back the next fall to teach. It's a little startling, the feeling I had of having to go home, with two small children, and tell Nancy I'd been fired."

Leon went on to tell me of an offer he received that summer that would have allowed him to give up teaching.

"It was an offer I shouldn't have been able to refuse—and one I should not have refused, in retrospect—but I did refuse it. I had an old friend named Herbert Greenwald. I had first met him when I was still in my teens, back before the war. There was

an arts-and-crafts program for children sponsored by a temple that I taught in and Greenwald supervised. Greenwald at the time was a struggling Ph.D. student at the University of Chicago, writing about the Russian Revolution. A very smart young guy, interested in philosophy. It was like he was the big brother I didn't have. My father was dead by that time. He would come by in his car—he had a car—and would pick me up and take me over to the classes and we would talk, you know. He was very well read. We would discuss books.

"Somehow, we lost contact with one another. Then, one day in the early fifties, I get a call from an old friend of mine from the University of Chicago, Pat Malone—we'd studied art history together. By this time, Malone has a job at the Art Institute, some curatorial position. And he says that he'd like to bring around a friend of his to see my work and chat. The friend turns out to be Greenwald. The same Greenwald I'd known, but a very different guy. It turned out he had married the daughter of a small Chicago builder, had gone into the business, and, because he was so imaginative and bold, had managed to become one of the biggest builders in the city. He was instrumental in bringing Mies van der Rohe to Chicago. He was the builder involved in Mies's Chicago projects. He, Greenwald, was interested in modern architecture and in modern art, too. He wasn't a collector, but he was interested to see that I was now a painter. And so we renewed our friendship.

"That summer, when Greenwald and I spoke and I told him I'd been fired, he made Nancy and me an offer: He would give us five thousand dollars so that we could take a year to just paint and I wouldn't have to teach. He mentioned how we might travel, leave Chicago for a while. It was a lot of money at the time, five thousand. And there was this part of me that wanted to just take it. But I was very proud, okay? I went out and hustled other teaching jobs."

That fall, Golub managed to make more money teaching fewer hours than he had in the spring, when he did most of his teaching at Wright. He had told me he felt that perhaps it had all worked out for the best. But this feeling did not last long. One of his new teaching positions was at George Williams College.

"It was a small Protestant missionary college," he said. "I liked it at first—they were nice to me, the kids were fine. Near the end of the semester, they asked me and this other instructor—there were two of us teaching art—if we would create some Christmas decorations for the school. And we said sure. We did these very modern mobiles, okay? But it was work, and it kept me at the school until midnight for two straight nights. And I remember coming home the second night, and having a late supper with Nancy, and I hadn't been getting any of my own painting done—and I finally just said, 'What the hell am I doing this for? Why am I refusing Greenwald's offer?' And the next morning I called him and said that if the offer still stood, I accept. I mean, I just needed out. And he understood. The money was there if I wanted it. I fulfilled my teaching obligations that spring, and then off we went."

They had decided they would go to Italy for a year.

"What I wanted," Leon said, "was to get a feel for the Mediterranean. To get closer to the sources of classical art. Ever since I had studied art history, I had wanted to explore this. I had actually done a painting in 1953, a painting titled *Thwarted*, where for the first time I was consciously looking to classical forms. *Thwarted* was inspired by the famous Belvedere torso, a fragment of a seated figure now in the Vatican collection. I was interested in the expressive or psychological aspects of the sculptural fragment. With *Thwarted* I worked from a photo. Now I wanted the Mediterranean light and color, the proportion and sense of possibility. I didn't know if I could get it, but I wanted it."

Leon told me that he and Nancy had sought from friends the names of places in Italy they thought would be the least expensive for a family of four to stay. The first place named by two people was Ischia, a small island northwest of Capri and a brief boat ride from Naples. Ischia was (and remains) a stylish summer resort for Italians; but housing was cheap enough once one got away from the beachfront. Leon, Nancy, and their two small boys arrived in June 1956. Golub rented a small apartment in one of the less-picturesque spots on the island, and he took a basement nearby to use as a studio.

On the train, looking through my notes, I tried to picture

how it must have been for them that summer on Ischia. It was this summer, I think, when Leon and Nancy truly came to understand how alone they were now. Not lonely, not at all. It was that their sense of belonging was no longer to a place, or to a group, or even to an idea ("success in New York"), but simply to each other, and to their work. There is a small, sweet picture Nancy drew four years later in Paris, and that is what I thought of now: two nude figures, Adam-and-Eve-like, the male bullet-headed, the woman ripe. They are in a cave, or something like a cave, and they are sheltered from a torrent. The drawing is called *Leon and Me*.

Mornings, when it was warm and sunny, they would take the kids to the beach; each afternoon Leon would paint (Nancy would paint late into the night); in the evenings they'd make dinner, put the boys to bed, then sit and read. Golub was working now every day. He was living—it occurred to him then, and he told me—"like an artist." And the new surroundings—the old churches and strong light and Mediterranean colors in every narrow street—had an almost immediate effect on his paintings. Golub's outlook, his essential understanding of the world and man's place in it, remained bleak, harsh, existential. But the space opens up in his Ischia paintings, his forms become more sculpted, and his palette softens and lightens. "Chicago" as an aesthetic, a way of seeing—Chicago, "tough" and "primitive"—was suddenly shed for something more "classical."

This change shows dramatically in *Orestes*, the first big painting he completed that summer. I had seen it in New York, at his New Museum show, and had a small, crude sketch of it, along with my scribbled comments, in my notebook for 1956. The painting is nearly seven feet high—larger than anything he'd done to date, and radically vertical (unusual for him). A nearly full-length figure, naked and stony and armless—like a broken sculpture in the Grecian severe style—squares himself before us in the foreground. His head is a great block; his face, the mix of colors that reads as bruised flesh, is a rough map of pain; his eyes stare out at you, but seem fixed elsewhere, perhaps upon something too awful, glimpsed not long before. Behind him is a raw and barren landscape. It could be the end of the world.

The basic composition and pose of the figure—especially the

way his weight is on one leg—also brought to mind Cézanne's famous *Bather;* it was as if Golub, sensing his times, had moved Cézanne's figure to the post-apocalypse setting of Stanley Kramer's *On the Beach.* The painting's title, of course, triggered other thoughts: This must be the Euripidean Orestes, the tormented existential, the Orestes of interest to Sartre, pursued and driven mad by the snaky-haired Furies. Maybe Golub's *Orestes* wasn't armless but straitjacketed. Maybe those eyes belonged to someone "inside," beneath the stony-looking carapace—someone in there aching.

I had talked with Leon about *Orestes,* and he had said, "In Italy, I had direct access to the classical. There was the Naples Museum. What the Field Museum had been for me in Chicago, okay? Now the Naples Museum, in a sense, became that for me. I would take day trips from the island. I saw these late-Roman sculptures and plaster casts—300 A.D., something like that. No refinement. Proportions all out of whack. No technique to speak of. They were grotesque, but in their own way grand. Or at least I thought so. Looking at them, you could see before you the original Greek ideal—the classical ideal—breaking down. These statues were like shells. So bombastic. Etruscan art, pre-Roman— I was crazy about this stuff, too.

"The actual sculptures I had in mind with *Orestes* were Etruscan. . . . I was reading about classicism that summer, too: Jane Harrison on Greek religion, Eric Auerbach's *Mimesis.* I was thinking: Get more objective. Get at the things—the existential things—but get at them more objectively. Classicism was a way into that. But classicism was an ideal, an impossible one for modern man to realize. And even more impossible for me."

I had asked him at one point about Cézanne's *Bather*—did he have the painting in mind when he painted *Orestes?* The right knee of both paintings was "off" in such a similar way.

"Oh, that," he'd said. "In Ischia I was working on the floor, mostly, in this basement. The ceiling was so low. The first time I lifted the painting up, I could see it was all out of proportion. I could never get that leg right."

And I had asked him, with this interest he had in the sculptural fragment, if he ever thought of actually making sculpture.

"If I had done sculptures of the sculptures, you would not be

as conscious of the idea, the metaphor—the individual in a crumbling civilization, alone and pained, things like that. And, anyway, I'm a painter."

At summer's end, Leon, Nancy, and family left Ischia and took an apartment in Florence. Leon liked the museums and the architecture, but he was soon aware that the best part of the trip was behind him, on the island. The city was damp and chilly, and their apartment never had enough heat to keep out the fall and winter. There was little space in the apartment to work, and not enough money to rent a studio. Before they knew it, spring arrived and the year in Italy was up—and, with it, the time to paint each day, the "life as an artist."

Back in Chicago, Golub accepted a full-time teaching post at Indiana University, and they moved to Bloomington. He would get to Chicago every other week to see friends and art shows (and to teach two groups of students privately). He would teach, paint when he could, and wait.

Leon: "Bloomington was okay, actually. One of the best things was the big studio they gave me. But Bloomington was not really where I wanted to be. Now, after a year there, in the fall of 1958, I receive another offer from my friend Greenwald— an offer of twelve thousand dollars for two years in Paris. Another unbelievable moment. Now, I should have been a little wary of unbelievable moments. But Paris—and all that time to paint! So I resign my job at Indiana, this is the spring of fifty-nine, and everything's set for us to leave for Paris in June. And then: Greenwald is killed in a plane crash. It must have been two, three weeks before we were set to go. It was awful. He left a wife and two small children. Here was an extraordinary young man who had already changed the way Chicago looked—had changed the skyline. And a remarkable friend.

"Now his widow offered to make good on Greenwald's offer, but I couldn't take the money—I didn't know what her finances were. And then—unbelievable again—Frumkin comes through." By this time, Golub had been showing several years at the Allan Frumkin Gallery in Chicago. "He agrees to give me twelve thousand against future sales—which, since I'm not selling well just then, is quite remarkable."

In Bloomington, Golub had continued to paint his Orestes-

like, classical figures: standing, seated, dropped to one knee, even (in one case) on horseback. He'd also begun a series he called *Colossal Heads:* mural-size portraits based on larger-than-life Roman sculpture fragments of the Constantinian period. Golub used white and fresco-thin pinks, reds, and blues to great effect in the *Heads*. In these "discolored" faces, even more than in the face of Orestes, there is the numb evidence of a battering that someone should have stopped but did not. He also began to explore more fully the expressive possibilities of the painting's surface. He had previously done deliberate damage to his surfaces, ripping and melting them, using a knife and other tools to raise welts and leave lacerations. But this registered on the viewer's eye mostly as an attempt by the painter to make his presence felt; it said "theater." What Golub was doing now was something else. He was beginning to get "inside" the figures. The abrading of the surfaces of these pictures did not seem an afterthought, or even a "thought"—a style devised. One read the abrasions in these pictures as one read Golub's lines and forms; they were necessary, they flowed from his involvement with what he sought to depict. His surfaces simply could be no other way.

He was working almost exclusively now with a lacquer called Dev-o-Lac. He had begun to use it before he'd gone off to Italy—employing it in conjunction with oil in a way that encrusted his surfaces and allowed for scraping and gouging. "But," he had told me, "I hadn't been systematic. In Bloomington I was now after something specific—I wanted to get a marbleized effect, like old sculpture. I wanted to capture a kind of physical experience of erosion—existential stone sculptures! A stony and implacable sense of survival. I developed a whole new way of making my paintings: I would build up ten, fifteen layers of lacquer. I would apply the lacquer, then pour on paint solvent, scrape the paint off, apply even more lacquer if those coats weren't enough, then scrape again. Physically, it was a fierce kind of painting—I would spend hours on the floor, on my knees, scraping these surfaces, the smell of lacquer and solvent suffusing the room. This was so important for me—I mean, this is still pretty much what I do. I was getting at something—this sense of erosion, the vulnerability that the worn-away quality gave these big, classical figures and portraits."

Golub's classicized, scraped paintings were a long way from his primitivist icons of just a few years before—they were no longer "Chicago." (Interestingly, paradoxically, it was around this time that Golub became identified most strongly with the painters he had been close to at the School of the Art Institute, and in the years that immediately followed. They got the name The Monster Roster, and in some circles Golub even now is referred to as a member.)

Frumkin showed a number of Golub's new classically inspired paintings and even sold a few of them. "But my sales up to that point had amounted to perhaps three thousand dollars in a good year," Leon had told me, "and here he was offering me double that against future sales."

Frumkin didn't have to wait long for Leon to earn back the advance. Just a week or so after Frumkin made Leon the offer, Lewis Manilow, a Chicago collector, unexpectedly purchased his first and only Golub—the big, new *Reclining Youth,* inspired by the great Hellenistic sculpture *Dying Gaul of Pergamon.*

Leon: "You get a call that someone has just spent—what? Eleven thousand, twelve thousand bucks for a painting of yours. My take was half, okay? The six thousand Frumkin advanced us was now really ours. And you know what this money has just bought you: Paris."

2.

THE FIRST CHESTNUTS underfoot; the sky at dusk a pale orange smudged black as if with soft coal; a chill, and the tap of dress shoes on pavement—in Paris, autumn had arrived. It was after six, and I was walking along the Quai D'Orsay to the Galerie Darthea Speyer at 6 rue Jacques Callot, a "wide street but very short," Leon had warned. I was to meet him there and I was late. And then, somewhere behind the Ecole des Beaux-Arts, I was lost. By the time I reached the gallery the opening was pretty much over, and the crowd, perhaps several dozen men and women, was breaking up.

I saw Leon standing and chatting in a small group at the curb.

Before approaching him, I ducked into the gallery to see the show. It was a small space by New York standards, and much too small, I thought, for Leon's paintings. The three big canvases in the show stretched from floor to ceiling; there was little wall left bare, little space left around the pictures to help you get a sense of scale—the sense of "public" scale that is crucial to an understanding of Golub's pictures. There was hardly room enough to step back and take in the largest paintings. This was an intimate gallery, a room for watercolors, delectation. It was as if Golub's pictures were not welcome here.

And this sense I had that the gallery space was not the best setting for Golub's pictures brought to mind a broader question of context: How could Golub's paintings speak to Parisians? Their bluntness, ungainliness, and also their "content"—Golub's cruel political criminals. The "Americanness" (in the broadest sense) of his political thugs, their specificity, might seem just the opposite: exotic, fantastical. The world of contemporary art is international as never before; art—and artists as well—move from city to city, continent to continent. Some art (and artists) can survive this, even thrive: In the 1980s, there were many new American paintings purposely flattened of history and of context—"neo" abstract or pop, minimal or conceptual—and these were rather easily marketed abroad (money, unlike meaning, being readily exchanged.) But there are other paintings that do not travel well, that cannot carry with them everything essential to their understanding, and I was beginning to suspect Golub's were among these.

I had seen these paintings of Golub's in his studio; they're good paintings. One, titled *Threnody,* of three woeful black women, had, to my mind, brought his "blacks" from their South African shantytowns back home. In this powerful—powerfully beautiful—new painting, the women could be huddled against the cold (and worse) in America's city streets. But *Threnody* and the others didn't look good to me this night in a storefront-size gallery in the sixth arrondissement.

When I got back outside, there were only a dozen or so people in the darkened, quiet street, milling around in twos and threes. I spotted Leon, who was busy making sure everyone headed for the party, knew where it was, and had a ride. The dealer Darthea

Speyer, an American expatriate, was an old friend of Leon's from his Paris days. She had organized a show of his work and that of the painter Balcomb Greene at the Centre Culturel Amércain in 1960, and had also bought a couple of his paintings from that period. On this night she was throwing him a party at her apartment in the seventh arrondissement, a ten-minute drive from the gallery. Leon and I squeezed into the backseat of sub-compact driven by a painter friend of Speyer's and off we went, winding through narrow streets and talking loudly over the small car's din.

Leon was in a good mood, ready to hold forth, and I was glad to see him, and to listen. "The French," he said with a wry smile, his hands up and talking, too. "It's all there on the surface—in art and everything else. Their whole thing about style, their way of defining themselves. They're subtle, the most civilized of people. But you never get inside. All the years I lived here, I never got inside. On all levels. There were people we knew here, okay? Would see occasionally. Never invited into their homes. Always in a restaurant." He was chuckling now, and I was, too. "You think it's funny? I'll tell you what else I never got inside. I never got inside the art market here. Five years in Paris I never sold a painting to a French collector. Not one. And I don't get the idea I'm going to break my streak with this show."

Leon went on to say that aside from Charles Saatchi in England, he had no real market for his new work in Europe.

"Maybe it's me," he said. "Maybe I'm too old for the hustle. I mean, you should have seen it in Germany at Documenta this past summer. The Europeans like the young Americans. Young flesh, you know what I mean? Who doesn't like young flesh? You buy the painting, you get a little—you come to New York, go to the fancy restaurant with your new artist, okay? It's aura. I don't think they want me." He laughed and paused. Then he said, "That's part of it, anyway. But it could be the rawness of the work itself. Who needs a painting of a death squad on the wall?"

Leon then brought up the name of Hans Neuendorf, a prominent German dealer.

"I haven't sold in Germany, but Neuendorf seems to think I can." Barbara Gladstone, Golub's New York dealer, thought he could sell in Germany, too. The director of her gallery, Richard

Flood, had told me so. The thinking was that Golub was an expressionistic painter—his roots were in German painting. "Neuendorf is going to represent me," Leon said. "He was at the opening tonight. He's constructing this large new space in Frankfurt. Nancy and I are flying there on Saturday to see it. An able and impressive guy."

He paused, and then said: "Now some of these European dealers—well, it's different. They have this whole approach, okay? They want the early work, too. They store it away someplace, and then when you're gone, or even when you are still around, in some cases, out of the mothballs it comes. I don't think I'd like the idea of somebody buying me up in quite that fashion, okay?"

We parked in a hushed and elegant residential block, and followed several others who had parked near us into a courtyard and up to the party. The apartment was grand—I'd never been in such a place in Paris. Twenty, thirty people were in the large, quietly lighted parlor. A proper young waiter was offering champagne. I lifted a glass from his tray and walked over to the window, where I stood for a while, taking in the fine view and listening to the murmurings in French and feeling, like Henry James's Nick Dormer, the city's "general sharp contagion."

I headed for the buffet table, where I filled my plate. And then, looking for a place to sit, I spotted Nancy on a sofa, in conversation with a woman seated across from her in a stuffed chair. I sat beside Nancy, and when the woman got up to get something to eat, I struck up a conversation.

"Your French sounds pretty good," I said.

"It's not. But it's better than Leon's. He never quite got comfortable with it. You know, I don't know if he was ever that comfortable here. I mean, he liked it, but comfortable . . ."

Nancy then mentioned that it was just about this time, late September, when they had gotten to Paris.

"I thought you'd come in the spring."

"Yes, we came to France—I mean, we flew to Paris. But we left immediately for the coast, for the summer." With the two boys, and their dog, Rouge, they'd driven north and west to the Atlantic coast. The idea, she said, was that they would drive until

they found an affordable place they both liked, and they did: an old cottage, just a few blocks from the water, in Deauville. "When I think of it," she said, "I always see this photo we took of me with the kids in the garden. It's a small garden, and I'm giving them a bath in a basin. There was no shower or bath in the house. Leon and I would use the showers when we went for a swim each day at the pool—there was a pool nearby. But the kids got spit baths."

It was chilly and damp, Nancy said, and there weren't many people around, and that was fine. They painted. Nancy worked inside, and Leon worked out in a small garage—on the floor, as he had in Ischia, three years before.

"It was that feeling again of being far away from things," Nancy said. "We didn't know anyone—it was Leon, and me, and the kids. Oh, and the dog. I remember that there wasn't even a phone, so we weren't in contact even in that way. I think Frumkin was the only person who knew how to get in touch with us."

Later, after coffee had been served, I sat for a short time with Leon and asked him what he remembered of that first summer in Normandy.

"You know what was so great?" he said. "We just got in the car and drove. The freedom of it—just driving. And then, the freedom to paint every day. What a thing that was."

I mentioned how Nancy had spoken to me of her feeling of being far away, how she seemed so comfortable with that.

"Well, about that I don't know. I remember how we got a telex—it must have been from Frumkin or something—telling us a photographer from *Time* magazine was on the way. This must have been for the 'New Images of Man' show at the Museum of Modern Art. That opened late in the summer that year, I think. That was something. I wasn't too far away to get the feedback on that."

"New Images of Man"—that I knew about. It was something of a legend in New York, notorious. The show, a large survey of recent figurative painting and sculpture, opened in September 1959. Included were works by Francis Bacon, Richard Diebenkorn, Alberto Giacometti, Jean Dubuffet, Willem de Kooning, and many others less well known, including Golub. The show was organized by Peter Selz, a newly hired curator and an old

friend of Golub's and longtime supporter of his work. They had met at the University of Chicago, where Selz was doing graduate work in art history during the years Leon was an undergraduate. Selz was already doing scholarly research on the German expressionist painters, a field in which he would establish his reputation in the 1950s with the first comprehensive study of these artists. (Selz is today a professor of art history at the University of California at Berkeley.) Selz had introduced Golub to the work of Dubuffet, and later he had written about Golub's paintings and mounted a show of them at Pomona College in California, while he was teaching there in the mid-fifties. When Selz talked with Leon about the big exhibition he was organizing at the Modern, and then selected five of his paintings for the show, including *Reclining Youth,* one of the biggest paintings in the show, Leon was naturally excited. (Selz also selected several sculptures by Golub's old friend, Cosmo Campoli.) This might be just what would get him—get his paintings—back to New York. One of the last things he did before leaving for Paris was write a statement about his recent work—his ruin-evoking lacquer paintings of sculpture-like classicized "heroes"—for the exhibition catalog:

> *The figures are implacable in their appearance and resistance. They are implacable in the compacted wearing-down of surfaces and forms to simpler forms but with more complicated surfaces. They are implacable as they take on the resistance of stone as against the undulation of flesh. They are implacable as they know an absolute state of mind (on the edge of nothingness) just as they know a nearly absolute state of massiveness.*

In his catalog essay for the show, Selz made no great claims for the work he had chosen—it was no manifesto, no argument of that kind. It was an eclectic show of painting and sculpture: work he liked, work that confronted and represented the human figure, work that in many cases (but certainly not all) had been somewhat overlooked in the preceding years, the years that had witnessed the triumph of abstract expressionism. The show was read very much as an argument, however, by the important New York critics, and perhaps, in retrospect, it had to be. It was

organized under the auspices of the Museum of Modern Art, then at the height of its taste-making power. And it came at a moment when the New York art scene was fluid, even uncertain as to what would matter next and what would not. There were so many new developments in art in New York in the late 1950s. There were the paintings of Jasper Johns and Robert Rauschenberg: neo-Dada. There was, in the spring of 1958, the first "happening," scripted by Allan Kaprow and held at the sculptor George Segal's chicken farm in New Jersey. There was the show (in 1959) of Barnett Newman's austere stripe paintings, organized by Clement Greenberg at the Madison Avenue gallery French and Company; this was the show that established (at least for some) that cool, non-painterly abstraction was the one true path out of the fifties.

So much new work, and so varied. But it could be argued—and eventually it was—that all of it fell within a tradition of New York art, a new formal "anti-figurative" tradition, as it had been established by the abstract expressionists, and especially by Pollock, in the late 1940s. Selz seemed to be getting at something else, or so it was thought. (Selz had actually included a few Pollock paintings in "New Images of Man," but this only served to heighten the anger of the show's formalist critics; it was as if Selz were daring to attempt to read some "humanist" meaning into Pollock's experiments in pure form.) Selz seemed to be saying that abstract expressionism hadn't "triumphed," if what was meant was a conquest. There were painters and sculptors who continued to work in other ways, even older ways; and there were painters and sculptors who continued to work outside New York. Most of the artists in "New Images of Man" were, in fact, not New Yorkers.

The critic Dore Ashton has written gently that "the response to the exhibition was troubled." "Savage" was perhaps the better word. William Rubin, who would later be appointed chief curator of the Museum of Modern Art's painting and sculpture collection, was writing for *Art International,* one of the most important art magazines (the other being *ARTnews*), and his was the most ferocious attack: "The works on view constitute as disparate and uninteresting a group as has ever been assembled for a major museum show," he wrote. And he singled out Golub in particular:

"This painter seems to interest a few people whose opinion I greatly respect, and it may be I'm blind to Mr. Golub's virtues, but I must say that I have seen very little outside the school studios that is so inflated, archaizing, phonily 'expressive,' badly painted, and generally 'pompier.' The only thing big about the result is its windiness."

Leon mentioned the review to me in Paris that night. But he didn't really want to talk about it just then. The reception that greeted "New Images of Man," and the Rubin review in particular, assured Golub that his work was not to have a significant place in New York, not now. That winter, the Modern mounted a show of new work titled simply "Sixteen Americans." As the critic and art historian Irving Sandler later wrote: "The museum [with this show] conferred its recognition on the no-and-anti gestural styles of [Ellsworth] Kelly and [Frank] Stella (whose black pictures provoked immediate controversy) and on the so-called neo-Dadas Johns, Rauschenberg. . . ." The 1960s were thus roughly mapped, a number of its brightest stars located. This was no time for Golub.

"When we get back to New York," Leon told me in Paris that night, "I'll show you the letter I wrote Rubin after the review came out. An interesting item."

He did, and it is:

Dear Billie,

Honey, I want you to know what a big slob you are—After comparing your bully boy critique of my paintings in "New Images" with your next pretty boy ecstasy—it's a pleasure to call you a sap, you sap—

Yum, yum, kid

Leon Golub

turn over, sap, for original drawings—

3. ON SATURDAY NIGHT I had dinner with Leon and
Nancy in a noisy neighborhood bistro in Montmartre. (The place
had been suggested by their youngest son, Paul, who was born
in Paris in 1961 and now lived there, working with the Théâtre
de Soleil, an experimental, politically minded troupe.) They had
been to Frankfurt for the day to meet with Hans Neuendorf and
to see the new gallery space he planned to open there. "I think
my paintings could do all right in Germany," Leon said shortly
after we were seated. "This is going to sound all wrong, like I'm
bragging, okay? But I had a show in Germany this past spring—
it was the show that had been at the Kunstmuseum in Lucerne,
in Switzerland. It traveled to Hamburg. And the night it opened

in Hamburg, when I walked in, people applauded. Have you ever heard of such a thing?"

Over dinner, Leon and Nancy told me something of what it was like during their Paris years. They lived in the sixteenth arrondissement—in Porte Dauphine—off the Avenue Foch, in an apartment that they rented from White Russian emigrés. "It was what they called a *hôtel particulier*, and we had the first floor," Nancy said, "with a room for the kids and a living room/bedroom for us and a studio we shared for a year or so until Leon got his own studio. And then a kitchen downstairs."

"I remember the walls of the place," Leon said. "Lousy walls—this cruddy, bilious green. For five years these awful walls."

"And the mattresses," Nancy said. "The worst."

I asked them why they didn't do something about the walls and the mattresses.

"Good question," Leon said. "We asked ourselves that years later, when we had left. It wasn't money—I mean, we had the money. Frumkin sold paintings of mine the whole time I was here. In the early sixties I might have been averaging fifteen thousand, even twenty thousand a year—a considerable amount at the time. While we were here, we did all right. We would go on vacations every summer—the island of Ibiza, the Adriatic, the Greek islands. But we lived with the walls and the mattresses."

I suggested that maybe they always knew they were not in Paris to stay—maybe that was why they did nothing to the apartment.

"Probably," Leon said. "Probably."

We ate and lingered, talking. And then after dinner we walked for a time. It was late and cool, and the steep, winding streets—which had been so crowded before, when we'd entered the restaurant—had emptied.

"I want to go to the bookshops and bookstalls tomorrow," Leon said, as we walked along. "It's got to do with my new plans."

I asked him if he had actually begun the new paintings he had spoken to me about weeks before in New York, the ones

that he thought might pick up on earlier themes of his from the 1950s: "monsters," "irrational" creatures part man and part animal.

"Yes, that's what I meant. I want to get some books. I'm looking for pictures of lions. Lions and sphinxes. That's part of what I'm thinking about now. I actually did a few sphinx pictures in Chicago in the mid-fifties, before I came here. Have you ever seen them?"

I said I hadn't.

"Well, they were really wild—some of the wildest things I ever did, I think. But now I want to give them a twist. I want to do—or I think I do—I want to paint cyborgs."

"Cyborgs?"

"A cyborg is a creature. Part human, part machine, part computer intelligence. Beyond human, in a sense. Real, but simulated. Powerful—more powerful than you or me. Yet vulnerable, too, but not exactly in the way we are vulnerable."

"And the sphinxes?"

"Well, the sphinxes were the cyborgs of their age. I mean, what I'm saying—what interests me—is that throughout Western civilization, there has always been this notion of crossings of this kind, extraordinary mixes of man and animal."

We walked along for a while longer, talking and looking for a cab. At one point I suggested that perhaps he, Leon, was doing these paintings now because he had the luxury of doing them. As a successful painter, he could return to themes that had not brought him acclaim, or even attention, in the past; that he could "recoup."

"Wrong. In fact, you are more at risk if you're successful. When nobody's paying attention you have nothing to lose. When you make it, there is a strong impulse to keep working in the vein that brought you success. It may be that your dealer, the critics who support you—nobody wants you going off on some tangent. When you've been through ups and downs, the only person you have to prove something to is yourself—and anyway, most artists are irascible, obsessed, convinced.

"A painting has to look right to me. Now, there is a strong possibility that these paintings I have in mind will turn out to be

regressive, sentimental—you name it. They may turn out effete—
that's the problem with the monsters the symbolists painted. But
if they don't work, okay, I'll destroy them. Simple as that."

4. THE PARIS SO important to other artists—the famed
Parisian light, the galleries of the Louvre, the faith in "form" and
"sensibility," even the texture of the city that affected those (like
Giacometti during the postwar years) not particularly touched
by either its aesthetic traditions or its latest trends in art—Paris,
as such, would seem to have meant little to Golub, to judge from
the paintings he did there. Under some the most powerful influ-
ences a place might exert on a painter (and in this case, a painter
so deeply affected by Chicago, the Field Museum, and then Is-
chia), Golub kept to his ways. The paintings of 1960 and 1961
might have been done in Bloomington, Indiana. His stony, clas-
sicized figures became less Grecian or Roman, more generalized
and "modern"; and his technique of layering and then scraping
the paint left his heroes not so much marbleized during these
years as horribly blistered. But these are subtle changes—espe-
cially when compared with the changes his work underwent when
he arrived in Italy in 1956. Perhaps it was that he was older now,
nearly forty, more settled and self-contained. Maybe—despite
the greeting his paintings received in New York—maybe he was
that sure he was on to something.

I talked with Leon about the paintings he did in Paris in the
early 1960s as we walked the streets around the Opéra late on
a Sunday afternoon, trying to find his old studio. "The work went
slowly for me here, especially at first," he said. "Back at Bloom-
ington, I had begun to be interested in putting the figures in
motion. And that led to a whole series of problems. It was like
I had to learn anatomy all over. Getting the gestures just right,
how weight shifts—things like that. This was new to me. I mean,
I'd learned about it in school, in theory, but that wasn't much
help to me. I had these figures, kind of frozen, okay? I wanted
to get them moving."

We were looking for Impasse Briare, too small to have found its way into my *Blue Guide*. I asked Leon as we walked along to tell me more about his attempt to get his figures moving.

"Now, one of the things I began looking at, in relation to this, was sports photographs," Leon said. "I was still working from reproductions of Greek and Roman sculpture, but now I had these other photos, first of wrestlers, then soccer players and rugby players. I wanted to get at that sense of being poised for action, the musculature and gesture. . . . Wait."

He'd recognized the block. A few zigs and zags through narrow, nondescript streets—it appeared from the shops to be an Arab neighborhood—and we were in the rue Rochechouart.

"This is the street."

And down a ways, hardly noticeable between two run-down apartment houses, was Impasse Briare: a dank, narrow, cobblestone alley. Thirty yards or so from the street, it opened onto a "courtyard"—a cement patch where the backs of buildings conjoined. On the side of one of the sooty gray buildings was what appeared to be a little, wooden addition, painted a creamy white: two runty stories and, on top, a skylight.

"This kind of place was used traditionally by carpenters, masons, and so on—they'd work here, store things," Leon said. I could see cardboard boxes; it looked to be a storage space now. "I worked in there for three years. I'd paint downstairs, and in the winter, when I got cold, I'd go upstairs, where I had this little electric heater. I had a *bail*, a lease, that I think I paid a thousand dollars for—and that gave me use of the place for three, four years. And then it was twenty, thirty dollars a month for lighting and so on. There used to be a little latrine up the stairs that everybody used, but it's probably gone."

It was getting dark and a little cold, and we went looking for a café. Leon suggested one a couple of blocks from where we were, a corner place where he used to have his lunch. It was still there, and we went inside and ordered coffee. Next to us, several Arab families had pushed together a few tables; kids were eating sweet things and running about, with the women yelling at them to sit, and the men talking and laughing and smoking.

We ordered coffee, and then Leon talked more about the paintings he made there in the early 1960s—how he had worked

to get his figures in action. "I wanted this sense of combat, of power not just implied, okay? I wanted it there in the musculature, the expressions, the actions—grappling, punching, and so on. And even as I'm getting better at the anatomy, I find I can't pull it off with the lacquer I'm using. Try as I did, I couldn't get my brushstrokes to do what I wanted them to do—convey the action.

"So what happens? One day I get a letter from the Dev-o-Lac people. That's the lacquer I was using, ordering it by the case from the States. Anyway, I get a letter that they're going to stop making it. So what could I do? I started to experiment with acrylics. I couldn't use oil—well, I could, but I wanted something faster-drying. I used Liquitex. Now, it was maybe a year before I could use it to my satisfaction—it was a kind of starting over. The main thing was, I couldn't build up the surfaces and scrape in the way I had, using the lacquer. I had to do other things. I had to emphasize line more, and contour. And with directional brushstrokes more than scraping—though I was teaching myself how to build up and scrape acrylic, as I do today—with the brushstrokes, I could animate things."

Combat I (1962) is the first of Golub's paintings in which the figures are set in motion—two warrior-like figures, naked and rippling with muscles, slug it out on a mottled-pink ground. The action is no longer on the surface, but in the forms, and yet it's not a great deal of action; the figures are still blocky, stiff; and there is little sense from the composition that they are doing any real damage to each other. Creating convincing movement in a painting has always been a problem. Even the Italian futurists, who had made such a point of depicting violent action or somehow conveying it, didn't really pull it off.

"Painting is so slow," Leon has said to me a number of times. And he is right. In his recent paintings, except in the rarest of instances—*Riot III* is one of them—he had posed his figures, kept them still. He had sought to have the viewer concentrate not on violence, but on the violence implied by the "types" he portrayed.

Golub told me that he had three gallery shows of his paintings in Paris in the early 1960s, two of them at the Galerie Iris Clert. Iris Clert was one of the more flamboyant figures on the Paris art scene. She liked to go to parties and affix to people's dresses and jackets little stickers that read: "Iris Clert, the world's most

advanced gallery." And she *was* advanced: She showed *les nouvelles réalistes*—Yves Klein, Jean Tinguely, Christo, and others—who, like Johns and Rauschenberg in New York, had their aesthetic roots in Dada. (Perhaps the most famous "show" at Galerie Iris Clert was held in 1957, when Klein exhibited no work, in the understood sense of that word; he simply showed himself, his "presence," and the hundreds of chic French guests at the opening became, to their pleasure and, in a few cases, dismay, the objects to be studied and scrutinized.)

I couldn't imagine Leon's paintings in this setting. I told him that it was as if he had found in Paris an island of the New York he was trying to leave behind.

"In a way, yes, in a way," he said. "There were a number of scenes in Paris at the time, though—and coming here, that was the attraction. You had the new realists like Klein and the others, though Klein himself had died by the time I arrived. You had American expatriate painters like Joan Mitchell. You had Giacometti continuing to go his own way, okay? I liked that. I really didn't want to be part of a scene, or a group—though a little more attention wouldn't have bothered me. I liked Paris because you could go your own way. In New York that wasn't so possible. New York had movements."

But he kept his eye on New York—he knew it was New York that mattered. Frumkin had opened a New York gallery while Leon was in Paris, and during the early 1960s Leon showed there several times, attracting the occasional respectable review, but no real attention. And he read the journals and magazines; he kept up on developments in New York, thought about them, measured his work against them.

"I was then, as I always have been, an American painter," he told me. "I didn't come to Paris to be a French painter."

5. AFTER COFFEE, we walked toward the Seine. Perhaps it was the neighborhood, with its bakeries with bags of pita and the shop signs in Arabic: It struck me then that Leon had lived

in Paris during the last years of the Algerian war, and that I had never heard him mention it. The war, which began in 1954 and lasted until the summer of 1962, was essentially a rebellion by Muslims in Algeria—the last French holding in North Africa—to gain independence. There were eventually more than five hundred thousand Frenchmen under arms in Algeria. By this time, in the early 1960s, the war had also been brought home to Paris. Frenchmen were discovering—as Americans would at decade's end, with the war in Vietnam—that the restraints exercised in the newly devised "limited wars" fought in small, underdeveloped countries were for the most part theoretical. There were stories in the French papers of young French parachutist officers torturing prisoners with electric shock, and photos of burned native villages and the roadside encampments of homeless, hungry Arabs.

But this was only a part of it. The war had also been brought home literally, violently. Fire bombs were being tossed into Paris cafés and bathrooms, and *plastic* planted in the editorial offices of newspapers. These bombings (there were hundreds of them) were mostly the work of the Organisation de l'Armée Secrete, a group of ultra-rightist Frenchmen aligned against the French withdrawal from Algeria, which by 1961—a year in which the group was credited with nearly six hundred bombings all over France—was looking more and more inevitable. The French left was nonviolent but militant—marching and shouting in denunciation of France's conduct in the war, and sometimes being beaten by the police. The police were also blamed when, from time to time, the body of an Algerian nationalist was fished out of the Seine. However, there was also a good deal of factional infighting among the Algerians in the city, and assassinations were neither rare nor discreet; Janet Flanner, writing in one of her regular "Paris Letters" for *The New Yorker,* made mention of the Algerians' fondness for machine guns and getaway cars—"Chicago-style" slayings, she called these political killings.

I brought up the war with Leon. "In a way," I said, "this was the one time you've lived with the kind of political violence you get at in the paintings you do now."

"You know, I have thought of that, too," he said. "I mean, it was bad here for a couple of years. Sixty-one, especially. Many

nights you could hear the explosions. Or you'd be walking along, and a police car would screech up. Searches, car searches—we had to stop a number of times driving back into the city, open our trunk, and so on."

He paused, and then said: "I'll never forget. One morning, it was in the spring, I'd gotten up like I always did, and taken the dog for a walk. I'd walk the dog, and buy a paper—*The International Herald Tribune*—then come back and have breakfast before going off to the studio. And I turn the corner, right down the street from the house, and there, on the curb, there's a body in a pool of blood. And I can see police coming from all directions, dozens of them. It turned out, according to the papers, that he was an Algerian who had been a tennis star in France, and also was a member, I believe, of the National Assembly. And he'd been killed for it. A 'traitor,' his killers called him when they phoned in or whatever to take the credit.

"And then later that day, when Nancy and I were picking the kids up from school—they were attending the Ecole Bilingue—near the school . . . well, there was this Arab who had a flower cart. We would buy flowers from him once in a while. He was in the midst of a sale when suddenly these policemen pull up, jump out of their van, grab him, literally throw him into the back of the van. It was pretty loud, rough. And then this scene of the pushcart, and the flowerpot on the ground, where he had dropped it when the cops grabbed him. I can remember the customer picking it up, putting it back."

I asked Leon if he had participated in either of the two big protests against the Algerian war that took place in 1961. On a warm April Monday, following Easter weekend, hundreds of thousands of French men and women demonstrated against the crazed, and ultimately farcical, "General's Revolt." Two days before, Frenchmen had awakened to the news that, in Algiers, French officers led by four retired generals had staged a putsch. This new junta issued a statement saying that the military under their command would not oversee an orderly French withdrawal from Algeria but rather would "save" it for France. The French government under de Gaulle, as well as the French people, was shocked. And then, on Easter Sunday, wilder rumors began in Paris: Legionnaires, parachutists, and French soldiers were on

their way back to France, and their intention was to dismantle the Fifth Republic and establish military rule at home. Calls for a general strike to begin the following afternoon at five went out over the radio and were published in the papers. And precisely at five the strike began. The Métro stopped. Buses stopped. Frenchmen took to the streets in massive numbers. All of Paris ground to a halt. It was the greatest street demonstration in French history.

And then in December 1961, just before Christmas, there was the famous march through Paris, organized by the left, to protest not the conduct of the war, or the threat of a coup, but France's very presence in Algeria. The protesters, about twenty-five thousand, were calling for French withdrawal—a radical idea to many Frenchmen, and one greeted angrily and violently by some. Thirty of the marchers were hospitalized when the protest turned into a brutal battle with the police in the streets between the Place de la Bastille and the Hôtel de Ville. Later, in France, it was discussed less in relation to the Algerian war than as a kind of clattery prelude to the events of May 1968.

"I remember the protests," Leon said, "but I didn't participate in them. I mean, you could say that it just wasn't me then. My values were, to use the word of the day, existential. That had to do with the individual in the world, human limits, how man accepts his fate, and so on. I wasn't into street action. I was into universals!

"And it was something else, too," Leon continued. "At least how I see it in retrospect. It was that this was a problem for the French, and I was an American. I remember the big strike against the generals when there was talk of a coup, and I remember the march and the protesters being beaten by the police with their nightsticks. It was quite moving—and I did think of joining in. Neighbors of ours marched, people who weren't even that politically involved. But it wasn't my place—that's how I thought of it. It was their country. Their issue. I was simply here for a while. An American."

VII

GOLUB'S
STUDIO

APRIL · 1988

PINOCHET,
1977

THE STORY OF Western art is not, for most of us, a matter ultimately of books and archives but of museums—a story told in pictures and objects. The museums, in their collecting and exhibiting, have proved over the years to be more and more rigorous and imaginative in their pursuit of art history, more inclusive than exclusive in determining what constitutes this history, and increasingly democratic in terms of the types of people (curators, board members, scholars) who get to define what is historic, and what is not. That is to say, our art museums (like our libraries and universities) have on the whole become more tolerant and responsive—more liberal—institutions.

To argue that, as a result of such liberalizing, our art museums have abandoned their "standards" is to be blind to what museums were like "traditionally"—to be blind to the academic art, the work of local Sunday painters, the cheap plaster casts of classic sculpture. To argue alternatively, that our art museums are simply part of the superstructure of late capitalism, or an outmoded holdover from the time before "mechanical reproduction"—that is, to argue that museums will wither away—is to be nothing but coy. The museums are not going away. What is happening, in fact, is that more and more aspects of culture (film, TV, rock & roll, advertising) are being procured, cared for, studied, judged, and displayed, in some cases in museums of their own. And museums of art, to judge from press attention and attendance, have never played a bigger role in American life. These museums are liberal places where you may see a painted masterpiece or watch a film or listen to a Marxist academic tell you the art museum is dead.

The art museums are better at certain aspects of art history than others. The history of Western painting is the fullest, richest story to be learned in the museums. Visitors to the great museums, and to the countless exhibitions mounted by museums of all sizes and stature, will in time piece together a history of Western painting that approaches what could be said to be (reasonably but ever warily) the truth. Those who began in the museums in the nineteenth century to identify, classify, and rank works of art systematically were at an advantage with Western painting. Western paintings had been collected, carefully kept; and also the painters themselves, throughout Europe, had an understanding of the paintings made before theirs, valued them, studied and copied them—in a sense, kept them alive in their own paintings. Not only the paintings themselves, but an idea of the history of Western painting (or, more accurately, many such ideas) existed for the curators and historians. Think of it this way: Western painting had a history, was understood historically, before there were museums devoted to Western painting. For museums, there was a foundation—of works and ideas—to chip away at or build upon.

But what of the other aspects of Western art history? Here, beyond painting, the museum's grasp of the history becomes somewhat more problematic. Because the history of Western painting is the most important legacy of Western art (if only because the artists have tended to agree this is so), and because this history approaches (roughly) the truth, we tend to reason that we have a true understanding of all the other Western forms: drawing, sculpture, and so on. But we do not have the same understanding in these cases, and cannot. Other Western forms of art, for one thing, were not so carefully collected. Drawings—watercolors, too—were fragile, and, perhaps because they did not have the monetary value of paintings, were not as carefully collected. No doubt many important drawings and watercolors have perished over the years. As a result we do not have as comprehensive an understanding of the history of these forms.

And sculpture: The history of sculpture cannot be articulated and narrated so easily in the museum. Our museums were (and continue to be) designed as "picture" galleries, and are rarely conducive to the viewing of sculpture. Moreover, much of the

best Western sculpture, going back at least to the Renaissance, cannot be brought into the museum, cannot be packed up and sent from place to place and set out to tell a story. This is particularly true of the sculpture of our time. In the winter of 1982— around the time Golub's *Mercenaries* and *Interrogations* were on view at Susan Caldwell—there was a retrospective of the sculpture of Robert Smithson on exhibit at the Whitney Museum. It was a disconcerting retrospective, because it couldn't begin to be comprehensive. Smithson had spent the last years of his life, in the late 1960s and early 1970s, constructing monumental "earthworks" in places like the desert outside Amarillo, Texas. These enormous sculptural works were not meant to be moved, could not be moved, and would fit in no museum if they could be moved. Moreover, what critics agreed was Smithson's greatest achievement—his fifteen-hundred-foot-long *Spiral Jetty,* at the northern end of Utah's Great Salt Lake—was no longer visible, even if one went out to Utah to see it. The lake had swallowed it up. The Whitney showed models and drawings and photo blowups of Smithson's earthworks; it was able to set out a story in pictures for its visitors. An important story to tell: Smithson is considered by many to be one of America's greatest and most influential postwar sculptors. But I feel—and I am sure others who visited the museum show feel likewise—that I can't honestly make a judgment of Smithson's importance, having never actually seen one of his earthworks. Photos and drawings and models cannot begin to stand in for an actual sculpture—for the *experience* of a work of sculpture. The experience is lost, and with it a grasp of a moment in sculpture's history.

Skeptics might point to other, more recently developed art forms, such as photography—museums cannot and will not begin to tell a coherent story about the history of this medium. Which photographs are "art" and which are not? Who are the "artists"? But I see little problem, over time, beyond such theoretical questions. The history of the art of Western photography—like that of painting or sculpture—will take shape through conversation within the liberal museum. That the conversation is particularly theoretical and interesting just now is a source of pleasure, not despair.

What is more troubling, I think, is that there remain activi-

ties—activities by artists—that cannot be told in pictures or objects at all, and, as a result, cannot possibly be part of the story of art history that a museum tells. It is a disquieting notion to recognize this, as I did one afternoon in April 1988 at the Museum of Modern Art. I had gone to the museum to see an exhibition titled "Committed to Print," a show devoted to American prints, with social and political themes, made in the past twenty-five years. I was particularly eager to see the part of the show devoted to prints created by artists in the 1960s and early 1970s to protest the war in Vietnam. American artists played a significant role in the anti-war movement. For several months I had been reading about the protest activities of artists, going through newspapers and magazines (there are few books of art history or criticism that deal with the subject). I was planning to sit down soon with Golub and discuss his role in these activities, and I thought that seeing the prints would provide me with a few insights.

From what I had read, and heard in talking with artists I knew—and in talking in passing with Leon himself—I understood that he had been something of an anti-war leader in the New York art community, beginning his involvement in organizing opposition to the American role in Vietnam shortly after he moved to New York in 1964. There was an anti-war print by Golub in the Modern's show, and prints by others involved with him in the protest movement (including a work by Nancy Spero). Seeing Golub's print and those of others, I imagined, would summon for me, as the news clippings could not, what that era had been like for artists, an anomalous moment in modern art history—one of group participation; of artists assuming the roles of sage and seer that society continued to believe they filled, despite the fact that the artists themselves (most of them, anyway) had long ago come to believe otherwise; of the artist and art alike serving as "a kind of instrument in the world" (to quote from the museum's catalog for the exhibition).

However, as eager as I was to look at the anti-war prints, seeing them proved an enormous disappointment. Many of the pictures lacked the graphic punch we want from any print, political or not. But any historical survey show attempting to tell the story of a particular era—and not focus only on its finest achievements—is bound to include second-rate work, work that

in such a context can often prove (historically) interesting. It was something else that was bothering me, something about what—as I looked at the prints—I was simply unable to see, recognize, feel. This began to dawn on me when I saw an image that I remembered seeing years before, during my student days. This was the Art Workers' Coalition's 1970 poster about the My Lai massacre. It is essentially a blowup of the famous *Life* magazine photo of dozens of murdered villagers stacked up on the edge of their destroyed hamlet, upon which are superimposed two lines from a Mike Wallace interview with a Vietnam vet who had witnessed the atrocity:

Q. And babies? A. And babies.

At the time I had first seen the poster—held aloft by someone at a protest rally in Philadelphia in 1971—it had seemed to say it all. It had shouted to me of the horrible toll the war was taking on innocent peasants; of our destruction of a rural, village-bound way of life we knew nothing about; of the madness not only of Lieutenant William Calley (who with other members of his company had carried out the massacre of hundreds of civilians, including old men, women, and small children), but of our very presence in Southeast Asia to "save" Vietnam; and also of our responsibility, back home, to get our soldiers—our nation—out of this moral and criminal mire. Looking at the print back then, I had one overwhelming sensation: *This cruelty has to stop, for their sake and ours.* Here, at the Modern, I got no such feeling. It wasn't that I had changed my mind about the war, or that I could no longer summon the anger and sorrow I felt during the protest era, or that for some purely aesthetic reason the image no longer worked for me. I don't believe my failure of feeling had much to do with me at all.

I think the My Lai print and the other anti-war pictures in the show were never meant to be hung in our museums. They were meant to be pasted on walls, or mounted on wooden poles and carried through the streets, or, at the very least, sold to raise money for the anti-war effort. They had been created as pictorial broadsheets, most of them; they were of the moment, meant to alter the moment. They were tools, no doubt effective tools,

though there is no way of accurately gauging this—except to note unequivocally (as history will) that the protests against the war changed the climate of opinion, and slowly, eventually, brought American involvement in Vietnam to an end. But tools, over time, give way to other tools, and the old tools then matter to us only as artifacts. They were created to be useful, and had been—now they were not. That's what the prints seemed to me: not art, but tools that at another time had done their jobs. Artifacts.

Looking at these prints, it struck me that a great Vietnam War painting has yet to be made, and perhaps never will be made. There is no painting that ranks with the Vietnam Memorial in Washington. It is a truly great public sculpture—a somber, moving solution to the national problem of regretting the war but not the courage of the thousands of American men and women who gave their lives in it. It will never be shown in a museum, but, interestingly, it is visited by tens of thousands of people each year who are making the rounds of Washington's museums, and it is approached carefully, as we approach art. Seeing it for the first time, taking in the sweep of its shiny darkness and whispering to myself fifteen, fifty, one hundred names, all the time hearing nearby a small cluster of vets quietly weeping, I felt as full of feeling as I have when standing before any other contemporary sculpture—and as much sorrow as I ever felt about the war while it was raging. Perhaps Vietnam, the "TV war," overwhelmed the painters with photographic images, intimidated them. Perhaps painting in the late 1960s, largely cool and abstract, simply could not take Vietnam as a subject. Perhaps it is that American painters have never done much effective painting about any war.

Was this what I was feeling at the Modern that afternoon, a disappointment, looking at the prints, that we lack even one strong painting about the war? Perhaps. But if I was feeling this, it was only because I understood that a painting can carry with it, for some future viewer's experience, a sense of the time of its own making. As artifacts, the prints not only failed to convey those deeper recognitions we expect from art; they also failed to speak of the artists who made them, of what had gone into them. The artist making protest art does not stand outside his time, detached; nor does he work toward the ideal time of his work— that of its completion. The protest artist works quickly, immerses

himself in the historical moment. Protest art's time is of the mo-
ment: a different, fleeting time.

If you happen to see the protest work at that moment—at a
street rally, say, for a cause you believe in—it can matter to you.
You can sense the artist's anger and indignation, and this may
have a powerful effect. But when the moment passes, this feeling
you have for the protest work is likely to pass, too, and, with it,
any sense of the time and effort the artist who made the work
had put into it. At the Modern, not only was I viewing tools for
which (thankfully) there was no longer a purpose (an immoral
war to bring to an end); I was sensing the very absence of those
whose energies had helped bring about an end to our involvement.

In no way, I realized, could one look at these prints and even
begin to understand what artists had actually done during the
Vietnam War years: the meetings, private and public; the organ-
izing and demonstrating; the time sacrificed, the purposefulness,
the accomplishment. Artists had been among the first to protest
the stepped-up American involvement in Vietnam, and artists'
participation in the anti-war effort proved to be serious, con-
spicuous, and resolute. The prints at the Modern could not carry
this history. It was too great a burden for them. Of course, the
show was not mounted as a history of artists' involvement in the
anti-war movement—that wasn't the story the show had prom-
ised. But my point is that—and, visiting the show, this is what I
began to grasp—there cannot be such a museum exhibition.

The artists who organized and protested, took action against
the war—this is a part of contemporary American art history.
But how will it be effectively retrieved and narrated by our mu-
seums? It is not a story that can be told in pictures or objects.
As such, it is not a story the museums can tell. The problem is
epistemological, not political, but a problem it remains. And so
this period—so crucial to an understanding of artists like Golub,
and in a broader sense to an understanding of how our culture
has been shaped—is likely to remain beyond the museum's grasp,
our grasp; beyond art history.

The Golub print in the MOMA show is titled *The Burnt Man*.
It is a silkscreen, done in 1970, but the image—of a crouching
figure, late-classical and sculptural, its "skin" worked to appear
scorched—was one Golub had first painted in the early 1960s,

in Paris, and continued to work and rework in subsequent pictures. There are words printed across the bottom of the silkscreen: MEN ARE NOT FOR BURNING. The reference now (as it was not in the original Paris painting) is to napalm. Not a bad print, very much of the moment in 1970. Had I seen it then, I might have thought... but who can know? It had been made for that moment and not, like his later paintings, for a moment when one might think: This is how it was.

Golub's involvement in the Vietnam protests is significant not only for what impact it may have had on the art-world aspect of the anti-war movement, and, indirectly, as part of this movement, on the government, but also for where it would take his own painting. Would Golub ever have painted a mercenary or torturer or death-squad goon had he not been involved in the anti-war movement? I can't see how. In the 1960s, Golub for the first time stepped into the history of his own time *as an artist*. It seemed to me, from what I had been reading, that Golub, through his protest activities, had reached a point at which he said to himself something along the lines of what Gustave Courbet, the great realist, had once said—that artists must paint their own time, that they are "basically incapable of reproducing the aspect of a past or future society." A story that fascinated me: Golub's anti-war activities seemed key to my understanding of why, beginning in the 1970s, he came to paint what he did. But the Modern's show of protest prints shed little light upon that story. The museums, our repositories of art history, may never tell the story. It is as if at the very moment when Golub and the others placed themselves in history, with regard to the history of Western art, they stepped outside it.

2. "WE MOVED TO New York in 1964," Leon began one evening, a few weeks after I had seen the Modern show, "because after five years Paris had begun to lose its edge." He and Nancy had talked about leaving Paris for a year, maybe more, he said. "There was no question, we would not go back to Chicago. We

were ready for New York." They rented an apartment on East Tenth Street, between avenues A and B, in what is now known as the East Village, but what was then simply the poor and sprawling Lower East Side. Leon rented a studio for himself on Wooster Street, in an old lower Manhattan manufacturing district that ten years later would be SoHo, the international art district. "It was a big loft, much bigger than any other space I had ever had to work in," Leon said. To inaugurate it, he began thinking he might paint an enormous picture, his biggest yet. "I continued to think in terms of an eroded, corrupted classical art—arriving in New York didn't change that right off," Leon said. "I had begun to set the figures in motion in Paris, to have them express a certain kind of violence and brutality. And now I was thinking about really getting into it—painting a huge frieze of giants or gods wrestling and battling in hand-to-hand combat. A great public artwork about the kind of battle the ancient Greeks called a gigantomachy."

I was struck by the confidence Golub recalled having at that moment. He was, when he settled in New York that fall, forty-two years old; he had been showing work in New York galleries for ten years, and he had had his paintings in exhibitions in several New York museums; but he had never really been a part of the city, its art life. The city had not welcomed him.

"I was an outsider," he said, "an artist outside of the traditions that had come to be formed in New York in the thirties and forties and fifties—the New York School."

I asked him if he had had a romance about New York in 1964, as he had had about Paris when he moved there in 1959.

"New York was too hard-nosed to be romantic about—or to be romanced by someone arriving. It would have to be taken: That's what I thought then. I wasn't going to seduce the place."

New York did not much care for his painting—he understood that; it had been made clear to him a number of years before. This lack of interest in his work was brought into starker focus for him near the end of 1964, when he learned from his dealer, Frumkin, that sales of his paintings, which had been just steady enough to support his family, had fallen off in the last year. He would have to look for a teaching job.

"I remember thinking, and even mentioning to Nancy, that

we might have made a mistake coming to New York when we did," he said.

It was the following spring, as Leon remembered it, when for the first time he attended a meeting of artists that was called to discuss the growing American involvement in Vietnam.

"It was at some church, I think—I can't remember," he said.

When I had called Leon the previous week and said that I'd like to talk with him in detail about his anti-war activities, he had agreed, but seemed to me a little hesitant.

"I really don't like to go on too much about all this," he had said on the phone. "I mean, I was very involved and all, but I never really laid it on the line. There were men and women who did so much more than I did, got arrested, put out of commission. I was very careful about that. I only would go so far. That's my politics, in a way. And also, I was a painter. Which meant I wanted to get back to the studio. Being a painter meant, too, that I was able, perhaps, to get away with certain things—*He's an artist after all, okay?* That kind of thing. Other people didn't have that luxury."

I reminded him of this phone conversation and asked him if his difficulty remembering the first meeting he attended might actually be his way of expressing a reluctance to talk about his protest activities.

He dismissed that idea. "No, it's just difficult to recall how it actually got started. It was very informal at the beginning, artists and writers meeting in a church, essentially wondering out loud together what we thought was going on—what the government was planning to do."

In August 1964, at President Johnson's urging, Congress had enthusiastically approved the Gulf of Tonkin resolution, granting the President broad powers to "take all necessary measures" to "prevent further aggression" in Vietnam—essentially, the unprecedented power to wage an undeclared war. Johnson had told key Democrats in Congress that North Vietnamese forces had attacked American ships in the Gulf of Tonkin on August 2 and 3, a misleading half-truth at best—as the Congress and the rest of the nation would learn when the Pentagon Papers were released. It was the type of deception, in the name of "national

security," that the White House would practice again and again during the Vietnam years.

By the spring of 1965, when Golub began to attend the first artists' meetings about the war, the President had already taken two fateful measures. U.S. B-52s had begun to bomb targets inside North Vietnam in early February. Not long after, for reasons that might have been strategic, or might have been simply symbolic—a show of might and resolve—bombing became continuous and frighteningly heavy: thousands of tons a day at times, the bombardiers leaving road-like stretches of devastation beneath and behind them. Then in March, two marine battalions in full battle regalia splashed ashore at Da Nang—combat troops, 3,500 of them, for the first time joined American advisers (then numbering near 30,000) in Vietnam.

"We talked in those first meetings about the bombing and the introduction of American troops," Leon told me. "If you were at the meetings, it was assumed you were against American involvement. I was reading people like I. F. Stone—I was convinced I was being lied to by the government. And also, having witnessed the French involvement in Algeria, and having read about their earlier involvement in Vietnam, I understood that it wasn't going to stop here—that it would get bigger and bloodier, and that we had the technology to cause tremendous destruction and suffering and death. And those attending the meetings—everybody felt the same, more or less. So it was more a question of strategy. What could artists do?"

Protest against American involvement was at this point scattered and rather subdued. Those Americans paying attention to the war overwhelmingly supported the President they had elected in a landslide only months before. Sit-ins, picket lines, and marches—strategies that had been crucial to the civil-rights movement—were only beginning to be put to use by anti-war protesters. Three hundred students in San Francisco had marched on the main branch of that city's post office, demanding the withdrawal of U.S. troops; seven students at George Washington University had "fasted for peace"; and early in 1965 at the University of Michigan students and teachers had held the first all-night "teach-in." Then in April the first anti-war march on

Washington took place. About fifteen thousand people, mostly students, participated—the largest Vietnam protest to date. But it was a modest turnout when compared with the hundreds of thousands who had turned out for the huge civil-rights marches on Washington in the early 1960s.

The New York artists were not contemplating a march, of course. There were hardly the numbers for a picket line. The model for their first action was not the students but the French artists of the 1950s who had protested the French war in Indochina and then the Algerian war. Having heard that a group of writers was preparing to publish a signed advertisement in *The New York Times* denouncing the war, the painter Rudolf Baranik arranged for artists to take part, offering their names and also ten dollars apiece to help toward the cost of the ad (seven thousand dollars). Thus was launched the first official statement of the Artists & Writers Protest against the war in Vietnam. The full-page ad, titled "End Your Silence," ran on Sunday, June 27, 1965, and stated:

> *A decade ago, when the people of Vietnam were fighting French colonialism, the artists and the intellectuals of France—from Sartre to Mauriac, from Picasso to Camus—called on the French people's conscience to protest their leaders' policy as immoral and demand an end to that dirty war. . . .*
>
> *We can do no less.*

Among the five hundred signatories were Robert Creeley, Elaine de Kooning, Richard Diebenkorn, Philip Roth, Norman Mailer, Edmund Wilson, James Baldwin, Ad Reinhardt, and Mark Rothko. Both Golub and Spero signed as well. It was a traditional form of artists' and intellectuals' protest: a petition, an act of conscience. It was already becoming clear to many artists and writers—Golub among them—that entreaties of this kind were not going to be enough, that they would have to give more of their time and of themselves to the cause of ending the war.

By the time the anti-war statement had been published, Golub had been at work for a month or so on a new painting, his first in New York, *Gigantomachy I*. "I hung a huge piece of heavy-

duty canvas—twenty-four feet long and ten feet high," he said. "There were two risers, you know, pipes for the heat, and the canvas, unstretched, fit between those. And then it went floor to ceiling. The background I left more or less bare, with some areas of red, earthen red, but also a little blue—a Mediterranean blue, a little something for me more than anything else, a sign to me of that part of the world. The classical, the work of the late Greeks and the Romans, was still important to me, to my work. I was utilizing classical sources still—in the case of the *Gigantomachies,* the altar of Zeus at Pergamon was a source—and also sports photographs, action. I had plans for numerous figures now, a great battle of these giants—some of them nine feet tall."

I asked Leon what he was getting at in painting such a huge picture. Was it about Vietnam, the war?

"It wasn't a specific statement about the war, no. But I did think of it as a social painting—a painting about the irrational frenzy our society is capable of, whether war or Buchenwald. I wanted to show this, not directly, but in a generalized way, stripped down, timeless. I wanted to take these late classical figures, Greek warriors, gods, heroes—symbols of a kind of rational perfection that has been corrupted—and put them in motion.

"The human figure, gesturing and interacting with others, is a marvelous way of showing the history of the world, I thought, and still do. You see men in space and, with their movement, their gesturing, you see them in time as well. With this language I was using, I was seeking to show that even within a rational society there is this other side that has to be recognized—this irrational, violent side.

"The point," Leon continued, "was not a realistic depiction but what I would call in those days a rhetorical painting. By rhetoric I meant in the old civic sense. In using a more universal language—a common language—all members of the community could approach a work of art and take away something from it. And for the Greeks, this held not only for spoken language but also for body language. In the staging of a Greek tragedy, an orator making a certain gesture was sending a signal that would be recognized. It was that rhetorical sense I was after. And I would say this, too, in regard to my use of a classicized style:

You maintain this distance. I wanted that distance, that measure. Art was one thing—it was separate, just as my making art and my involvement in the protest against the war were separate."

Later, our conversation came back around to Leon's anti-war activities. It was during the summer of 1965, he told me, that his involvement in the protest movement deepened. The previous summer, just before he was to leave Paris, he had received an invitation to work at the Tamarind Lithography Workshop in Los Angeles, established in 1960 and already (with Tatyana Grossman's Universal Limited Art Editions workshop on Long Island) an American print studio to rival the great French ateliers. Tamarind's policy was to award an artist a grant to come to the West Coast for six weeks, learn the lithography process from its master printers, then pull a suite of prints. Golub had expressed interest, but he asked if he might postpone the visit until the summer of 1965, when he would be settled in New York, and Tamarind had agreed.

"We got out there—Nancy and the kids and I—in July, I guess it was," Leon recalled. "We rented a house in Santa Monica and I began to work—I think the image I was doing was a sphinx-like image of some kind. Anyway, from the minute I get to Los Angeles, there is this talk about artists and the RAND Corporation. Everybody was into talking about the war in Vietnam. It was way ahead of where we were at in New York. And it all centered on this protest of RAND that artists out there had organized."

Leon suggested that if I wanted to know more about the RAND protest, I should get in touch with the painter Irving Petlin.

"Petlin was from Chicago, a generation younger than me," Leon said. "We got to be friends with him in Paris, when he was painting there. It was Petlin who got the artists' protest off the ground in L.A. In a way, it all really began there with him."

3. PETLIN'S LOFT WAS downtown in Tribeca, and I visited him there a few days later. He was ruggedly handsome and fit; from his work, delicate pastels, I had imagined him differently. I soon became aware that Petlin is fond of discussing politics, has a keen political sense. We sat and talked in his tidy studio, and he filled me in on the anti-war events in Los Angeles in which he had played the key role twenty-two years before.

One Saturday in June 1965, only weeks before Golub had arrived in Los Angeles, several dozen area artists and writers had marched on the offices of the RAND Corporation, located not far from the pier in Santa Monica. Already, in the summer of 1965, it was understood by those opposed to the war—in Los Angeles and nationwide—that most of the "systems analysis" research being carried out by RAND, the country's first corporate-scale think tank, was for the department of defense: RAND was providing advice to the government on how to wage the war. In South Vietnam, as Frances Fitzgerald wrote in her Vietnam history, *Fire in the Lake,* young men from RAND, under contract from the defense department, were bounding through the countryside in their Land Rovers, assessing village hierarchies and the efficacy of local elected councils and the ways that land reform might affect the motivation of peasants. Back in Santa Monica, at the home office, weapons systems were studied and evaluated, not by soldiers but primarily by economists and a new type of expert, the strategic theorist. As Richard Goodwin, who had worked in the Kennedy and Johnson administrations, would later write in *The New Yorker,* the "most profound objection to this kind of strategic theory is not its limited usefulness but its danger, for it can lead us to believe we have an understanding of events and control over their flow which we do not have." The men at RAND were convinced (in 1965, and for sometime after) that the war could be rationally, scientifically planned, analyzed, and won. The war in Vietnam was a good war, a new kind of war—one in which American technological and social-science know-how would prove to be the decisive weapons.

Petlin, at that time a young artist in residence at the University

of California at Los Angeles, was particularly troubled by RAND. "I got to know some of these people at RAND the way artists tend to get to know such people," he told me. "I would meet them at dinners, parties, even at openings. Monday nights on La Cienega Boulevard was the scene those years in Los Angeles—that's where the galleries were. And some of these RAND people would turn up. Listening to them talk about the war, it was as if things like culture and history did not matter. They didn't seem to know or care that the French had been unable to defeat the Vietnamese, or what the Vietnamese might be fighting for. The RAND people I met had a detached, businesslike approach to the war. They were the intellectuals, the 'liberals,' in a way—that's how they saw themselves."

Petlin was already something of a protest veteran by 1965. He, too, had been in Paris during the Algerian war, but unlike Golub, he became active in the protests there. When American involvement in Vietnam began to escalate in early 1965, he sensed something ominous.

"I could smell it," he told me. "I remember when I would talk with Leon—in Paris and later—we would agree on this at least—that it's something we are supposed to be able to do. Artists have the antennae out. There is a special sensitivity to things—I believe that. We're not connected to bureaucracies, we're independent, clear. And also, in my case, and maybe in Leon's, too, I think it's about being a Jew, having that understanding of what governments and powers can do. Understanding the cruel and horrible things that can happen to men and women. Many relatives of mine perished in Europe."

Early in the spring of 1965, Petlin called a meeting at the Dwan Gallery, then best known perhaps as the West Coast outlet for the work of Robert Rauschenberg and Jasper Johns.

"I had been talking with people at dinners, casually, about how we should do something," he said, "and the reaction was: 'This is Los Angeles—are you kidding?' So I decided to try to get people out for a meeting almost on a dare." A few dozen artists and dealers showed up for the first meeting. More meetings followed, and each time more artists and art-world people and writers as well turned out. "I would talk about how artists have to be the radar of the country," he told me. "A kind of early

warning system. And despite this idea I had that Los Angeles artists probably wouldn't respond—Southern California was a politically conservative place, then as now—they did. It didn't take long for things to go from whether we should do something to what should we do."

Petlin suggested the RAND picket, and what was now calling itself the Artists Protest Committee agreed. Artists were notified by postcard of the date (Saturday, June 26) and the meeting place—the apartment of John Weber, who was at that time the Dwan's director. The press was notified, too, and was on hand with cameras when the protesters marched the few blocks from Weber's apartment to the RAND office building.

"Now, what's really interesting, what really assured that it would be more than a one-time event," Petlin continued, "was that several RAND staffers came out and began talking with us. One thing led to another, and eventually, before we disbanded that afternoon, we had an invitation to come and sit down with them and discuss the issue. Inside RAND. A number of us, and a number of them, at the same table."

Petlin liked the idea, but in the days that followed he also came to think that the meeting shouldn't be held quietly, in the RAND offices, but out in public—a kind of Santa Monica town meeting on the war. He was emboldened to hold out for such a meeting as a result of a call he'd received from one RAND staffer who was privately souring on American involvement in Vietnam. ("Not Daniel Ellsberg," Petlin assured me.) According to Petlin, the staffer told him that RAND would agree to any kind of meeting the artists sought.

"He told me that Defense Secretary Robert McNamara had told RAND officials that it was crucial that they meet with the artists, in order to listen to and comprehend our objections to the war," Petlin said.

Whatever policies the artists disagreed with then, McNamara was said to have told officials at RAND, the general public may well disagree with in two, three years' time. Whether at Mc-Namara's urging or not (McNamara will no longer discuss the war), RAND agreed to the public meeting—but only if the artists would agree to meet privately first with RAND staffers. The private meeting could be held in July, RAND proposed, with a

public debate—moderated, and with questions taken from the audience—to follow early in August.

"It is at this point that Leon enters into it," Petlin explained. "We were old friends, as I said. I can remember debating about Algeria with him in his kitchen in Paris. I knew what a great debater he was. RAND said we could bring a small group of people. I wanted Leon to be one of them."

When I next saw Leon and brought up the meeting at RAND, he said that along with Petlin and himself, there were perhaps ten, eleven other members of the Los Angeles Artists Protest Committee who met with RAND representatives at their Santa Monica offices in early July. Included among them were the Los Angeles artist Larry Bell, the poet Michael McClure, and the art and film critic Annette Michelson. Both sides gathered around a big conference table; papers were distributed and discussed; the meeting lasted nearly six hours. (One of the things Leon remembers is that none of the artists was allowed to go to the bathroom without an escort—"I think they thought we might try to sneak out with their papers, though what I would want with them who knows," he said.) There was a good deal of careful questioning and answering, and also a fair amount of tension. "I can remember that as I was leaving," Leon said, "one of the RAND guys made a point of saying to me that I should not forget that I was an American, and that America was on the side of right. You see, after all the charts and studies and so on, that is what it came down to, even at RAND.

"I had learned something in that meeting," Leon went on to say. "It was kind of profound, really. Here were these experts, big guys, okay? They had all these studies, some of them had been to Vietnam, they knew the numbers, and so on. But really, when you got right down to it—and this was a startling thing for me—they basically had no better idea than we did as to what was actually going on. Where was the war headed? What would the situation be like a year or two down the road? They had no idea, really. It essentially came down to: We're Americans, we're right.

"And of course history showed they had no idea what the war was about, how to go about fighting it. It was in this meeting, I guess, that I saw that those in power cannot be simply trusted

to do the right thing, to even know the right thing—that they play hunches, take gambles, even, as in this case, with people's lives. And you could say that ever since that meeting I have operated on this assumption. I've been trying to call people's attention in one way or another to the way power is used and abused."

I asked Leon about the public meeting with RAND officials held a month later, at the Warner Theatre.

"We went into that meeting in a different frame of mind." He explained that he, Petlin, and the art critic Max Kozloff represented the artists, and that among the handful of RAND representatives were Guy Pauker, a Southeast Asia specialist; and Bernard Brodie, already well known for his books on nuclear strategy. Not only were the members of the Artists Protest Committee more confident; the RAND representatives were more reticent than they had been in private. (Petlin believes they were under instruction to be careful not to reveal classified information.) Often, when questioned by Golub or Kozloff or Petlin, they would not or could not provide answers. The audience—essentially hundreds of anti-war students—was aligned against RAND from the beginning. By the end of the evening, according to accounts carried in the Los Angeles papers, the moderator could hardly keep the crowd quiet. "It was this amazing thing," Leon recalled, "to be onstage, the crowd behind you, essentially winning a debate with the government on the war—right there, at the very beginning. You could sense not only that you should do something about the war, but could."

Golub and Spero returned to New York later that summer, and through the fall their lives came more and more to be shaped by the war—their involvement in the protest against it. They attended a vigil at the United Nations and several other demonstrations and rallies. The members of the Artists & Writers Protest met frequently, and the number of artists and writers involved increased steadily. This was no doubt a reflection of the United States's increasing involvement in Vietnam. The American role in the war had widened considerably since the spring. By November 1965, American troop strength in Vietnam had reached nearly two hundred thousand. Golub, who was assuming a leadership position among the anti-war artists in New York,

began to understand at this point, he told me, that protesting the war—convincing others of its immorality, destructiveness, and cruelty—might take years.

The largest, most conspicuous "action" of that fall was taking place again in Los Angeles. That city's Artists Protest Committee had "sent out a call" (Petlin's phrase) to artists around the world to send two-by-two-foot panels—paintings or painted signs—that could be attached to a planned outdoor construction the L.A. artists were calling the Peace Tower. The committee had leased an empty, two-acre lot at the top of La Cienega near Sunset Boulevard, and on it the committee planned to construct, from a design drawn up by the sculptor Mark di Suvero, a temporary fifty-eight-foot steel tetrahedron. On its four faces, near the bottom, the committee members worked through the fall attaching the dozens of signs and paintings that were making their way each week to Los Angeles from New York, Chicago, Paris—everywhere. By early 1966, when the tower was inaugurated, more than four hundred panels were in place, and the Peace Tower site soon became a favorite drive-by spot, and also, after a while, a meeting place for Los Angelenos interested in exchanging news and views about the war. (It was also seen by some as unpatriotic, and on a number of nights, despite the presence of volunteer guards, it was attacked and vandalized.)

Golub had volunteered to serve as the New York coordinator of the Peace Tower project, and through the late fall and into the winter, the floor of his Wooster Street loft was scattered with small panels to be packed and shipped west. Leon talked of how one artist would drop by, then perhaps another, and before long there would be coffee and discussion. "If you've ever been involved in any activity of this kind—I'm talking about protest activities in general—you know how much time these things can take up," Leon said. "You're on the phone all the time. There's mailings to be done. Meetings. Arrangements for everything. Around this time we organized a sale of art for peace. We had this crazy march down to the post office to send 'gifts'—pieces we'd made—to the Pentagon. They actually mailed them, can you believe it? Including this wild ticking piece, like a bomb, okay? The guy working there picked it up, held it to his ear,

shrugged, and sent it along—though who knows if any of this ever arrived? What I am saying is that if you really get involved it's your life. And that's what it became for Nancy and me—our life. Our social life, for example. The artists we met, the people we saw for dinner, and so on—these were people who, like ourselves, were involved in the anti-war effort. We simply had no time for other things. It was the same way back in Chicago when we were students—Exhibition Momentum had been just like that. And here we were again—a kind of loose-knit group of artists and critics, wanting to right what we saw as a wrong, meeting for drinks and talking and hanging out. In New York in the sixties that was our scene."

4. "IN NEW YORK in the sixties—as a painter? I didn't mean a damn thing," Leon was saying. It was a couple of weeks later, at his loft once more, and discussion had come back around to how his work—his work in the studio, his painting—had gone in those first years in New York. It was a different story from that of his role with the Artists & Writers Protest—one not of engagement, of being caught up in momentous times, but of marginality and isolation. "It was worse than being attacked, like when Bill Rubin attacked my work in the show at the Modern in the late fifties and that," Leon said. "It was that I simply wasn't relevant. There was little interest among critics in viewing the work. I was 'known,' but what I was doing had no connection to the current crucial issues in art. In this kind of situation, a painter like myself did not count."

I asked him if he ever thought his protest activities might be his real art of this period. I brought up Abbie Hoffman and the Yippies, how they looked upon their anti-war events—showering the floor of the New York Stock Exchange with dollar bills, "levitating" the Pentagon—as artworks of a sort. A similar approach was advocated by the Situationists, the European avant-gardists who shunned traditional forms of art-making and called instead for a youthful, playful surrealism in the streets, what they

called "the construction of moments of life." Their theories remained pretty much theoretical until May 1968, when the students in Paris—who had been reading Guy Debord, the best situationist writer—brought them suddenly, wildly, anarchically into the boulevards. Damning and laughing at the "spectacle-commodity society," and bent on "rupturing" it, they staged sit-ins, occupied buildings, scrawled cryptic (and often quite poetic) slogans on walls and buildings, called for and got a general strike, and for several weeks brought the republic to the brink of crisis. It was the one true situationist masterpiece—astonishing street theater, but doomed (as any anarchic event is) to a very short and ultimately ineffective run.

"Okay, that's interesting—the idea of thinking of protest as art," Leon said. "But for me it wasn't like that. I never saw what I was doing—the protests and so on—as art. I don't want to make a general statement. Maybe for others it was art. However, to my way of thinking—today, and then, too—I saw it more as a kind of demonstration of anger, of moral revulsion, okay? Artists could attract attention, create excitement and furor. And we did to some extent. And that was important. But for me, anyway, there was never the intention to make this my art. Art I did in the studio, alone. In my mind I was always clear about that. I painted."

We talked about his paintings of the mid-sixties, the *Gigantomachy* paintings. After finishing the first one in 1965, he went on to paint four more over the next three years. They were his most ambitious paintings of the period (he did maybe fifteen other, smaller pictures), and perhaps of his career.

Small photo reproductions notwithstanding, I had actually seen only one of them, *Gigantomachy III* (1966), when it was included in his New Museum show. But because they vary essentially only in the number of figures in each, and in the poses and gestures of the figures, it is easy to talk about them as a group. In the *Gigantomachies*, Golub's figures seem a good deal less sculptural and blocky than in his Paris paintings—that's the first thing you notice. The paint is still thick in spots, but with long, dry strokes of black and white and red, he managed to free up the gestures, turn arms and legs sinewy, make the movement seem, if not "natural," considerably more fluid. And the faces of

the men have shed their stony masks—eyes dart, mouths turn down, brows knit. But they are still a long way from being fully articulated individuals. When I first glimpsed the running, stomping, and sprawling figures in *Gigantomachy III*, I thought of those life-size, clear-plastic models used in medical schools to teach students about musculature and the nervous system, except Golub's giants aren't antiseptic in that way—they might be wrapped in dirty, bloodied gauze.

I mentioned to Leon, as we talked about the *Gigantomachies*, that they struck me as anomalous works: ambitious in theme and certainly in size, but to my mind—taking into account what would eventually follow them—transitional paintings. They were "social" paintings, in that each depicted a group of figures, but in another sense not social at all, in that they depicted no particular society. It was true that they sought to communicate to viewers something of what is most awful about mankind—our capacity for cruelty and violence, for inflicting pain—but they did so in a language—a roughly classical, symbolic "art" language—that by the mid-sixties would be lost on most people. Who knew the classical myths? Who knew what a gigantomachy was?

"Well," Leon said, "I would say this—in some respects the *Gigantomachies* are, in my opinion, the most important paintings I have done, in their extreme austerity, fatality—to me they are unrelenting. The paintings were largely ignored, so it's hard to argue that they communicated with a lot of viewers. But the metaphoric nature of these more generalized figures is something I still think is valid. People continue to understand symbols. Also—and I can remember talking about this back in the sixties— you relate to an image with what is called your 'body image.' That is, you carry within you a certain normal notion of yourself—your ego, your health, and so on—which is itself rather generalized. And when you see figures that are distorted or disfigured, as the figures are in the *Gigantomachies,* there is a connection, a recognition. If people did not see the paintings then, are not seeing these paintings now, that doesn't rule out that they might someday, and connect."

He painted the first two *Gigantomachies* in the Wooster Street loft, the other three after he moved his studio to the loft on La

Guardia Place—his current home and workplace—in 1966. None of the paintings left either loft for a New York gallery. By the end of 1965, Golub no longer had a New York dealer. He had gone in to see Allan Frumkin one afternoon and essentially asked for his release.

"Another one of those moves I used to make, especially with dealers, that seem so lousy in retrospect—immediate retrospect," Leon said.

His paintings weren't selling at Frumkin's gallery, as they had while he was in Paris. Leon thought that perhaps a change of dealers might help. He talked it over with Nancy, off and on, for almost a year. Should he leave? Should he stay? "What I should have done was stayed—Frumkin was a good guy, good to me," he said. "Or, at the very least, I should have checked around to see if anyone was really interested in taking me on. But I was proud, you see. Headstrong. A little angry."

Angry about what?

"I wasn't getting attention. I wasn't selling. A few sales I had on my own, but not enough to support myself and my family. I can remember being more frustrated about money at times than about anything [else]. There were two rents to pay—by 1966 we were living on the Upper West Side because Tenth Street had gotten dangerous, especially for the boys. I was teaching again to help make ends meet. At first I was commuting to Philadelphia, to the Tyler School of Fine Art, but in 1966 I got a job at the School of Visual Arts here in New York. Mostly, however, my anger had to do with my work, the lack of interest people had in it. When you believe in what you are doing, and you can't get anyone to get what you are up to, it is extremely frustrating. When you are told that the way you make art—my style and concerns—just has no place, is historically kaput, you get angry."

5. AMID THE PROBLEMS —the lack of interest in his paintings, the lack of a dealer, the lack of money—Golub continued to organize and participate in anti-war activities. He contributed

a print to a portfolio of protest pictures—an image of a wounded figure similar to *The Burnt Man* print I had seen at the Modern. He attended demonstrations, went to meetings, spoke out at panel discussions. In Washington he was arrested at a Vietnam sit-in on Capitol Hill and, along with dozens of other protesters, spent a night in jail.

Early in April 1966, the Artists & Writers Protest placed an ad in *The Village Voice* announcing an "Artists Peace Party" to raise money for anti-war groups. There would be a rock band, the screening of a film about the Peace Tower in Los Angeles, and a cash bar. The party was to be held at the loft of a sculptor named Bernard Aptekar. Among those who made note of the ad was the New York City Police Department. The police, in turn, notified the Fire and Buildings departments. Late in the afternoon of April 8, as Golub and several other artists were readying the loft for the night's bash, a fire inspector came by and warned them that the building they were in was technically a factory, and that to use a factory as a place of assembly for more than seventy-five people required a permit. Several hours later, just as the guests began arriving, the police arrived, too, and repeated the fire inspector's warning about the need for a permit should the crowd grow to more than seventy-five. By around ten, there were one hundred fifty guests talking, dancing, and drinking. The police, who had waited downstairs in their cars for the inevitable, moved in, broke up the party, and served two art students, who were volunteering as bartenders, with summonses—liquor was being "sold" without a license. Golub was handed a summons, too, for defying the building-code regulation that he'd been apprised of by both the fire inspector and the police.

The party was over—but not quite over. Golub proceeded to lead a band of about one hundred artists—among them Claes Oldenburg, Ad Reinhardt, and George Sugarman—first to the local police precinct house, then east to City Hall, where they arrived, at around two A.M., replete with chants and signs ("Vacate Vietnam, Not Peace Parties"). The impromptu march got sympathetic coverage in the *Voice* and the smaller alternative papers; and then, too, most of the guests had already made their donations before the police came knocking. The Artists & Writers Protest claimed victory.

Perhaps the single largest artists' protest against the war to be organized in New York took place late in January of the following year. American troop strength in Vietnam was near four hundred thousand; and Americans at home were beginning to see (in newspapers and magazines, and especially on TV) the terrifying scale and intensity of the war. American troops were taking the offensive, implementing grand new strategies. For instance, newspapers in early 1967 carried stories of how the RAND-developed theories of "forced urbanization" and "pacification" were being ambitiously field-tested: Thirty thousand American troops launched Operation Cedar Falls, a full-scale assault on what might or might not have been a Communist stronghold north of Saigon, near the Cambodian border. Hamlets were bombed, rice paddies and surrounding jungles doused with herbicides; what remained was bulldozed or torched by the infantry. The damage was such that no one was able to conclude if there had been enemy bunkers and tunnels; there was quite literally nothing left. In all, some seven thousand inhabitants— who might or might not have been Vietcong, or supporters of the Vietcong—were forced to flee. That the American military could somehow believe that the wholesale destruction of this area would result in reduced support for the guerrillas seemed inconceivable, even mad. Who were the refugees likely to blame for their painful uprooting, the devastation of their land, their fearful, dispirited families? That General William Westmoreland and his supporters in the Johnson administration never asked themselves what kind of "victory" was crucial enough to require this kind of cruelty seemed madder still.

It was within this context—of large-scale war and destruction, waged confidently, with sophisticated ideas and technology, using a faraway country as a kind of military laboratory—that the artists' protest, like the rest of the anti-war movement, turned more mean and angry. In the first week of January 1967, the Artists & Writers Protest, in conjunction with other arts-based anti-war groups (dancers, filmmakers, theater people) and the Greenwich Village Peace Center, announced Angry Arts Week, seven days of anti-war events to begin January 29. Among the events scheduled, the announcement stated, were a "Napalm" poetry reading; a midnight concert at Town Hall in which the

musicians played without a conductor "to symbolize the individual's responsibility for the further brutality of Vietnam"; the creation (by forty filmmakers) of a film collage, *For Life, Against the War;* and, under the aegis of the Artists & Writers Protest, a one-hundred-twenty-foot long Collage of Indignation.

One hundred fifty painters and sculptors worked in one way or another on the anti-war collage, Leon told me one afternoon in May, as we continued our long conversation about the sixties. "It was something of an event in itself—the making of the collage. It was in Aptekar's loft again, on Prince Street, and for five days artists would drop by, affixing things, scrawling things, maybe just signing their names, maybe doing an image of some kind. We'd originally sent out a letter asking for contributions and the response was overwhelming, just overwhelming."

The Collage of Indignation—consisting of twenty panels, each ten feet high, to be arranged like a long, zigzagging room divider—was installed at the Loeb Student Center of New York University, on Washington Square. On each panel was attached (or written) a loose arrangement of anti-war slogans, images, and objects.

Irving Petlin (slogan): "LBJ, Infant People Burner, Long May You Roast in History's Hell."

Roy Lichtenstein (image): A Benday-dot explosion.

James Rosenquist (object): A length of barbed wire.

Golub had affixed a photostat of his "Burnt Man" image to one of the panels.

I asked Leon what he got out of working on the collage, and what he thought it accomplished. "I didn't look at it as political art—I said that many times back then," he said. "I don't know, in a situation like this, what art can do. Art today is too autonomous, too much about getting it right as art. This was about anger, revulsion—having an outlet for these feelings. Doing ugly things, being insulting, okay? One of the slogans was 'Fuck Hate,' I remember. That gives you some idea of the mood. We spat the thing out—you don't do that with a painting.

"As to its effect, who can say, right? I don't even know if we actually were worrying about that. We were showing our feelings, going public, making noise. And maybe that caught people's attention—thousands of people came to see the collage. Maybe

they saw that they, too, could vent their anger, indignation—express something about the war."

Listening to Leon, I thought how the anti-war protests, their growing fury, must have been a kind of release for him, therapeutic in a way. Angrily (and justly) demonstrating against the war, he could vent the frustration he was feeling as well with the "art establishment," the dealers and critics who were largely ignoring his *Gigantomachies*. I thought, too, how strange it was that he was still keeping the war out of his studio, his paintings. I asked him about this: Did he ever think this was strange? An incongruity of some kind?

"Starting around this time, sixty-seven, I thought about it all the time. It was strange to me, too. Now, in using the 'classical' figures, keeping them naked in unspecified settings, I thought—as I have said—that I was offering a kind of condensed, symbolic picture of our violent world, war and destruction depersonalized. I continued to want to paint this more existential metaphor. I didn't want to make topical paintings—that's how I looked at it. It had to do, I guess, with notions I had about what being an artist meant. I wanted to depict what the great artists had always depicted: man struggling against social forces and fate. What I was after was this idea of a civilization corrupted and destroying itself—and remember, the art of the sixties was not about that. It was upbeat, confident—the way so much of the country was."

So why not try to depict what was actually going on?

"Well, that's what we're talking about, okay? This contradiction, you might call it. Nancy and I would talk about it. By sixty-seven, she had resolved it for herself, in a sense: She was doing work on paper, ink drawings and gouaches—helicopter attacks on civilians and so on, fantastic things. But me, I couldn't figure out a way to do it. I got to the point—this is probably sixty-eight sometime—when I began to feel embarrassed about this being out of phase with myself. I mean, if I'd been the kind of artist who made paintings of bowls of fruit or something, I wouldn't have cared. And plenty of artists like that did protest the war, okay? For them, the work and the protesting were such obviously different items. But me . . . my whole thing was violence, destruction. What the hell was I trying to prove?"

6. LATE IN 1968, with the American involvement in the war at its height—and with calls to end the war suddenly so much a part of the political mainstream that Richard Nixon was attempting, in the November presidential election, to appeal to voters as a peace candidate—Vietnam made its way for the first time into Golub's studio. In a painting titled *Napalm I,* a painting for the most part similar to the *Gigantomachies* of the previous four years, a figure sprawls and writhes in the foreground, his chest smeared with scabrous red paint, which (drawing on the title) we are to understand as either a splotch of defoliant, or the resulting, horrible burn caused by the chemical. Golub did a second *Napalm* painting early the following year. They are both the last "classicized" and first "political" paintings he made. No major transition is easy for a painter—it was clear now he was in a profound transitional phase—and the difficulty has a way of announcing itself in the work. Golub's scraped and crusty areas of red comment less, I think, on the use of napalm by American forces in Vietnam than on the inability of the painted surface— or, for that matter, of naked Hellenistic-looking figures—to convey the raw agony caused by a very specific and most fearsome chemical weapon. Golub was in transition, and, as a painter nearly fifty years old, somewhat in trouble.

In 1970 he began teaching full-time (three days a week) at Rutgers University, and thus was getting very little painting done. That year he finished one big painting. Rather than a napalm victim, it depicts two of his figures recoiling from something outside the canvas, perhaps gunfire—broken lines crisscross the canvas. And the only works he has to show for the following year are a number of rather woeful painting-constructions assembled from scraps of thickly painted canvas. He gave them names like *Pylon* and *Napalm Gate Fragment,* and they depict no figures of any kind—they are his only abstractions. When I spoke of them the next time I visited him, he said, interestingly, "I was weighing this idea of how to get specific. Not in these works, but in my mind. I had to face the most basic questions: How do I draw? Compose? Choose colors? Specify?"

It was in the summer of 1972, with the American involvement in the ground war in Vietnam winding down—although American bombers continued to drop four thousand tons of bombs each day on North and South Vietnam—and with those involved in the protest movement (what remained of it) spending most of their time and energy working to get George McGovern elected, that Golub began to sketch out a painting overtly about the war: his first realist picture. It might have been expected that he would start small, experiment with a style of representation he was not familiar with, but he did not. On a stretch of canvas twenty-eight feet long and ten feet high, he began to draw three big infantrymen—and to the other side of the enormous picture, a number of figures, men and women, with Oriental features. His original title for the painting was *Assassins,* though later he changed it simply to *Vietnam.* It was to depict an atrocity.

I asked Leon what it was like to be drawing and painting in a realistic style, and he said, "It's hard to get across how difficult it was for me. In this painting, just doing the smallest detail— doing it specifically—was a project. The guns the soldiers are holding—I remember agonizing over the guns. You know, how did light come off metal? How does a guy grip a gun? I did the soldiers with bare chests to avoid having to paint their clothing. I was interested in this realist style, in perhaps developing my own expressive way of doing it. In realism, it is not only the gestures the figures make, but things like light and shadow, proportion, and particularly the looks of individual faces that signal to us certain meanings. But I was also still holding back. I didn't know how far I wanted to take it. I didn't know if I wanted to have to worry about teeth, and wrinkles in pants."

Vietnam I, and the two other *Vietnam* paintings he completed the following year, might be said to illustrate Golub's dilemma. The faces and bodies and clothing (which he did depict in the last two *Vietnams*) belong to no one in particular. There is none of the rigor—the rough, wooden tension of an artist working to get something right—that one senses beginning with the *Mercenaries* of the late 1970s. The figures in these great paintings can be jerky, marionette-like; however, this reads not as amateurishness but as dogged relentlessness—reads as a hand in search of truth (think of the jerky quality of Egon Schiele's line

and touch in his erotic self-portraits.) In the *Vietnams,* the figures seem not so much wooden as cardboard. The paintings convey, as the critic Peter Schjeldahl has observed, "some anonymous soldiers engaged in standard atrocities." Golub was as yet not searching with his eye and hand for something more, something deeper, something inside.

In 1974, Leon began a fourth *Vietnam,* but he never completed it. "The painting," he told me, "just didn't work." American involvement in the war was over by then, and Vietnam, as a subject for him, was finished, too. The Artists & Writers Protest, which had played such a large role in his life and his thinking during the 1960s, had fizzled out by the end of the decade. Early in 1969, hundreds of artists had joined a new Art Workers' Coalition. In its first years, the group continued to focus on the war, and on other national and international political issues. It spoke out in support of the Chicago Seven, sent money from its treasury to aid the starving in Biafra, pressured galleries and museums to close on the first Moratorium Day (October 15, 1969), and published fifty thousand copies of the "Q: And Babies? A: And Babies" My Lai poster. By the early 1970s, however, the Art Workers' Coalition was living up to its name—focusing not so much on politics, generally speaking, as on questions concerning the production and consumption of works of art. The Art Workers' Coalition wanted what it perceived as its share.

Writing in *Studio International* magazine in November 1970, the critic Lucy Lippard, a leader of the group, stated: "The A.W.C. will be powerful only in the art field, where artists have power, and it seems to me that if an artist is more involved in the Peace Movement than in artists' rights, he should be working directly for the movement." It was on galleries and museums and funding agencies that artists could "exert an influence." Artists were no longer to function as society's conscience or its "early warning system," as Irving Petlin had said. The A.W.C. had little to do with the broader society at all. Artists wanted more money for their work, wider distribution of their work, jobs, and a say in the institutions—the museums and galleries—that exhibited and sold their work. They envisioned themselves not as society viewed them—as intellectuals, sages, elites—but as a kind of proletariat.

Golub went to a number of Art Workers' meetings, but he played no organizing role. He told me that he was tired of the meetings and phone calls and wanted to spend more time in the studio. He also told me, "I didn't think major change would ensue. The museum directors and trustees were not going to relinquish power to artists."

But I doubt if he would have gotten any more deeply involved if he thought that representatives of the A.W.C. had a chance of actually getting to sit on museums' boards. Nor do I imagine he thought of himself as someone who wanted a "job" as an artist. He has struck me as a painter who works within the system— learning from the works in museums, showing in commercial galleries and museums whenever he has had the opportunity to —not because the system is fine, but because the system is what allows him to make his work and show his work. He is—he has said as much—a painter, and not an art worker.

Leon told me, as we talked of his work in the mid-1970s, that the years 1974 through 1976 were perhaps his worst as a painter. He began, but failed to finish, a number of paintings. "They were rough times," he said. "It's one thing when what's outside—galleries, the art world—is pressuring you. You learn to deal with that. But this was something else, something inside." He paused, then said, "It can be lousy being a painter. Not only can you make something you don't like. Not only are you then made aware of the fact that you have just spent time doing something that actually kept you from doing what you really want to do. You then have to walk the damn thing downstairs and throw it out." He paused again, then went on. "I wasn't sure I could paint anymore. I mean, I didn't know what else I could do, but I was feeling all screwed up on how to put it together."

Leon did believe that he had found a subject that interested him: mercenaries.

"I guess," Leon said matter-of-factly, "that they were in the news." It was at this time, in 1975 and 1976, that both the Senate and the House of Representatives were holding hearings into the conduct of U.S. intelligence agencies, and writing reports on their findings—findings that were regularly leaked to the newspapers and TV networks. There were stories of millions of U.S. government dollars flowing to "secret armies" and other groups "en-

gaged in hostile activities." Americans were learning of how the C.I.A., for more than ten years, had maintained a clandestine army of mercenaries in Laos; of the vast and ugly role the C.I.A. had played in Vietnam, organizing and running the Phoenix program; of U.S. government-initiated assassination attempts (at least eight) made on the life of Fidel Castro. Terms such as "mufti-clad contractors" and "close-in support types" turned up in news accounts. The Senate Select Committee on Intelligence concluded its investigation with the assessment that covert operations, often of a paramilitary nature, that had been run by U.S. intelligence agencies represented not an aberrant or excessive manifestation of U.S. government power abroad; rather, the operatives and hit men and mercenaries amounted to a "parallel but invisible system."

Emboldened perhaps by Congress—which had also turned up evidence of American newsmen "free-lancing" overseas for the C.I.A.—the press began paying more close attention to this system. Early in 1976 *The Christian Science Monitor* published a report that the U.S. Army was training three hundred mercenaries, half of them Americans, at Fort Benning, Georgia. Most of the American mercs were reportedly on indefinite leave from Army Special Forces. Upon completing their "course," they were to join another group of mercenaries in Angola, where a civil war had been raging since Portugal had granted the country its independence in November 1975. Later, in early 1977, a number of newspapers reported the claim by David Bufkin, an American mercenary, that the C.I.A. was recruiting soldiers of fortune to fight rebels in Zaire.

I asked Leon what in particular had struck him about this news.

"Well, I had always been interested in power," he said. "And I guess it was around this time that I began to believe that perhaps to figure out American power, you had to go to the peripheries. Mercenaries come into play when governments are reluctant to get involved directly, overtly. Now, what is interesting to me is that at the time I begin to think about this, get an understanding of this, I, too, am at the margins—peripheral, you might say. There has to be a connection."

In 1976, he began, and completed, a painting of two soldiers

carrying a prisoner, perhaps back to camp; the prisoner is tied to a long pole that the soldiers support on their shoulders.

"I based the painting on a photograph that I think was taken in Pakistan," Leon told me. I have seen this painting only in reproduction, but even in photographs it is possible to glimpse that Leon was on to something. The soldiers are dressed (one in overalls, the other in khakis), and facial and gestural details are beginning to emerge. Leon, in this painting, had found the beginnings of a new style. "I did pull off this one painting," Leon said, "but still I knew something was not working. I couldn't get the scale or representation right in any painting but this one. So I gave up the mercenaries."

I asked him what he did next, and he brought up the small portraits of political leaders.

"Now, how I came to begin these is pretty strange. In my last Vietnam painting, I noticed that the face of one of the guys looked like a young Gerald Ford. So I thought: Why not paint Ford?"

"Why paint Ford? What were you trying to accomplish?"

"Well," he said, "I remember thinking: Scale it down. It was a way to get back to painting, painting something: working. I knew I needed to work at my painting, the specifics in a face. And I can remember how much I enjoyed painting the heads— how much I enjoyed painting again. I would sit at a table and work, okay? It was close-up work, different from how I had worked, and I would work for hours."

At first he cut photos of political leaders from the papers— tightly cropped head shots—and painted from these. Several months after he began the series, having completed several "heads," as he refers to them, he learned that the wire services and certain photo agencies for a small fee loaned news photos by the batch.

"Ho Chi Minh, Arafat, Kissinger, Mao, Franco—I brought them all home," he recalled. "Some I drew from the photo onto the canvas freehand—I used this rough unsized canvas. Some I projected onto the canvas and traced. Then I would paint them and scrape them down."

I asked Leon how this squared with his idea that if you want to figure out power, you have to go to the fringes—to where the mercs operate.

"These small paintings were about something else, in my mind. What I was trying to do is paint them without affect, get them down right, get them as realistic as I could. Get the sense of skin. And maybe hollow them out. How do they come on? How do they try to get their power across? This would be important later, in the *Mercenaries* and *Interrogations,* and so on. The self-confidence you sense from a certain look, or the way the figures look at each other or out at you. Facial expressions can convey such a great deal."

The portraits are much larger than the photos they were based on—some are twice life size—but they are small paintings by Golub's standards. And, considering that they are of public figures, Brezhnev and Kissinger and Pinochet and others—are of faces you have seen time and again—they are strangely intimate pictures. It's as if, in seizing the news photos—such a source of identity for the powerful in modern society—then crudely *reproducing* the reproductions, scraping at the painted surface, painstakingly making them his own, Golub wore away the media aura. It is clear, especially in the later portraits, that Leon was feeling more comfortable with the drawing and color—with the details of eyes, mouths, and facial expressions; the possibilities of underpainting, the many shades that go into making flesh. By the winter of 1978–79, he had taught himself the new language— the expressionist-realist language—with which he would paint his extraordinary pictures of those whose power was not something to be glimpsed on the front page of the morning paper.

It was in the spring of 1979 that Golub—his confidence buoyed, and his interest in the "heads" flagging after making more than one hundred of them—returned to painting mercenaries. He finished four of them over the next year and a half, three of which I saw at Susan Caldwell in his 1982 show. "It was a good feeling," he said. "I could tell they were working."

I asked him, before I left his loft that evening, how he would portray himself at that point, as a painter. His painting, during the time he had been in New York, had changed so dramatically. How had his conception of himself as a painter changed?

"In a sense I began to see myself as a reporter. I'm reporting on power at the margins with these paintings. You want to keep America number one? These are the guys doing the dirty work.

They exist alongside other paintings, of course, but they also exist with news stories, reports about human-rights abuses, things of this kind. That isn't to say I won't go off in other areas from time to time—as with the cyborg paintings I've talked about with you, and plan to get to work on soon. But for the most part I want the work to be legible, to be read. I want these guys I paint to assert themselves, to insert themselves into your life, and for you to insert yourself into the painting—into their lives. I want people to see things, to look closely at the kinds of individuals they might not normally get to see or pay attention to.

"And something more: Maybe the paintings I make will not be assimilated by society now. Though with shows around the world, and reproductions in magazines, the images do get around. Some of my paintings have been used to illustrate political stories. I like that. But maybe on the whole we are not ready to really look at the kinds of guys our government sends down to Honduras and so on. But paintings have a way. . . . I am not saying that people will be looking at my paintings in forty, fifty years. Who knows? But there is the chance that they will have their best showing at such a time. It's possible that viewers then will look at these paintings and say that's how it was in 1980 or 1985. And in this respect they will be right."

VIII

ELECTION NIGHT

NOVEMBER · 1988

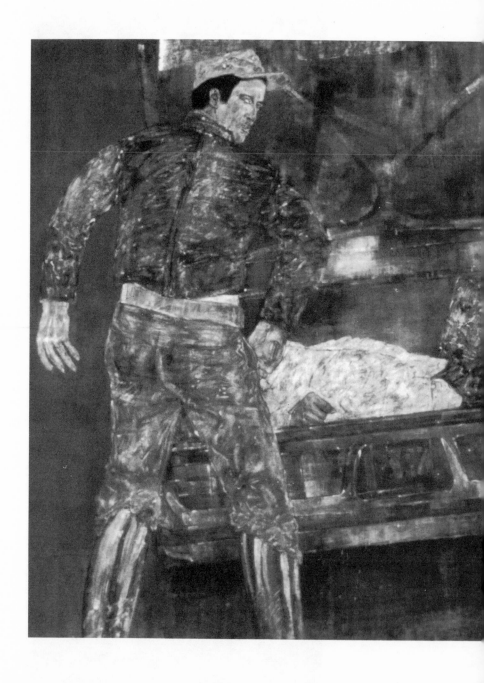

WHITE SQUAD IV,

1983

I T WAS ELECTION NIGHT, 1988. Leon and I had just sat down for dinner at Chez Jacqueline, and he was continuing a conversation we'd had on the walk over to the restaurant. "I'm a liberal—that's simply what I've always been," he was saying. "This doesn't mean I don't have radical perspectives on certain things. But I believe in a liberal society—a society open to challenge, open to question. In the sixties that wasn't enough for some people, and now that's too much for some people, if you know what I mean—but that's how I think of myself. And that's going to affect not only how I vote and so on, but my involvement as an artist in things, how far I'm willing to go."

We were talking not about the presidential campaign—which had begun with George Bush's tireless effort to affix the liberal label to Michael Dukakis, and ended with Dukakis's eleventh-hour confession that, yes, perhaps he was a liberal, one in the "tradition of Franklin Roosevelt and Harry Truman," the meaning of which, for the nation's course, we would never get the chance to know—we were talking not about Bush and Dukakis, but about a young artist named Tim Rollins. Rollins was an artist whom Leon admired, and one who, to Leon's mind, had taken his "involvement as an artist" about as far as any artist might today. In 1981, when Rollins was twenty-seven and not long out of art school, he had gotten a job teaching at Intermediate School 52, a dead-end junior high in the South Bronx. His art classes were unwieldy, impossible—seven a day, thirty students to a class, many of the teenage boys and girls suffering from severe emotional or learning problems. A number of the students, however, did show an interest in the rudiments of art-making, and Rollins

encouraged them with what little time there was left in the day, meeting with them during lunch breaks and after school, experimenting with different techniques to get them first to think visually and then, slowly, to draw.

One of his strategies seemed to click. Rollins would read aloud short passages or even whole sections of literary works he thought might get the students' attention and hold it: Stephen Crane's *The Red Badge of Courage*, Daniel Defoe's *Journal of the Plague Year*, and Franz Kafka's *Amerika*. He would then discuss the particular book with the students (often in Spanish, in which he is fluent—the fifteen or so members of the loose extracurricular group were Hispanic). The point was to make connections: Defoe's black plague with AIDS; Kafka's fantasy, near his novel's end, of angels tooting long golden horns, with the freedom in a democracy to express oneself; Crane's Civil War story of Henry Fleming's first experience of gunfire with the dramatic increase in gun-toting among inner-city youths. After a time, when the students were comfortable with a given text, Rollins would ask them to conjure a visual metaphor that they thought evoked its meaning. The students would talk until a rough consensus emerged; then they'd begin to make sketches, sometimes hundreds of them, based on this metaphor.

The Red Badge of Courage, for example, came graphically to mean wounds and scars to the students, and wounds and scars were what they began to draw. Rollins, in a number of interviews, has told the story of how the after-school group chose at first to draw its scars from the model, as in life class: Two of the students lifted their shirts and showed their stitched-up slashes, and the others examined them closely before sketching. When they discovered, as all students do, how difficult it was to make a satisfying and convincing drawing, they began to ask Rollins how other "real" artists had drawn flesh that had been pierced. Rollins then showed them reproductions in art books, gently introducing them to a tradition. He suggested that they look particularly closely at one late-Gothic stigmata—a detail of the celebrated Isenheim altarpiece Mathias Grunewald painted early in the sixteenth century. It was a huge hit. The students looked at contemporary abstract art as well, and they saw how "reality" could be transmuted into countless shapes and forms. Then, directly

on pages of Crane's novel, they painted reddish wound-like shapes not only "after Grunewald," but strange freehand bio-morphs, jewel shapes, stars. These pages were then pasted neatly, edge to edge, on a length of canvas to form a large picture. The students, on some level, had made—of their experience—art.

In 1985, Rollins left the public-school system and established a not-for-profit art workshop for South Bronx youths, the Art and Knowledge Workshop, not far from the school on Longwood Avenue. Around the same time, he and the fifteen-odd students he had been working with after school at I.S. 52 began exhibiting their constructions. Calling themselves "Tim Rollins and K.O.S." (Kids of Survival), they were soon signed up by Jay Gorney, who had a small but influential gallery in the East Village. The pictures attracted the attention of critics and a number of prominent collectors (including Charles Saatchi). The Philadelphia Museum purchased one, as did the Museum of Modern Art. In June 1988, a number of them went on view at the Venice Biennale. By that time, Tim Rollins and K.O.S.'s biggest pictures were selling for around thirty thousand dollars each.

Leon and I had bumped into Rollins at an Election Night TV "viewing" party in SoHo hosted by Group Material, an artists' organization with a leftish, communitarian ethos. In the late 1970s and early 1980s, Group Material had mounted a number of protest shows on the Lower East Side. Its aim had been to attract neighborhood residents as much as regular gallery-goers, and the group's members tended to make works that directly addressed issues affecting the local community: poverty, racial strife, "gentrification." Rollins had been one of the founders of Group Material, but he was no longer a member. He was now pursuing his work in the South Bronx full-time. There were not only the collage paintings to be conceived and executed. He explained to Leon and me that the money earned through the sale of the group's works had to be carefully divvied up and recorded; he was doing a good deal of bookkeeping as well as art-making. Some of the money was set aside so that the group could make trips abroad to Venice and other places where their work was showing. (I had bumped into Rollins and the "Kids" in Madrid in the winter of 1987. Rollins, a kind of scoutmaster in East Village black, was leading an outing to an opening.) Rollins, in

addition to paying himself a modest salary, was saving a per-
centage of the income so he might one day establish a South
Bronx Academy of Art—a school, as he envisions it, where other
art teachers would work with teenagers in the close collaborative
mode he had developed. The remaining money went to the
youths. He kept separate ledgers for each member of K.O.S., he
explained, allotted each of them what amounted to an allowance,
and placed the rest in individual trust funds to be held for them
until they are eighteen, and hopefully art-school- or college-
bound. A few of the K.O.S. youths, he told us proudly, were
already enrolled at Manhattan's Art and Design High School.

"Now, you can just see how certain critics can't wait to get
their hands on a guy like Rollins, let him have it," Leon had said
as we left the party, at eight-thirty, minutes after the networks
began calling the Bush victory. "What an easy target he must
seem, okay? The folly—that is the word they might use—the folly
of this guy going up to the ghetto, and of collectors buying the
work of these kids. But look what he's done! These are kids
everyone had given up on. And Tim has really put himself on the
line up there. He has to contend with guys in gangs and so on—
he's a white guy on the edge up there."

At the restaurant, Leon was talking about Rollins more as a
way of explaining himself. "As an artist, I can't see myself doing
what he does," he said. "I'm in the studio, painting alone. As I
have said many times, I have no program. What I have is a certain
critical distance, a certain detachment. I work as an individual.
I do a kind of reportage. I'm aggressive about it. The content is
up front, right on the wall. Let's face it, when real changes come
along, revolutions and things like that, I'm the kind that gets
censored, or shoved in prison, or worse. In how many countries
in the world today could you show paintings of interrogation
scenes, for instance? That's not to make myself out to be a hero.
I'm just saying that here I am left alone to do my work. I live in
a society in which an individual has the liberty to operate on his
own—is protected by laws and rights and so on. Now, these
rights do come under attack. There seems always to be would-
be censors and self-proclaimed protectors of our *values*. But es-
sentially it's a liberal society with regard to liberal freedoms, if

not truly liberal in some other ways, and I function in it as a liberal artist."

2. How might we begin to describe the "liberal painter"? We might begin by saying, as Leon has, that he is more deeply attached to the liberal concepts of artistic freedom and independent judgment than he is to the creation of some new social order that promises a faster or truer extension of freedom and equality to all (*i.e.,* the "classless society"); or that promises political and social institutions shaped, as they once were in the West (and are now in some parts of the Middle East), by divine guidance; or that promises the sort of nationalistic renewal Hitler promised the Germans. The liberal painter, fairly well informed by the institutions (the schools, the press) of his society, knows enough about history, including the history of art, to know how fragile liberal concepts like freedom and independent judgment— invariably promised, in some form or another, by communists, fascists, and, more recently, Ayatollahs—have proved. Like Orwell, the liberal artists today can look at the map—to the militarily controlled governments of Latin America; to the juntas in Africa; to the repressive communist societies; to the theocracy in Iran—and see that from the West, the "democratic vistas seem to end in barbed wire."

The liberal painter knows the sorts of things within his paintings that are likely to get him into trouble in illiberal societies. He knows that the ambiguities and brooding ambivalences that often give his pictures their charge—and the doubts that give rise to the ambiguities and ambivalences he paints—would not be countenanced in most countries of the world, countries where pictures exist, like written propaganda, clearly to instruct. Moreover, he would understand that there are many types of individuals who simply cannot be represented, in art, in illiberal societies. These types of individuals, the liberal painter knows, would be dismissed as decadent or blasphemous, or for not being rendered in an idealized enough fashion. They may exist, these kinds of

people, the liberal painter can hear the cultural commissar explaining, but the painter's job is to paint the promised future; when the future arrives, these decadent, blasphemous, non-ideal individuals will matter not at all. They will no longer *be*.

The liberal painter knows this is not the way the world has worked. He remains hopeful, but also prepared for the worst. Cautiously optimistic, he clings to his own time, to the idea that the specific individuals *here and now* matter, and that individual actions (including the works of previous painters) matter; he wants to continue to paint things as he sees and imagines them, and to draw on other such paintings for inspiration. He knows that in illiberal societies he will not have this opportunity—that what he considers his *work* may be considered corrupt, sinful, or criminal. Only in a liberal society—a society in which what cultural officials there are work for a government essentially committed, in J. S. Mill's formulation, to optimizing the balance between leaving people's lives alone and preventing suffering—can a painter explore *being* in all its fathomless complexity.

As I walked up Sixth Avenue on Election Night, after I'd finished dinner with Leon, I thought of his paintings—the paintings very much of a liberal artist. I thought of the cruel beauty of his mercs and rioters, the ambivalence I had felt looking at his blacks. I found myself thinking of how he was bringing to light that which remained cruel about the society in which he lived, particularly the miserable role the United States played in regions like Central America, colluding—for the purpose of maintaining influence or credibility—with those capable of the most terrible political crimes. And it was then that I recalled the essay on cruelty I had read years before by Judith Shklar, and how she had traced the liberal notion of putting cruelty first to one man's reactions to barbarisms committed in that very part of the world more than four hundred years ago. That man is the essayist Montaigne, the barbarisms those committed by the Spanish in the New World. Shklar maintains, and I think she is right, that it is in the sixteenth-century moral essays of Montaigne—in his condemnation of the conduct of the Spanish conquistadors—where there emerges for the first time the notion that cruelty is the worst thing we do.

The Church, around which the sixteenth-century West still

revolved, did not put cruelty first; cruelty was not one of the seven deadly sins. Reading Dante, our great guide to the Church-centered worldview, we find Judas, betrayer of Christ, in the deepest reaches of hell; we also find proto-liberals like the Roman statesman Seneca suffering in the afterlife—and find Dante himself capable of considerable cruelty. (Coming upon Filippo Argenti, a bitter political enemy, in Circle Five, Dante speaks to us as the Argentine torturers might have spoken in the late 1970s to those whom they subjected to the horrible *submarino: It would suit my whim/to see the wretch scrubbed down into the swill/ before we leave this stinking sink and him.*) As far as the Church was concerned, the worst thing one could do was to reject God. Those who did so might well end up *justly* humiliated, tortured, or killed, if not on earth (think of the Inquisition), then in hell (think not only of Dante but of Giotto's *Last Judgement* in the Arena Chapel in Padua.)

It was this cruelty in the name of God that horrified Montaigne. He was particularly appalled by the torture, enslavement, and slaughter of the natives of the New World at the hands of the conquistadors. He blamed the Church for its failure even to condemn this slaughter; he blamed the Church for a worldview that failed to take into account that the natives, despite their non-Christian beliefs, were human beings. Montaigne had come to believe that only in a man-centered world could cruelty of the kind the conquistadors routinely practiced be checked. There would no doubt continue to be men who would believe cruelty worked (he rightly identified Machiavelli as the first theorist of cruelty, and condemned his new amoral science of politics). But in a secular world, there would be at least the *possibility* of those with power acting not with zeal but with measure and "virtue."

The greatest student of Montaigne's writings, Montesquieu, carried this notion of putting cruelty first into the eighteenth century, the time of the Enlightenment. And it is at the end of the century, in Spain, that there emerges the first painter to put cruelty first—the painter Francisco Goya. Goya, we know, befriended many of the *ilustrados,* as the proponents of the Enlightenment in Spain were known. But whether his decision to devote so much of his career to painting human suffering, and those responsible for it as well, was brought about by contact

with these liberal men of letters, or whether this had something more to do with his temperament or that of the times—or whether, as is most likely, his temperament and his times and the influence of his friends together made of Goya the painter he was—we cannot really know for sure. What we have is the work. And in this work we recognize the concerns and desires of a liberal painter.

We see Goya putting cruelty first most starkly in the famous series of prints known collectively as the *Disasters of War*—scenes of battlefield gore never published during Goya's lifetime, but intended perhaps (we do not know) for viewers later, for whom they might serve (and have) as grizzly warnings. However, Goya sensitizes us to suffering in more rich and subtle ways, I think, in his paintings. I am not talking only, or even mainly, about paintings such as *The Second of May* and *The Third of May*—paintings devoted to the political violence that tore through Madrid during the Napoleonic invasion of Spain in 1808. In numerous other paintings, made at many different points in his long career, we sense Goya's desire to bring into painting as much as he could of the human pain he understood, and also the faces and gestures of those who, because of their power, had responsibility for this suffering.

In *The Family of Charles IV* (circa 1800), for example, we have the first great painting of corrupt, eroded—and thus unpredictable—power. We sense, as in no painting before it, the fragile vanity of a king, and the lengths to which he may go to convince us he is still in charge. Power here is more complicated, and more scary, than in a Velázquez painting; there are few people more frightening than the head of state who believes it is now mostly a matter of keeping up appearances, of "seeming" powerful—but who cannot keep up the appearances well enough to fool you. (Think of Richard Nixon during the summer of 1974.) Goya's monumental painting—and the monumentalizing itself of such a brittle image creates an edginess—is not a caricaturing of royalty. It is, rather, an expressively realist rendering of the faces of those who themselves no longer believe in their own ordained destiny. Theirs are the confounded faces of those trying desperately to *save face*.

In Goya's tapestry cartoon of 1775 titled *The Snowstorm*, a

work from early in his career, we are shown five men not atop
Spanish society but at its bleakest margins. *The Snowstorm* is a
gray and dismal scene, devoid of the blues and greens and yellows
of traditional eighteenth-century tapestries. The peasants who
march blindly in the blizzard Goya has painted are not Brueghel's
Hunters in the Snow (1565). There is no tidy, consoling village,
with fires lit and youngsters skating, awaiting Goya's exhausted
young men, as there are awaiting the returning hunters in Brue-
ghel's crisp picture; there is nothing in Goya's landscape but
barren hills and a few trees harshly bowed by the wind. Brueghel's
hunters seem weary, and their kill has been small, but they are
well dressed, warm. In fact, no snow is falling, and a soaring
blackbird hints at a certain temperateness. Goya's peasants, on
the other hand, are wrapped in blankets against the freezing,
driving snow, and two of them sink deep in drifts—they are
literally flattened by the storm, by Goya.

And unlike Brueghel's hunters, the peasants Goya painted are
facing us—individuated, but just barely. Have we seen such faces
before in a painting? I'm not sure we have. These are the sor-
rowful, storm-bitten faces of the down and out. Their "kill,"
strapped to a lagging horse, is a pinkish pig, looking more "col-
orful" and alive than the peasants. It's not something they've
hunted, not something for them to eat, but something they have
raised and are dragging to town to sell. Even the dog in Goya's
picture tells a story different from that of Brueghel's excited
hounds; Goya's dog, his tail curled up between his legs, has no
idea where to go, and would seem unable to go much farther.
The scene Goya painted is not simply a meteorological dilemma,
nor is it a generalized allegory of the seasons. It is a painting of
the wretched.

And yet the peasants in *The Snowstorm* are tramping not only
toward us, not only away from some village, but also into paint-
ing—and the fact that Goya *has* painted them lends them their
dignity, and the picture its ambivalence. Among the questions we
find ourselves asking, standing before the picture in the Prado,
is a social one: Why is it that these men and women have no
shelter? But then quickly, perplexingly: How is it that such a
picture holds our gaze?

Recalling *The Snowstorm* as I walked home Election Night,

I recalled Manet's *Old Musician,* so similar to the Goya in form and content and "Spanish" feel. And, of course, I recalled how I had thought of Manet's painting years before, when I first looked hard at Golub's *Mercenaries II.* Then, too, looking at Golub's painting, I had sensed that what I was looking at had never before been painted; then, too, the picture brought to mind political questions. But Golub, like Goya, had used form and color to make a picture that was beautiful, cruelly beautiful—and so, despite what he was showing me, his painting held my gaze.

The kind of painter Golub could be was born not in Chicago, or in the Germany of the expressionists, but in Spain, at the advent of a liberal West, with the first modern pictures.

3. To ARGUE, as I have, that a painter like Golub is a liberal painter, and that a liberal is one who puts cruelty first, is not to say that in a liberal society the painters should paint only pictures that sensitize us to cruelty. In a liberal society (as in no other) there is, for the artist, no *should.* His paintings are un-beckoned, his finished works uncensored. He is free.

The development of liberalism in the nineteenth century freed the Western painter not only once and for all from God and the Crown. Liberal government—increasingly striving to prevent suffering, increasingly careful to leave people alone, increasingly conscious of *selves*—allowed for the deepening self-consciousness which, in turn, led to the unfolding of the epoch we call modernist. And the modernist artists, of whom we might call Goya the first, have been concerned not only, or even primarily, with the societal-level suffering felt and caused by men and women. Liberalism opened numberless possibilities. Artists began to map the private pain of the new, liberal, inviolable self (think of Munch). The moral rehabilitation of desire undertaken in liberal society generated new possibilities; modern painters brought earthly sensuousness to pictures and stripped naked desire itself (think of Manet). Enlightenment scientism was taken up by many painters in the second half of the nineteenth century, and

painters—the impressionists, then the pointillists, then Cézanne, the cubists, and so on—began to ask of themselves and their medium: What is seeing? How does a painting *picture?* This is the tradition of art for art's sake, a tradition tolerated only in a liberal society. This is the tradition formalist critics in the 1960s believed (looking back) to be the century's dominant art tradition; and this is the tradition that painters, in the late 1970s, believed had run its course with Robert Ryman's all-white paintings. In the early 1980s, when I first saw Golub's paintings—saw them amid so many other new expressionistic, realistic, metaphoric, and narrative paintings—the art-for-art's-sake tradition seemed not so much "dead" as smaller, one of many traditions of painting to have developed in the liberal West. Liberalism—and, I would say, modernism—is not reductive.

Irony—an essentially liberal invention born perhaps of the uneasiness that the God we wrested society from was laughing at us—found its way into painting, and into our understanding of painting. It was there from the beginning: Manet, along with making paintings that sensitized us to cruelty, or explored desire, or examined the foundations of painting itself, painted ironic pictures. (One might think of the greatest modernist painters, Manet and Picasso, as those who alone mastered all the possibilities opened to them by liberal society.) In our century—the century of Freud and Auschwitz—irony deepened. Deeply skeptical artists, beginning with Marcel Duchamp, began to work toward a chilling goal, one more final than that pursued by the art-for-art's-sake formalists. It was not a matter, for the radical ironists, to paint the most ironic painting, as it was for the formalists to paint the flattest, nonreferential painting. The radical ironists, or so their critical supporters maintained, wanted to paint the very last painting, the one that would bring to an end the entire liberal, modernist notion of painting *as art.*

In the 1980s, this end game was reached (according to those rooting for it) by the artists who applied the strategy that came to be called "appropriation." At their most extreme, these appropriation paintings are *of* nothing more or less than other paintings. For example, the painter Mike Bidlo painted exacting replicas of the still lifes of Giorgio Morandi, then moved on to paint a copy of Picasso's *Demoiselles d'Avignon.* Bidlo and others

like Sherrie Levine were thought, by radically skeptical critics, to have ironized painting once and for all. Theoretically, every painting could be appropriated—that is, have its core, intended self remade. Nothing was original, or as intended, or new; nothing spoke of form discovered, or sensibility imparted, once it had been carefully knocked off by a contemporary artist who might well move on to an entirely different "period" later that same day. Appropriation paintings did not simply represent a loss of creative energy, or (as I think, in fact, is the case with Levine) a certain poetic melancholy about the Waning of Modernism, or the sensibility of those who had been overwhelmed with imagery—news photos and TV images and magazine ads (and art reproductions) that seem at times to float around us, unmoored from the contexts that lent them meaning. The point was—or so went the argument—that there was no argument on such *art* terms. Whether a Bidlo "Morandi" was a Bidlo or a Morandi was, questions of connoisseurship aside, a philosophical question. The only question one could really ask of a Bidlo is: Is this art? Its only value as art was its commodity value; philosophy or not, it could still be collected (and wasn't *that* ironic?).

Arguments against this notion that art had simply become a visual branch of philosophy could be made, of course, on terms other than those of art. One could point out that the "end of art" argument had been tried before—by Hegel, for instance, in his grand *Aesthetik*. "Art," he wrote, "is a thing of the past." What Hegel called art's "earlier necessity in reality" during the Christian era was to his mind no longer necessary or desirable; of "greater need" was "the philosophy of art." It is well to point out that Hegel was writing in the 1820s, at the very dawn of the liberal, modernist West—in the first years of a century that would, despite his philosophy of art, produce Courbet, Manet, van Gogh. The unfolding of history, one might say, has a way of historicizing the historicizers, whether Hegel or the appropriators and their theoretical defenders. It would not be surprising for history to find, in the works of appropriation artists—or, more accurately, in the radically skeptical analyses of appropriation—not so much a critique of, say, "late capitalist society," but a mirror onto a reactionary political moment when the country's leaders urged us to see our roles as citizens strictly in economic terms. The

notion of a painting as nothing more than a commodity, and the notion of citizenship as the right to turn one's back on cruelty and simply purchase more of the good things in life—both are similarly cynical and illiberal.

A liberal could also point out that the history of art has indeed ended in our time, not in the galleries of SoHo, but in the nations dominated in our time by the Soviet Union. In the societies of Central Europe, modern art suffered what the exiled Czech novelist Milan Kundera has called a "violent death," one "inflicted by bans, censorship, and ideological pressure." (A liberal would also hope that this situation is now truly changing—that Central Europe, and perhaps Russia, too, will succeed in their efforts to liberalize, and, if the novels of its exiles be any guide, resume their vital contributions to modern painting.)

But I would rather, as a liberal, simply set the radical ironists aside—say they are *interesting*, but irrelevant to public life, and by extension to the kinds of painting, like Golub's, that address us publicly, as "we." And to enable me to set the ironists aside, I will borrow from the liberal thinker Richard Rorty. Rorty, like all liberals, draws a thin but meaningful line between private and public life, or, more specifically, between our private and public selves. But Rorty takes us beyond the thinking of the Enlightenment rationalists—beyond the belief that "we" are bound together *naturally,* that we share a core soul or consciousness or mind that binds us. He acknowledges that many of us construct for ourselves (and construct for others) a sense of self that is little more than a web of belief and desire, shaped by chance and circumstance: a self that is, as today's most radical ironists might say, nothing more than language—and language can always be ironized, or "deconstructed."

Golub himself is inclined toward such a view in constructing his own self. There may be some elusive, dark muse that is the essential inspiration for his paintings, but he is not particularly interested in chasing it down. He is more apt to talk of chance, context, circumstance. His best paintings—those of the mercs and torturers and other political criminals—may never have gotten painted, he likes to say, had his earlier paintings been critically successful. And the figures he paints, he constructs of fragments, shards of images.

But if Golub believes that man is "contingent," to use one of his favorite words, how can he hope to address a public, a "we," with his paintings? If there is no center to the self, if we are in effect only the results of our webs of belief and desire, and the outside forces that push and pull us, how can we bind together to think and act as a society, think and act politically? Don't we need some shared, bedrock beliefs that are not contingent, that can not be made relative by some ironist? To act politically, to participate in a public life, there must be a general recognition of a social bond, some way of saying "we," that cannot be deconstructed.

Because Rorty believes any formulation of such a bond grounded in phrases like the "natural rights of man" is ultimately susceptible to a relativistic, ironic reading—because there is no moral truth, written or stated, that is always and everywhere true—then the social bond must be found outside language, in something more solid, more palpable. Rorty has located such a place: the human body. What we share, what is our true social bond, is our bodies' shared ability to feel pain. This is where politics begins for us. We seek to forge a public life—reluctantly, simply to assure the continuation of our private, and perhaps ironic, cultivations—in order to prevent pain. We seek to prevent physical pain, of course, but also, as Rorty writes, "that special sort of pain which the brutes do not share with the humans—humiliations."

What struck me, on my long walk uptown Election Night, was this: It is precisely this aspect of man that Golub has chosen to represent—or, as Rorty might say, to effect a recognition of. Through his paintings he takes us into the deep jungles and dark cells where pain and humiliation are at their most awful. It is the political criminal more than anyone else who seeks to penetrate and break down that inviolable self (ironized or not) that we liberals want left alone. It is the torturer and the goon who *embody* (in complex, ambiguous ways) the most profound threats to liberal society—threats to liberty, the freedom to make of oneself what one chooses, the ability to be. Golub has painted his cruel criminals—and those like his blacks who have overcome cruelty and suffering—in the hope perhaps that others, in viewing his paintings, will notice what he has noticed.

"Solidarity," Rorty writes, "is not discovered by reflection [upon either the self or the philosophical questions of general understanding] but created. It is created by increasing our sensitivity to the particular details of the pain and humiliation" done by ourselves and others to others. In the paintings of Leon Golub, as in no others of this moment, we glimpse these details, and (if we are liberals) we shudder.

4. I HAD MET Leon on Election Night at his loft, and on the wall in his studio I had seen, not quite finished, one of his new *Sphinx* paintings. Against one of his familiar scraped red backdrops he had painted a monstrous beast—the head of a man atop a long, lionesque body. The surface was beautiful, especially near the top of the painting, where the reds and whites and pale blues might have been not paint on canvas but ancient fresco. However, the image itself did not convince. Golub's hand and eye work best when he's wrestling with hard specifics: *this* hand, *that* mouth, *these* clothes. Moreover, the idea of such an image struck me as somewhat portentous, as if he were taking it upon himself to give shape and substance to the monster "within" his cruel (but very human) victimizers. Cruelty, as Golub himself had shown, is to be glimpsed right on the surface—in the gestures and "looks" of those who victimize, or have been victimized. Painting itself takes care of the deeper meanings.

At dinner later, Leon and I had talked about his *Sphinxes*. He was pleased with them, but now he would return to his "reporting." We talked, too, about politics, about the Bush victory, and then for some time about how El Salvador would likely be in the news again soon. Death-squad killings were on the rise once more, and the right-wing ARENA party, whose leaders include many who have been linked to the death squads, were favored to win the general election in March and take control of the government. Talking with Leon about El Salvador, it crossed my mind that perhaps in a world in which he glimpsed no pain and humiliation of the kind meted out, for example, by death

squads, he would have done what most of the painters of our modern, liberal age have done—explored the nature of painting itself, or, as strikes me as more likely, journeyed into the viscid, tangled web of private beliefs and desires. This exploration of the "self" has been modern painting's great achievement, a great liberal achievement. Few artists have sought, as Golub has, to envisage the pain and humiliation of others, and to envisage, too, those who cause others pain and humiliation (or seek to). Perhaps the painters thought it best to leave it to the photographers— despite the fact that a painting is not a photograph, and that there are places the camera does not go. Perhaps it has to do with liberal society's having put an end to so many types of cruelty, at least those readily felt by its painters.

Golub had made cruelty his subject. In a sense, he has spent forty years or more in his studio painting little else. These for the most part have been big public paintings about social and political cruelty. His career can be framed as an attempt to answer the question: *How, in my paintings, can I represent this cruelty, those who cause it and those who feel it?* And I think, whatever his frustrations over the years, painting the pictures he has—especially those of the last dozen or so years—has given him a deep sense of satisfaction, a satisfaction lost, I am sure, on those today who seek only to ironize and philosophize with their art. It is the kind of satisfaction the writer and political philosopher Hannah Arendt brought up once in an interview when she was asked if she thought the protest movement of the 1960s in America—a movement that in a very real sense made possible Golub's extraordinary paintings of the late 1970s and beyond—had been, in general, a historically positive process. Arendt thought it had, and she noted that, along with changing public opinion, the protesters had managed to find pleasure in what they did. She was talking about a particular kind of pleasure, one born of liberalism. She noted that the protesters had "discovered what the eighteenth century had called *public happiness,* which means that when man takes part in public life he opens up for himself a dimension of human experience that otherwise remains closed to him and that in some way constitutes a part of complete happiness." I am inclined to think that Golub, making the paintings he does, has also discovered this happiness.

Leon and I hadn't talked about this at dinner, not directly. But he had said something that got me thinking about all this—thinking about Arendt's comment about public happiness; and Rorty, and his theory of pain and humiliation as the starting point for our politics; and Goya and the beginnings of liberalism. I had asked Leon, as we sipped our coffee, if he ever had the desire simply to paint a lovely little picture. There were passages in many of his paintings—lines, shapes, colors—that to me spoke of such a desire.

Leon lifted up his water glass and looked intently at it. "There are painters," he said, "who look at something like this, a glass, and see the world. I have the greatest admiration for all kinds of painters like this. Some of the great paintings are ones in which the painter has discovered a world in this way. But it's not for me. My world is bigger. It's a world of man. It's a world of power, of control, of vulnerability, of tremendous brutality, of resistance. You can look all night if you want, and you aren't going to find that world in a water glass, okay? That world is out there somewhere, a world of real events in real time unfolding right here and now. And that's the world I paint."